Searching for Art's New Publics

Searching for Art's New Publics

Edited by Jeni Walwin

intellect Bristol, UK / Chicago, USA

First published in the UK in 2010 by
Intellect, The Mill, Parnall Road, Fishponds, Bristol, BS16 3JG, UK

First published in the USA in 2010 by
Intellect, The University of Chicago Press, 1427 E. 60th Street,
Chicago, IL 60637, USA

A catalogue record for this book is available from the
British Library.

Cover photo: Gillian Wearing, Family History, 2006, Installation
view, Forbury Hotel Apartments, commissioned by Film and Video
Umbrella and Artists in the City in association with Ikon Gallery.

Cover designer: Holly Rose
Copy-editor: Rebecca Vaughan-Williams
Picture researcher: Laura Eldret
Typesetting: Mac Style, Beverley, E. Yorkshire

ISBN 978-1-84150-311-0

Printed and bound by Gutenberg Press, Malta.

Contents

Acknowledgements

I am particularly grateful to all the artists, curators, writers and academics who have contributed material to this book. Many of them gave presentations at the *Searching for the Spectator: Art for New Publics* symposium at the University of Reading in the autumn of 2007 and they have subsequently reworked their material for this publication. Others have created new texts especially for the book and I appreciate the time and commitment that they all have devoted to the project. I would especially like to thank Alun Rowlands, artist, curator and course leader in the Department of Fine Art at the University of Reading. Early conversations with him and a subsequent collaboration with the University led to the symposium event and this substantially influenced the development of the publication. I am grateful for all the work that Kerry Duggan contributed to the early stages of this project. I would like to thank Dave Beech for his involvement and his proposal for the shorter, snappier title. Enormous thanks go to Laura Eldret for her unstinting work on the picture editing and research. It has been a pleasure working with the publishing team at Intellect, in particular thanks go to Sam King for her early support to the project and to Melanie Marshall who has managed the production stages. The greatest thanks are extended to Tammy Bedford, Arts Manager at Reading Borough Council, who has encouraged the project at every step on the way and without whose unswerving support none of this would have been possible.

Jeni Walwin

The publication has been supported financially by Reading Borough Council, through their Artists in the City programme; by Arts Council England South East; and by the Henry Moore Foundation.

The Henry Moore
Foundation

Preface

Reading Borough Council has been active in commissioning artists to work in the public realm for many years and was one of the first UK local authorities to adopt a 'Percent for Art' policy. Our understanding of the contribution that artists can make to the places in which we live, work and play has developed over time and has grown out of the experience of working on a wide and diverse range of commissions, some of which are included as case studies in this publication.

Artists in the City, Reading's relaunched public art strategy and programme, represents an approach to working with artists which encourages a creative collaboration with commissioners. There are many reasons why local authorities, developers and others involve artists in the public realm. High-quality public spaces, imaginative regeneration schemes, creating a sense of place and identity – these are aims often shared by those responsible for delivering the contexts in which artists will work. But what lies behind all of this is the people who use and interact with the public realm, whether as residents, consumers, employees or simply passers-by.

As a local authority our interest in commissioning artists is the contribution they can make to people's experiences of Reading. How that happens will depend on the context of each project. Some projects set out to actively promote public engagement and participation through the process and/or outcome. Other projects will require a more exploratory approach in which the element of public engagement may not be immediately obvious. But the involvement of an artist will have made a difference, and that is the legacy of any commission.

We still have much to learn. Our involvement in the 'Searching for the Spectator' symposium and this subsequent publication has been to share our experience of working with artists in public contexts, but equally importantly to explore these issues further through the contributions of artists, curators and writers on other national and international projects.

Tammy Bedford
Arts Manager, Reading Borough Council, 2009

Introduction

Jeni Walwin

This is a book which looks at the blurring of distinction between an artwork and its public – that fine line between creator and spectator, maker and viewer, artist and audience. Within the Artists in the City programme in Reading we have for some time been concerned with the impact that a work in the public domain may have on the public whose domain it is. Conventional approaches to making work for public space focus on the physical site and the historical and sociological context for the work. Direct engagement with the public is usually planned as a separate and discrete exercise – either in the build up to the work, through that highly suspect device, consultation, or during and after its installation through related workshop and introductory activity that will offer access, understanding and engagement.

Meanwhile artists who have never considered themselves to be public artists in that sense, and whose practice is commonly associated with gallery viewing, have been exploring new ways of working which challenge traditional boundaries and confront the complex relationship between artist, environment and spectator. For these artists, contributions from members of the public have become an integral and influencing factor within their practice. This book examines how and why some artists open up their working method to embrace the involvement of non-art communities, allowing the final form and content of a work to be shaped to a great extent by someone other than themselves.

The public in this instance can be defined in many different ways. They may be passers-by encountering and participating in the work unexpectedly, or they may be professionals from other disciplines invited to perform a specific role or they may be members of a particular community bringing their own local or political agenda to the project. Whoever they are and however they might contribute, this way of working establishes quite a different form of interaction from that experienced by the community arts movement of the late 1960s and 1970s, where process was paramount and the professional artist usually invisible. The divide between community arts practice and contemporary art activity at the time was immense.

Writers and academics have alerted us to the narrowing of this divide in recent years. Nicolas Bourriaud and Claire Bishop have written eloquently on the subject and Dave Beech

in his keynote essay here responds to their texts and proposes a way forward, setting the scene politically. Beech unpicks the terminology commonly associated with this way of working – participation, collaboration, interaction – with reference to recent developments in art theory. Sally O'Reilly uses Beech's terminology as the starting point for her investigation of the *Granville Cube* – a public works' project on a West London housing estate. Other contributors consider how far it is possible for the public to become both viewers and subjects of the work, while resisting the possibility of becoming objectified by artists for the benefit of their art.

The original ideas for this publication grew out of a symposium on the subject held at the University of Reading in 2007. All of those who gave presentations that day have edited, rewritten or re-presented their material in order to make it more relevant to book form. In addition further contributions have been invited from writers with an interest in the field. *Searching for Art's New Publics* gives equal attention to essays by academics, critics and theorists as it does to the voice of curators and artists currently engaged in a practice which generously embraces the public. Placing artists' original source material next to academic critiques is an unusual approach, but one that has been deliberately chosen in order to illustrate the thinking and experiences of the people who create and curate the work alongside those who articulate a position for it within the broader context of contemporary cultural theory. Illustrating this diversity of experience allows the reader to make direct links between history, theory and contemporary practice. Those whose profession is writing – academics, critics and writers – have made insightful contributions, but many of the texts come from those who do not regularly express themselves with the written word. Composers, artists, curators and filmmakers have therefore selected a singular, and often unexpected, means of translating their experiences into book form. The resulting texts come in a variety of formats which reflect the energy of their authors. On the one hand there are the more conventional footnoted texts from those used to delivering essays for academic consideration; but there are also interviews between artists and curators; a memoir of a project; conversations between artist collaborators and a script for an unmade documentary where historical reference and living voices interweave seamlessly.

The material is divided into chapters with Dave Beech's essay acting as a reference point for them all. Each chapter deals with a particular aspect of the search for the new publics of the title, bringing together a variety of contributions which, in very different ways, unpick some of the history and the experience of this endeavour. In Chapter One, 'Participation: Open or Closed', five texts explore the extent to which artists are able to give participants the lead. Sally O'Reilly uses the framework of a script for a potential documentary film to discuss twentieth-century precursors to this way of working and to pose questions to the intended beneficiaries of a twenty-first century project for a non-art community. Artist Adam Dant may not handpick his participants, but he certainly handpicks the contributions they make, and while their work is easily recognizable in the end result, he makes it clear that the artist is in editorial control throughout. Sophie Hope speaks as an academic, curator and as an artist-enabler in her text which describes her determination for projects

to remain open – as wide open as possible – so that participants can shape outcomes during production and influence their evaluation. Marisa Sanchez discusses with American artist Harrell Fletcher his early motivation for the participatory mode of practice and highlights three of his projects since the early 1990s in one of which he offers creative collaboration with a young individual and in others access for thousands of voluntary participants.

In 'Sonic Openness' the opportunity for participation within a particular strand of art practice is explored. The attention here is on sounds – composed, sung, improvised – and the proposal that inside every one of us there is a musician longing to perform. David Briers traces the historical lineage of sound art and looks in particular at those composers and artists who have opened up their work to untrained performers and in so doing have disrupted the idea of a 'separate' audience. In much of their work Juneau Projects have given voice to the young – inspiring sonic and lyric creativity in open and expansive contexts. The two artists discuss the unexpected but rewarding sonic and poetic results of a recent project. A choral participant in one of Melanie Pappenheim's projects points to the importance of a strong artistic drive and the need for a finished piece to be aesthetically and sonically confident. For this amateur singer a focus on process and open access alone is not rewarding for the participant.

The texts in the following chapter, 'The Emancipation of the Spectator: The Viewer completes the Circuit', explore three very different modes of art practice each of which entices the viewer inside the work. J.L. Dronsfield investigates Thomas Hirschhorn's work where theory, practice, art and philosophy are all equal, and the spectator makes personal choices about the connections between them. Graeme Miller's memoir of an East London sound walk implicates the listener as witness where 'places are read/write surfaces; we contribute by observing; we are written into them by listening; we are measured by measuring them'. And for London Fieldworks the gallery-goer in *Polaria* is an integral component of the finished work – 'electrifying' the installation and literally completing the circuit. In both *Polaria* and *Little Earth*, the audience, the participants and the collaborators are to a certain extent interchangeable. London Fieldworks' collaborators are drawn from scientific, and occasionally from literary and musical, disciplines and they reach into other non-art communities who in turn expand, influence and contribute to the artists' initial ideas, helping to shape each project as it develops.

In the final chapter we return to an inspection of the art object, to see how far this previously rigid form has broken out of its casing, dissolved and embraced people. Vincent Honoré profiles the political nature of the work of Nina Beier, tracing the build up to a recent commission *All Together Now* which investigates forms of resistance and engages with a notion of human labour as a material condition, to the point where, as the artist, she is barely visible in the final work. Helen Sumpter interviews Gillian Wearing and Heather Wilkins (the subject of a recent Wearing video installation) about issues of authorship and ownership, revealing the artist's desire to offer a platform to people who would otherwise not have one, and Heather's clear view that, while the agenda was Gillian's, this project wouldn't have happened without her. Adam Sutherland tracks the recent history of Grizedale Arts

following the transition from public art object to public art participant in his quest for art as a social benefit. Mike Ostler was a participant in Nina Pope's film project *Bataville: We Are Not Afraid of the Future* and he is as vehement in his distaste for the art object as he is for his celebration of the film and the journey he has taken with Nina's project, which continues to this day with his responsibility for the Bata Reminiscence and Resource Centre. The mutability of the art object in an exhibition context is unravelled by Paul O'Neill in the closing essay which proposes an evolving, collaborative, non-hierarchical, co-productive process for exhibition-making.

One reading of the title of this book *Searching for Art's New Publics* might suggest that the people that the word *Publics* refers to are ones that we have yet to find, but I hope that the reader will soon realize that these people are here already, all around us, engaged in art practice, collaborating, participating and influencing. They are as much a part of art as they are of the everyday. The only reason that they have traditionally been separated from so many of our discussions of art practice to date is that, as Dave Beech alludes to so poignantly in his essay, we cannot focus on a theory of art which deals with the art of encounter, if we are not 'at the same time rethinking social relations at large'. This is surely reinforcing the potential role that art can play in the shaping of our society, if only we are ready to respond to the call.

Keynote Essay

Don't Look Now! Art after the Viewer and beyond Participation

Dave Beech

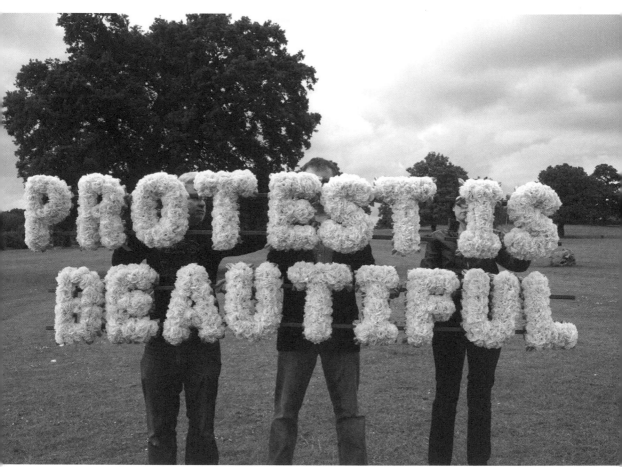

Freee, Protest is Beautiful, photograph, poster, 2007.

Collective authorship represents the promissory social space of the organization of art's ensemble of skills and competences beyond their privatization in 'first person' expression, aesthetics, and the whole panoply of possessive individualism inherent in the Cartesian Theatre.[1]

John Roberts

Introduction

Why would we want to search out art's new publics? Are they not already there? Or, better still, aren't we already here? The short answer is 'no'. The slightly longer answer is 'absolutely not' – because it is important to be absolute here to avoid relativism and instrumentalism. Art's new publics are neither to be understood in the relativist sense promoted by postmodernism (what is new is the disappearance of the new), nor in the instrumentalized sense promoted first by publically funded art institutions with their outreach programmes and now part of the fabric of arts administration (new audiences are scooped up from previously neglected demographics). Rather, I want to talk about the new as a qualitative shift, something akin to revolution. Following J.L. Austin[2] I want to say: not just the new, that is to say not just any old new, but the *really* new, where 'really' distinguishes between false or apparent versions of the new on the one hand, and genuine or deep versions of the new on the other.

My model of the really new public for art is drawn from Slavoj Zizek's analysis of a bitter joke in Brecht's famous poem 'The Solution' in which he reasons, ironically, that since 'the people/ had forfeited the confidence of the government/ and could win it back only/ by redoubled efforts' the government had decided 'to dissolve the people/ and elect another'. Shockingly, perhaps, Zizek argues that it is Brecht, not the government, that is wrong in this scenario: 'one should bravely admit that it is in effect a duty – even *the* duty – of a revolutionary body aware of its historical task, to transform the body of the empirical people into a body of Truth'[3]. I think Zizek is absolutely right, here, and I think what he has to say applies to art, too. Art can only regard itself as revolutionary if and only if it is wholeheartedly committed to the task of transforming its 'empirical' public into a new public – a really new public.

Even if the transformation of art's public into a revolutionary body of truth is not on the cards at the moment, our understanding of art and its publics must, nevertheless, be understood in these terms or else we are left with one of its 'empirical' publics presented as its only, rightful or true public.[4] What has to be transformed, in this task, is not just the body of the public in the collective sense, but also the body – and the senses – of each and every member of that public. In other words, pleasures and sensations will not be untouched by the transformation of art's public. Unlike Zizek's example, though, this transformation cannot occur within art from the top down. No government can impose this new public on art. It will emerge – or be produced – only as the result of changes to art itself. At present contemporary art is taking this challenge, I want to argue here, to the very heart of the aesthetic experience of art by doing away with the viewer. Let me explain.

The Viewer and its Rivals

It now seems like an age since art theory raised the question of the 'disembodied eye' of the gallery-going viewer. Nowadays we hear less about the viewer and of viewing art than we do about interactivity, participation and dialogue. A new art of the social encounter has transformed our conception of the viewer along similar lines to the transformation of the art object during minimalism, conceptualism and post-minimalism, when attention to the immanent qualities of the autonomous work seeped out into an interest in the space, site, process and documentation of the work. The viewer has lost its erstwhile shape, and the familiar ideologies that went along with it. The viewer isn't dead, but the gallery is now occupied by new rival subjects and bodies, and much of the new art is no longer made with that customary aesthetic subject – the viewer – in mind.

Before going on to examine how the art of encounter promises to transform art's public into a really new kind of public, however, I need to mention the fact that it has not entered art's terrain unopposed. It is only to be expected, of course, that the new art of the encounter, which constitutes an assault on art and aesthetics, would not be allowed to do so uncontested. It finds itself in competition with the 'new formalism'[5] of Jim Lambie, Roger Hiorns, Eva Rothschild, Shahin Afrassiabi and Gary Webb. If we were to draw a distinction between the new art of encounter and the new formalism, we would do well to couch it in terms of their different publics, or their differently framed experience of art. And if we do, then, I think we will see that the new formalism appears to preserve exactly those qualities and experiences that the new art of encounter threatens. It is, so to speak, a precise picture of what the current incumbents of artistic taste think is most at risk from the new art of encounter.

The new formalism is therefore like the post-Enlightenment religious believer characterized by Alenka Zupančič[6] in terms of a joke:

a man believes that he is a grain of seed. He is taken to a mental institution, where the doctors eventually convince him that he is not a grain, but a man. He leaves cured but

Harrell Fletcher and Jon Rubin, *Garage Sale*, Gallery HERE, Oakland, CA, 1993.

returns within seconds claiming that there is a chicken outside the door that wants to eat him. 'Dear fellow,' says the doctor; 'you know very well that you are not a seed.' 'Of course I know that,' he replies, 'but does the chicken know?'

Zupančič shows that knowledge alone is not sufficient to effect change. As such, visual pleasures and aesthetic practices will persist not necessarily out of a lack of knowledge about the expansion of art's social ontology, but as a result of that knowledge and despite it.

But now that the new social ontology of art has been thematized in the new art of encounter, there is no putting it back in the box. Indeed, what happens is that the new formalism starts to be praised for traces of social encounter detected in it. Lambie's use of junk shops, for instance, or Hiorns' abandoned Home Space Available project will be picked up on because they bridge the gap between the two opposing camps. But, like the man in the joke frightened of the chicken who ultimately retreats from the full implications of what he knows, the new formalism must ultimately retreat from the full implications of the social, because, insofar as it is formalist, it cannot do away with the viewer altogether.

In fact, any trace of social encounter found within the new formalism, I would argue, ought not be credited to this art at all but to the art of encounter it opposes. For, just like when modernist formalism transformed our perception of painting and sculpture so that we began to see pre-modern works in terms of their abstract qualities, the new social ontology of art applies even to that work which remains aloof from it. This point is made by Nicolas Bourriaud when he argues that the history of art could now be rewritten retrospectively as a history of art's social encounters. 'Today', he goes on, 'this history seems to have taken a new turn. After the area of relations between humankind and deity and then between humankind and the object, artistic practice is now focused upon the sphere of inter-human relations'.[7]

There is no viewer of these inter-human relations, and if there were then this would probably be seen as a troubling social presence that affects the inter-human action that it views. At the same time any objects that are used within these inter-human relational artworks are generally *used* rather than *viewed*. Liam Gillick's work, for instance, can be understood as a politicization of the visual in art and culture. The work is always visual, he has said, because he is interested in how the visual environment structures behaviour. Hence, even when his work looks well designed or even beautiful, it 'is better as a backdrop to activity'.[8] Whatever else is going on in Gillick's work, in tandem with the works of many of his peers, here we are quite clearly cast by the artwork *not* as a viewer. The idea of art-as-backdrop is, therefore, simultaneously the idea of the viewer as no longer a viewer (without prescribing what else they might become). 'If some people just stand with their backs to the work and talk to each other then that's good,'[9] Gillick has said. This is a glimpse of something new to do with art.

An art not to be looked at is an art that proposes a thorough reconfiguration of art's materiality, agents and agencies: the art object is no longer necessarily the primary focus of the encounter with art; the white box institutions in which we encounter art adapt by

mimicking libraries, cafés and other social spaces; the artist itself turns to unfamiliar skills to produce the new art; and art's addressee, no longer necessarily even a gallery-goer, is not a viewer, but is a subject expanded with a range of new activities and new styles of engagement.

We need to understand two things here. First, the assault on the viewer, which has roots both in conceptualism's critique of the primacy of the visual in art, and earlier in Duchamp's dismissal of 'opticality'. Secondly, we need to understand the rise of the concept of relationality and practices of participation, collaboration and performativity that have largely been taken to replace the gap left by the ousted viewer. We should not assume, however, that participation (and its relational cousins) is the best or only way of thinking about art after the waning of the viewer. I want to suggest, in fact, that the true value of the displacement of the viewer can only be obtained if we think beyond participation.

The Post-Cartesian Artist

In *The Intangibilities of Form* John Roberts provides a clear and full articulation of what he calls the emergence of the 'post-Cartesian artist'[10] after Duchamp. 'Too often the discussion of the readymade languishes in the realm of stylistic analysis, the philosophical discussion of art and anti-art, or, more recently, the Institutional Theory of Art', Roberts says, 'not as a *technical* category'.[11] With this new focus in mind, he argues that Duchamp inaugurated a shift away from handcraft and representation that ushered in 'a discourse on the diffusion of authorship through the social division of labour'.[12] That is to say, Duchamp should not be understood simply as rejecting art, authorship or skill with his introduction of the readymade. No, the key transformation is that the readymade 'brings the link between artistic technique and general social technique in the modern period into inescapable view'.[13]

Duchamp creates a disruptive 'diffusion' that we need to see as having a double movement in which art sheds its old techniques and absorbs the whole gamut of techniques at large. The result is an ontology of art in which there are no longer any specifically artistic skills or techniques, such as painting or sculpture, that define art (what Theirry de Duve calls 'generic art'[14]), in which art draws its techniques from industry, politics, entertainment, philosophy, science and so on – without limit. An example that suggests itself is Alex Farquharson's list of Carsten Holler's practices: 'zoologist, botanist, paediatrician, physiologist, psychologist, occupational therapist, pharmacist, optician, architect, vehicle designer, evolutionary theorist and political activist'.[15]

Roberts' new reading of Duchamp is also a new reading of art after Duchamp. What Roberts calls the 'aggressive Cartesianism and asocial aestheticism of modernism',[16] is radically undermined by Duchamp and then redoubled by Warhol's 'Factory', but it is only fully jettisoned by conceptualism, when art's preoccupation with crafting a unique object is replaced with a repertoire of techniques borrowed from anywhere and everywhere. And this means, among other things, that the artist goes through the same kind of expansive

transformation and can no longer be identified or conceptualized in the old ways. This is the birth of the post-Cartesian artist.

Thus, for Roberts, 'the artist's voice becomes subordinate to the forces of reproducibility and general social technique'.[17] This means 'making' art (often, making without making) with non-artistic skills and techniques, 'making' with the hands of others and 'making' through instruction. This subordination opens the artist up to a multitude of previously unavailable roles, discourses and modes of address:

> The displacement of the first person singular discourages the author to think of himself or herself as a unified subject bounded intellectually and conversationally at art historical precedents (rather than, say, for example, a performer of a set of cognitive/artistic skills indebted to the problems of philosophy and science and other non-artistic discourses).[18]

This displacement of the first person singular, of course, may often mean the artist working in the first person plural i.e. collaboratively.

The Art of Encounter

It is not just the art object and the artist that is transformed by these developments within the post-Duchampian ontology of art. The birth of the post-Cartesian artist is matched by the transformation of the encounter with art. The viewer isn't dead, but its hegemony – the reign of the 'disembodied eye' – has been broken. However, we cannot go on to develop a theory of the post-Cartesian viewer, as the viewer of art *as* viewer is Cartesian through and through.

A detailed and expansive debate has been taking place over the past several years about the relative merits of various categories of social encounter in art. I want to argue that this interest in interactivity, participation and dialogue in contemporary art, that jettisons the Cartesian 'viewer' from art, is one of the most conspicuous legacies of the post-Duchampian ontology of art. So, we can say that this ontology is the *shared ground* of (1) Nicolas Bourriaud's relational and convivial aesthetic, (2) Claire Bishop's art of antagonistic social relations and (3) Grant Kester's advocacy of artists and arts collectives who operate 'between art and the broader social and political world'.[19] I want to group these competing approaches to contemporary practice under the heading 'the art of encounter'. And I want to explain its relation to the post-Cartesian artist. This will then allow me to engage more critically with the inadequacies of current thinking on art's social ontology.

Nicolas Bourriaud published his first book, *Relational Aesthetics* just a few months after Matthew Collings launched *Blimey!*[20] into the mediascape. From the outset, Collings' book looked cynical – the author preferred to think of it as ironic and intelligent – in its reluctant but resigned packaging of young British art. However, it was not the work that was superficial but its reception at home. This became clear after the translation of *Relational Aesthetics* into

English in 2002. By comparison, *Blimey!* which had previously seemed cool, knowing and sophisticated, looked frothy. Bourriaud, albeit by focusing on a different constellation of this generation of artists, showed that something much deeper and more sophisticated could be seen within this work. For all its failings, Bourriaud's book raised the intellectual stakes.

Bourriaud provided a sophisticated theoretical defence of such social events as Rirkrit Tiravanija's Thai soup installations, Carsten Höller's scientific tricks, games and amusement rides and Andrea Zittel's furniture-as-meeting-place. Saying that these relational works 'outline so many hands-on utopias'[21] Bourriaud at once politicizes contemporary art and situates it beyond actual political processes. 'So the artist sets his sight more and more clearly on the relations that his work will create among his public, and on the invention of models of sociability', Bourriaud explains.

> I mean that over and above the relational character intrinsic to the artwork, the figures of reference of the sphere of human relations have now become fully-fledged artistic 'forms'. Meetings, encounters, events, various types of collaboration between people, games, festivals, and places of conviviality…represent, today, aesthetic objects likely to be looked at as such.[22]

Claire Bishop takes issue with Bourriaud's emphasis on conviviality and 'immanent togetherness', emphasizing instead an art that reveals real antagonisms within its social and cultural exchanges. Bishop is right to ask questions about 'the *quality* of the relationships in relational aesthetics'. In particular she seeks to contrast the 'informal chattiness' of a typical relational artwork with the inherent friction that Chantal Mouffe argues is necessary for any genuine democratic process or political dialogue. For this reason she highlights projects '*marked* by sensations of unease and discomfort rather than belonging, because the work acknowledges the impossibility of a "microtopia" and instead sustains a tension among viewers, participants, and context'.[23] She cites the work of Santiago Sierra and Thomas Hirschhorn as examples of work that is disruptive and destabilizing with friction, awkwardness and discomfort.

Bishop's main argument – that Bourriaud's conviviality is not adequately antagonistic to count as democratic – provides a strong corrective to Bourriaud's ethics of inter-subjectivity. In the process, Bishop makes the case for an antagonistic (i.e. political) rather than convivial (i.e. ethical) account of art's social relations. Nevertheless, Bishop's account turns on its own structural absence. She promotes antagonism and censures conviviality insofar as they are present *in the work itself*. In other words, she presupposes that the politics of the encounter has to be resolved formally in the work. This is why she praises Sierra and Hirschorn: she is after works that are *marked* by antagonism. But why would the antagonism have to appear *in* the work? Does Bishop not neglect the variety of possible ways in which hegemony can be challenged and the variety of ways in which art can contribute to that process?

Grant Kester has offered a third model that neither limits its social encounters to convivial ones nor restricts its political antagonisms to ones that mark the work. In the book

Conversation Pieces, Kester tracks a politically spiced-up 'new genre public art'.[24] Unlike Bishop, though, his approach does not focus on the dialogical *structure* of artworks and more on the dialogical encounters with communities, emphasizing the contrast between a 'patronizing form of tourism' and 'a more reciprocal process of dialogue and mutual education'.[25]

Kester thus proposes a new role for the artist: 'A dialogical aesthetic suggests a very different image of the artist, one defined in terms of openness, of listening…intersubjective vulnerability relative to the viewer or collaborator'.[26] By focusing on the conduct of the artist in relation to the communities it encounters, Kester's argument, unfortunately, defaults into a moralizing analysis. However, there is a more serious problem. There is an in-built limit to Kester's account. The social models and techniques that Kester's dialogical artists use typically derive from political contexts, such as WochenKlausur, who have collaborated with communities to help set up functional temporary institutions to assist and support socially marginalized groups. But why restrict the art of encounter to political forms of organization and communication? A political interrogation of the art of encounter surely does not require that artworks take their models of encounter from the political field.

Where does this leave us? We now have three theories of contemporary art's new social ontology, each of which has been subjected to critique. First, Bourriaud's utopian celebration of inter-human conviviality, which avoids antagonism. Second, Bishop's art of antagonism, which underestimates the diversity of ways in which art can contribute to counter-hegemonic struggle. Third, Kester's dialogical art, which reverts to an ethics of the artist's conduct. And together they map a context, albeit incomplete, of the art of encounter. They also provide a set of debates through which we might begin to evaluate a variety of specific works and theories, especially in terms of its relative ethics, politics and social relations. We are now, therefore, in a position to assess the various claims made on behalf of interactivity, participation, collaboration and co-operation in contemporary art.

Include Me Out!

I want to consider interactivity, participation, collaboration and co-operation in contemporary art as a structured set of relations. They are best defined, I'm suggesting, in terms of each other. I want to dwell for a moment on the words themselves. Interactivity has two means, which tend to be conflated in discussions of interactivity in art: (1) acting with each other and (2) (especially in computer science) responding to the user. Participation means having a share, taking part or being part of a whole. Collaboration (broken down as co-labouring), means working together, as does co-operation. Neglecting these differences, the discussion of interactivity, participation, collaboration and co-operation in contemporary art, is reduced to a one-dimensional measurement of the degree to which the work's public is active within the work, including, crucially, how early or late that activity is.

In her book *Participation*, Claire Bishop correctly distinguishes between participation and interactivity, explaining that the latter, especially in connection with developments in digital technology, merely incorporates the viewer 'physically' (pressing buttons, jumping on sensitive pads and so on). Participation, Bishop points out, is not so much 'physical' as 'social'. And this is precisely the sort of distinction that fuels the advocacy of participatory art.

There is a temptation, therefore, to treat participation as a solution to the problems endemic to the whole range of prior forms of cultural engagement, from the elitism of the aesthete to the passivity of the spectator, and from the compliance of the observer to the distance of the onlooker. Acknowledging the problematic social histories of these forms of engagement, which are still in the process of being written up, the rhetoric of participation proposes a break. Participation is thought of as a style of cultural engagement that does away with all previous problematic forms of cultural engagement by eradicating the distinction between all of the previous cultural types and all cultural relations between them.

Miwon Kwon, in the book *One Place after Another*, interprets the rhetoric of participation within 'new genre public art' as precisely that of democratizing art with 'pluralist inclusivity, multicultural representation and consensus-building'[27] that shifts the focus 'from the artist to the audience, from object to process, from production to reception, and emphasises the importance of a direct, apparently unmediated engagement with particular audience groups (ideally through shared authorship in collaborations)'.[28] Kwon remains sceptical about such claims, and rightly so. Participation, although disguised as a generous shrinking of cultural division, can be seen as an extension of art's hegemony and, as Grant Kester argues, an opportunity for the artist to profit from their social privilege.

Jacques Rancière highlights this by arguing that participation carries a pernicious distinction that participation cannot shake off: that between those who participate and those who don't. Even if we view participation in its rosiest light, Rancière argues that its effects are socially divisive. The critique of participation is, here, immanent to the development of participation as an inclusive practice that does not and cannot include all. Seen in this way, participation must be excluding because it sets up a new economy which separates society into participants and non-participants, or those who are participation-rich and those who are participation-poor.

It is vital to the critique of participation, therefore, that we locate it within – rather than beyond – the differential field of culture's social relations, as a particular form or style of cultural engagement with its own constraints, problems and subjectivities. We can begin by noting that the participant typically is not cast as an agent of critique or subversion but rather as one who is invited to accept the parameters of the art project. To participate in an art event, whether it is organized by Rirkrit Tiravanija, Jeremy Deller, Santiago Sierra or Johanna Billing, is to enter into a pre-established social environment that casts the participant in a very specific role.

The point is not to single out individual artists who fail to meet the potential of participation's promise. The point, rather, is that participation *always* involves a specific invitation and a

specific formation of the participant's subjectivity, even when the artist asks them simply to be themselves. The critique of participation must release us from the grip of the simple binary logic which opposes participation to exclusion and passivity. If participation entails its own forms of limitations on the participant then the simple binary needs to be replaced with a constellation of overlapping economies of agency, control, self-determination and power. Within such a constellation participants take their place alongside the viewer, observer, spectator, consumer and the whole panoply of culture's modes of subjectivity and their social relations.

Both in art and politics, participation is an image of a much longed for social reconciliation but it is not a mechanism for bringing about the required transformation. In politics, participation vainly hopes to provide the ends of revolution without the revolution itself. And in art, participation seems to offer to heal the rift between art and social life without the need for any messy and painful confrontations between cultural rivals.

There is, perhaps, great potential in the proposal of participating in a promising situation – and this is presumably the only scenario envisaged by the supporters of participation. However, there is potential horror within the threat of participating in an unpromising situation. Participation presupposes its own promise, therefore, by assuming the benign character of the situation to which the participant is invited. As such, participation sounds promising only until you imagine unpromising circumstances in which you might be asked to participate. In troubled and troubling circumstances, participation is a malign violating force that neutralizes difference and dissent.

Consider, for instance, Gillian Wearing's *Signs that Say What You Want Them to Say and Not Signs that Say What Someone Else Wants You to Say*, 1992–1993. When someone complains that such work is ultimately controlled by the artist, or that the work addresses those internal to contemporary art rather than those represented by the images, what is tapped into is the underlying tension between art and the rest of culture. The point behind the complaint is that the participation of civilians in artworks does not fundamentally challenge the cultural distinctions that separate them from the artist and the minority community of art. In fact, participation simply re-enacts that relationship in an ethnographic fashion. It would be unfair to expect a single artwork to overcome such systemic ills, but this is precisely the problem with the concept of participation: it is based on the misconception that properties of the artwork could offer a technical solution to art's social marginalization.

One way of getting a handle on the limitations and constraints imposed on the participant is to contrast participation with collaboration. It is the shortfall between participation and collaboration that leads to perennial questions about the degree of choice, control and agency of the participant. Is participation always voluntary? Are all participants equal and are they equal with the artist? How can participation involve co-authorship rather than some attenuated and localised content? The rhetoric of participation often conflates participation with collaboration to head off such questions. Collaborators, however, are distinct from participants insofar as they share authorial rights over the artwork that permits them, among

READING CHILDREN'S POLICE FORCE

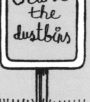

THIS AREA OF READING TOWN CENTRE HAS BEEN SURVEYED BY THE READING CHILDREN'S POLICE FORCE AS A PART OF...

...OPERATION DUSTBINS

WHILST IN THIS AREA, KNOWN AS 'DUSTBIN HEAVEN', YOU ARE REQUESTED BY THE READING CHILDREN'S POLICE FORCE'S 'RUBBISH CLAN' TO MAKE CERTAIN THAT NEARBY DUSTBINS ARE FED REGULARLY THEREBY ENSURING THEIR WELL BEING. THANKYOU

THE RULES & REGULATIONS GOVERNING THIS DEPARTMENT OF THE READING CHILDREN'S POLICE FORCE HAVE BEEN DECIDED UPON THROUGH THE PROCESS OF **MACROBOCRACY**

Do Not litter and starve the dustbins

Operation Owl Club by Adam Dant. The image above has been made by artist Adam Dant and incorporates sights recorded by Year 6 pupils at Caversham Primary School during a surveillance day in Reading town centre. **For more information: www.artatthecentre.org.uk**

Adam Dant, *Operation Owl Club*, 2004.

other things, to make fundamental decisions about the key structural features of the work. That is, collaborators have rights that are withheld from participants. Participants relate to artists in many ways, including the anthropological, managerial, philanthropic, journalistic, convivial and other modes. The distinction between them remains.

Don't Look...What Now?

So, when I said earlier that interactivity, participation, collaboration and so forth can be seen as an incomplete map of art within the post-Duchampian ontology of art, I meant that we have a very narrow view of the possibilities. The main restriction on contemporary practice, I would say, is the over-emphasis on redressing the power of the author. Co-authorship is certainly a major element of post-Cartesian art, but it is clearly not *all* that it implies.

It is essential to recognize the devaluation of the 'first person' in art – and artists are collaborating today at an unprecedented rate, as well as addressing their various 'publics' as participants and encouraging them to participate or collaborate with each other – but working together, both co-operatively and antagonistically, and getting help from technicians, professionals and experts, is the tip of the post-Cartesian iceberg.

We used to have three heroically singular elements to art: the artist, the art object and the viewer. All of these have been opened up to 'general social technique', creating a lot of anxiety and excitement, and a handful of theories, each promoting one possible way of being post-Cartesian. We need to see that the critique and transformation of the gallery, which has occurred roughly at the same time, is fundamentally related to the emergence of the art of encounter: the gallery is the institution *of* those three singulars, and therefore it cannot survive their demise. Thus, the gallery, which has begun to mimic or host other institutions, has itself been opened up to general social technique.

So, it is not an adequate response to the current state of art to celebrate collaboration or participation in contemporary art. Nor can we merely add these social elements together to arrive at an ideal practice (an arts collective working with participants on self-institutionalizing events from materials and skills at large). In fact, while social authorship and social cultural reception seem to both follow from the post-Cartesian condition, collaboration and participation, as we understand them, are unhappy together. If you have collaborators and participants working together, you have a *hierarchy* of authorship, responsibility and control.

The fundamental reason why the current map we have is incomplete and inadequate is that it does not yet face up to the fact that when art is opened up to general social technique, our theory of art has to become a theory of the society that we want. We simply cannot have a theory of the art of encounter without at the same time rethinking social relations at large. We need a better map. More importantly, though, we need to change the landscape that is being mapped.

Notes

1. Roberts, J., *The Intangibilities of Form* (London: Verso, 2007), p. 125.
2. Austin, J.L., *Sense and Sensibilia* (Oxford: Oxford University Press, 1962), pp. 73–76.
3. Slavoj Zizek, *The Parallax View*, MIT, 2006, p. 49.
4. This is, in effect, I would argue, what the discourse of aesthetics invariably does. It reduces the field of artistic experience to an inherited set of 'aesthetic' experiences which are derived from the history of engaging with art. No future can be made out of it. No art can be guided by it without sacrificing its Zizekian duty to transform the body of the empirical public.
5. See Evans, N., 'Tired of the Soup du Jour?: Some Problems with New Formalism', *Variant*, 2(16), 2001, pp. 35–37.
6. Zupančič, A., *The Odd One In*, (Cambridge, MA: MIT, 2008), p. 173.
7. Bourriaud, N., *Relational Aesthetics*, trans Simon Pleasance and Fronza Woods (Paris: Les Presses du Réel, 2002 [1998]).
8. Gillick, L., *Renovation Filter: Recent Past and Near Future*, catalogue, Arnolfini Gallery, Bristol, 2000, p. 16.
9. Gillick, *Renovation Filter*, p. 16.
10. Roberts, *The Intangibilities of Form*, pp. 101–132.
11. Roberts, *The Intangibilities of Form*, p. 22.
12. Roberts, *The Intangibilities of Form*, p. 53.
13. Roberts, *The Intangibilities of Form*, p. 53.
14. de Duve, T., *Kant After Duchamp* (Cambridge, MA: MIT, 1999), p. 51.
15. Farquharson, A., 'Before and After Science', *Frieze*, 85, 2004, p. 93.
16. Roberts, *The Intangibilities of Form*, p. 128.
17. Roberts, *The Intangibilities of Form*, p. 115.
18. Roberts, *The Intangibilities of Form*, pp. 115–116.
19. Kester, G., *Conversation Pieces: Community + Communication in Modern Art*, (Berkeley: University of California Press, 2004), p. 9.
20. Collings, M., *Blimey!: From Bohemia to Britpop: London Art World from Francis Bacon to Damien Hirst* (London: 21 Publishing, 1997).
21. Bourriaud, *Relational Aesthetics*, p. 9.
22. Bourriaud, *Relational Aesthetics*, p. 28.
23. Bishop, C., 'Antagonism and Relational Aesthetics', *October*, 110, 2004, p. 70. My emphasis.
24. See Lacy, S., *Mapping the Terrain: New Genre Public Art* (Seattle: Bay Press, 1995).
25. Kester, *Conversation Pieces*, p. 151.
26. Kester, *Conversation Pieces*, p. 110.
27. Kwon, M., *One Place after Another* (Cambridge, MA: MIT), 2004.
28. Kwon, *One Place after Another*, p. 107.

Part I

Participation: Open or Closed

This section looks at the role of the art project participant, touching on some of the ethical issues in relation to this way of working. The writers analyse the status of the participant within the artwork to see how far they might be considered collaborators, inspecting the relationship they have with the author, and assessing whether or not they are unwitting contributors to the final evocation of the work.

Chapter 1

The Anatomy of a Participatory Project

Sally O'Reilly

public works is an art/architecture collective consisting of architects Sandra Denicke-Polcher, Torange Khonsari, Andreas Lang and artist Kathrin Böhm. All public works projects assess ways in which users of public space are engaging with their environment and how design and programmatic strategies can support and facilitate physical, economical and social infrastructures in the public realm. public works use the methodology of art-led processes to explore ways in which existing social dynamics can inform spatial, architectural and urban proposals. The writer and critic Sally O'Reilly investigates the role of the public participants in the Granville Cube, *a public works project for a social housing development in Kilburn, West London. The Cube is a simple metal frame structure that will travel to various locations around the Granville New Homes development. The structure acts as a communication and facilitation device, hosting small-scale local events and collecting and staging ideas for the use of the public realm. The weekly programme ranges from carol singing to swap shops, flower planting to mega fish tanks. Simple add-ons can turn the cube into an exhibition space, small stage, outdoor screen or a workshop space. The cube will be appropriated over time, turning into an archive and an enactment of ideas for the public space in the area.*

In her text Sally O'Reilly explores the experience of the authors and participants in this project – revealing its shortfalls and successes, the unexpected hazards and the rich legacy of this way of working. O'Reilly sets this research against the backdrop of two related issues – the current language of participation (which as Bohm points out 'gets theorized, sometimes for its own sake, and highly refined by critics...') and the progenitors of participatory practice within recent art history (in particular two projects by Rirkrit Tiravanija and Robert Morris). In a clever resolution of a format which allows for all these voices, for leaping backwards and forwards in time, and for asides and comments on the way, O'Reilly has written the piece as a script for a documentary which is yet to be made.

The following is a script for a documentary, *The Anatomy of a Participatory Project*, which is yet to be made. It includes interviews with many of the people involved with public works' project the *Granville Cube*.

EXT. STREET SCENE — DAYTIME
A number of adults and children congregate around a yellow metal structure, planting seeds in small pots.

 NARRATOR (voiceover)
 This is the *Granville Cube*.

CUT TO:

INT. BUSY STUDIO — DAYTIME
Half a dozen men and women, wrapped up in coats and scarves, work at computers.

 NARRATOR (voiceover)
 And this is the studio of public works, a group of artists and architects who instigated the *Granville Cube*. I'm here to ask them how they view their role in the project, as authors of the situation, perhaps, or facilitators of an ongoing series of micro-projects. First, though, we need to address a fundamental question.

CUT TO:

CLOSE-UP OF STUDIO TABLE TOP — DAYTIME
A book lies open on the table and an anonymous hand turns the pages to show us a series of photographic stills of a noodle bar, an outdoor cinema, a ceramics workshop, a donkey derby, a group of knitters, kite flyers, etc.

 NARRATOR (voiceover)
 Why are participatory art projects so unphotogenic? Documentation of public events, whether donkey derbies, knitting marathons or snacking sessions, do not serve the visual art publication well. They look just like the jumble of ordinariness that life is generally made up of.

CUT TO:

INT: EMPTY WHITE GALLERIES — DAYTIME
Narrator walks around talking to camera.

NARRATOR
Rirkrit Tiravanija, the golden boy of relational aesthetics, forsook imagery entirely in his Palais de Tokyo retrospective, instead relying on spoken commentary delivered through headphones to evoke past projects.

Photographic documentation of these sorts of event-based projects, where people other than the artists generate content or activate a physical or social structure, invariably fails to communicate the experience of taking part. While we have known about this discrepancy between image and experience for some time – especially in live art quarters, where the documentary photograph or video has been all but outlawed as a purveyor of lies and ensnarer of souls – it is interesting to think of this lacuna in terms of authorship.

CUT TO:

INT. CLOSE-UP OF STUDIO TABLE TOP — DAYTIME
The book is still being leafed through, more images of haphazard looking events.

NARRATOR (voiceover)
While the composed or fortuitously grasped photographic moment speaks of virtuosity based in aesthetic judgement, the snapshot displaces classical composition with visual disorder. The participatory project, too, replaces the primacy of the well-ordered image with a hidden structure or concept that is equally authored, but whose outcome is less controlled or visually apparent.

CUT TO:

INT. GALLERY — DAYLIGHT
Two rails, frontally to the camera, bisect the screen, their perspectival foreshortening flattening the space even further. [A] ball runs unsteadily along the rails from the rear wall towards the camera, an unoriginated movement, which halts with a close-up of the object's surface: not wood, it could be concrete, or, perhaps, polystyrene. This 'to-and-fro' action is repeated several times. CUT. The cylinder rolls across the screen only this time its space is occupied by a revolving clothed male figure, arms and legs tensioned against the interior surface like spokes of a wheel. Briefly we recognize the figure as Morris. CUT. A thick hemp rope stretches across the screen, suspended above the ground. Panning across the rope, the camera encounters a naked foot balancing on the rope exerting a gentle pressure, up...down...up...down...[1]

Camera pulls out to reveal an extensive installation, which looks rather like an obstacle course and is being clambered over by children and adults alike. The fashions are outmoded, though – this is obviously archival footage from the 1970s.

NARRATOR (voiceover)
In 1971, for his retrospective at the Tate Gallery, Robert Morris fabricated a large installation that the audience could clamber over in an infamous response to the idea of the 'open work'. The open work, as described by Umberto Eco, was kinetic, shattering the traditional fixity of optical reception. The simple fact of its movement was radical enough back then it seems.

ROBERT MORRIS walks to edge of gallery and talks to camera in his famously self-interrogational style.

ROBERT MORRIS
Could we say you always had a suspicion of the image? After all, greyness seems to predominate? No optical celebration of lush surfaces are to be found in your oeuvre. Your strategies had more to do with locating conditions that generated objects and divided spaces. Still, we are left with images when all is said and done. No, you are left with photographs and words when all is said and done. Still, there seems to have been in the past a certain resistance to the 'image', as if this offered you a certain purchase, a certain foothold (pardon the image here) from which to work. And how does such a stance feel today? Well, it is like standing in a station platform watching the express go by.[2]

NARRATOR (voiceover)
Critic Michael Shepherd found this lack of emphasis on the image most disconcerting, as if its displacement were a regressive barbaric act.

CUT TO:

CLOSE-UP OF BEARDED MAN IN SUIT

MICHAEL SHEPHERD
The trouble with participation, it seems, is that apart from making us forget what art's all about, and inducing the very restlessness of mind which it's suppose to ease, it makes people behave like wild beasts…[3]

CUT TO:

EXT. STREET SCENE — DAYTIME
Back at the Granville Cube, *youths sit on its armature, people paste posters on to its walls and passers-by stop to chat.*

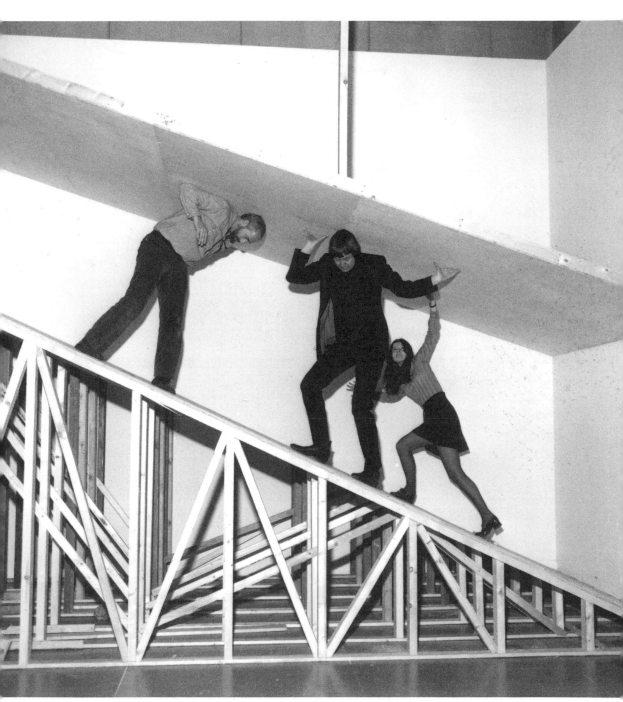

An installation image of Robert Morris's 1971 exhibition *Bodyspacemotionthings*.

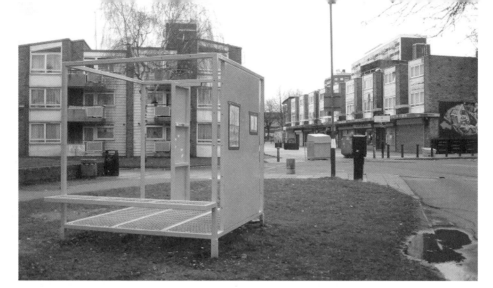

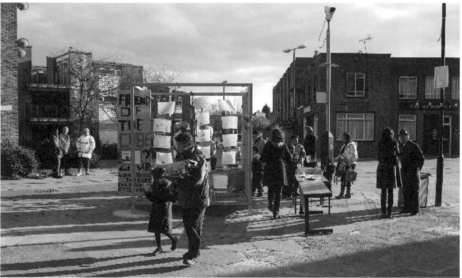

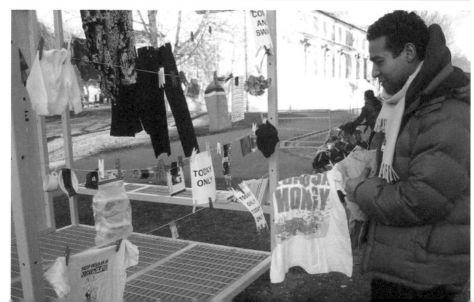

NARRATOR (off camera)
So here we are, back at the *Granville Cube*. I have to say that rather than behaving like wild beasts, the Cube seems to have a very different effect on the locals. Chris, you work on the council regeneration scheme. Can you tell me about your involvement in the *Granville Cube* and the problems and benefits it presents?

CHRIS
Sure. My predecessor commissioned the cube as part of a regeneration programme and the question was how to involve the local residents, how to get them to claim ownership of their community. The Cube is literally a skeleton. There were concerns from local business owners that it would encourage anti-social behaviour, but it hasn't, it's been adopted by everybody. You have local dance groups, people putting on celebrations, workshops. It's a free-spirited piece of public furniture. It's a bench that could be deemed to be dangerous – there are corners on there. The borough is taking a bit of a risk in that hasn't been sanitised or made very, very safe, given soft edges and so on.

CUT TO:

EXT. STREET SCENE — DAYTIME
In a suburban play area some children are playing a game that involves throwing a knife into a cordoned off square of soil, which they then take as a corner marker and section off a square 'territory', which they then occupy.

NARRATOR (voiceover)
As we saw earlier, participatory practice, socially engaged or open artworks, call it what you will, are not new, and neither are the attendant health and safety issues. While we talk about the new North American-style litigious culture in Europe, even back in 1971 Robert Morris's installation was closed after five days because of splinters. Artists know only too well the frustrations of health and safety, but they also know some cunning ways to get around it. This is a traditional Dutch street game that represents capturing land and marking territory. The artist Jeanne van Heeswijk proposed a re-presentation of the game in a gallery context but, when it came to the issue of the knife, this was vetoed on health and safety grounds. Van Heeswijk got around the problem by commissioning another artist to make a knife so that it was a 'collaborative sculpture' and therefore bypassed the usual evaluative procedures.

Top left: public works, *Granville Cube*, South Kilburn, London, UK, Nov 2005 – ongoing.
Middle left: public works, *Granville Cube – Launch of the Friends of the Cube Group*, April 2008.
Bottom left: public works, *Granville Cube Swap Shop*, Feb 2006.

CUT TO:

INT. LECTURE THEATRE
A man takes the stage and sits behind a desk, preparing to deliver a paper.

NARRATOR (voiceover)
This incident is a rather cynical example of the perceived status of 'collaboration' as a cultural process. It implies cross-fertilisation between disciplines, which in turn has implications for audiences, which opens doors and purses alike. Artist and critic Dave Beech has been carefully reappraising words like 'collaborator' and 'participant', dissecting them for their ethical implications.

Sound fades up so that we can hear the lecture.

DAVE BEECH
In contemporary art, though, the difference between interactivity, participation, collaboration and co-operation, not to mention collectivity, is measured in terms of a sliding scale of the degree to which the work's public is active within the work, including, crucially, how early or late that activity is [...]
 It is the shortfall between participation and collaboration that leads to perennial questions about the degree of choice, control and agency of the participant. Is participation always voluntary? Are all participants equal and are they equal with the artist? How can participation involve co-authorship rather than some attenuated and localized content? The rhetoric of participation often conflates participation with collaboration to head off such questions. Collaborators, however, are distinct from participants insofar as they share authorial rights over the artwork that permits them, among other things, to make fundamental decisions about the key structural features of the work. That is, collaborators have rights that are withheld from participants.[4]

Lecture audio fades out.

NARRATOR (voiceover)
But outside of the lecture theatre, how does this language apply? What do the individuals involved call themselves? Where do they position themselves in the structure of authorship?

CUT TO:

INT. BUSY STUDIO — DAYTIME

KATHRIN
The vocabulary of participation reflects on the complexity of the matter, but not on the language used by actual participants. It gets highly refined by and through critics but, while practitioners also use this language, they seem less concerned with defining roles and differentiations. Those who actually participate might describe their roles very differently from the terms suggested by the artist or critic. This choice of language may be less complicated, but that's not to say that the concepts are simplified.

CUT TO:

EXT. STREET SCENE — DAYLIGHT
Back at the Granville Cube *a number of individuals, of all ages, have gathered and are talking with NARRATOR.*

POLLY
I am an artist and a member of public works and I think of myself as more of a facilitator and a collaborator with the local residents. We come up with ideas together rather than me instructing them.

VALERIE
I got involved because I saw Polly out there with the children and I do flower arranging and I said, well, can I do some workshops, and she said yeah. And, er, what are they called?

CHRIS
Public works.

VALERIE
Yeah, they'd buy the flowers and oases and what have you and I'd run the workshops.

YASMIN
The Cube has really helped the environment a lot. The precinct is a lot greener now. There's plants and nice things. I discovered the cube with my friends. We'd have Easter parties and have fun. So the message is, look after your local environment, recycle, try your best to take care of everything around you. Litter on the floor, it's not a good role model.

NARRATOR
As someone who was involved in the planning from early on, do you feel responsible for what happens?

TC
You let it happen but it's not for me to take ownership of it – it's about the kids, really and what they can do on it, in it and around it. It's like a nephew, you know the nephew's

coming, the nephew is here, the nephew is now actually grown up, but it's not out of step. If the young people can put on it what they want to say and we can understand it – wow – even if we don't understand it, someone has been able to express themselves.

CHRIS
We don't have a detailed strategy on who uses it; it gives the residents some continuity in uncertain times; essentially what we really want is for the community to take ownership of the cube. We're looking at fostering cohesion.

JUDA
I held a small art exhibition at the Cube – I was showing off some of my drawings. The Cube is a landmark. It's always there if you want to show something. And now that I've shown there I feel more invested in what other people do.

CUT TO:

INT. BUSY STUDIO — DAYTIME

NARRATOR (off camera)
As one of the instigators, indeed the architect, of the project, how do you feel when other people talk about it in terms of ownership?

ANDREAS
It is clearly a public works project and as such I feel strong ownership over it. We are keen that the cube gets taken over by locals or local initiatives, whether physical or event-based – that was always the point to design an open structure. If needs be, we take an advisory role in this, especially if permanent changes are being proposed.

CUT TO:

EXT. STREET SCENE — DAYLIGHT
Back at the Cube the public continue to pass by, occasionally stopping to chat. There are signs of unspecified activity, but nothing is discernibly happening.

NARRATOR (voiceover)
So it seems that certain claims made for these sorts of practices, of the democratization of production, do not entirely hold sway. What in fact seems to have happened with the Cube is that everyone involved imports the project into their own framework, with terms like 'ownership' replacing 'authorship' in the rhetoric of council-led community projects, and the word 'collaboration' barely entering the frame, as in the practical world of everyday living people tend to evaluate a situation in relation to their own aims. In

this case, collective authorship tends to be a series of atomized pertinences rather than a consensual outcome. Political theorist Chantal Mouffe explains this in macrocosm…

A woman walks into frame and sits on the bench-like shelf of the Cube.

CHANTAL MOUFFE

[The] ideal of a pluralist democracy cannot be to reach a rational consensus in the public sphere. Such a consensus cannot exist. We have to accept that every consensus exists as a temporary result of a provisional hegemony as a stabilization of power, and that it always entails some form of exclusion. The ideas that power could be dissolved through a rational debate are illusions which can endanger democratic institutions.[5]

NARRATOR (off screen)

So are you saying that to even attempt coherent co-authorship is a folly? That these uncomposed images are a better representation of a process of true democracy whereby ownership, authorship and other forms of production are temporarily seized with the understanding that they will be eventually relinquished?

CHANTAL MOUFFE

[That's right.] By warning us against the illusion that a fully achieved democracy could ever be instantiated, [agonistic pluralism] forces us to keep the democratic contestation alive. To make room for dissent and to foster the institutions in which it can be manifested is vital for a pluralist democracy, and one should abandon the very idea that there could ever be a time in which it would cease to be necessary because society is now 'well-ordered'.[6]

ENDS

Notes

1. Bird, J., transcript of 16mm film *Neo Classic*, 1971, in the essay 'Minding the Body: Robert Morris's 1971 Tate Gallery Retrospective', in eds, Michael Newman and Jon Bird, *Rewriting Conceptual Art* (London: Reaktion Books, 1999), p. 89.
2. Morris, R., *Have I Reasons* (New York: Duke University Press, 2008), p. 77.
3. Shepherd, M., *Sunday Telegraph*, 9 May 1971.
4. Beech, D., 'Don't Look Now!', paper delivered at Art in the Social Sphere conference, Loughborough University, 29 January 2009.
5. Mouffe, C., *The Democratic Paradox* (London: Verso, 2000), pp. 104–105.
6. Mouffe, *The Democratic Paradox*, pp. 104–105.

Chapter 2

Interview with Artist Chris Evans

Will Bradley

Chris Evans deliberately muddles the roles of artist and patron, author and viewer, artist and public. For his series, The Rock and the Judge, *he asked police officers around the world to make a drawing of a judge who had made a significant impression on them. In response to each drawing, Evans makes a sculpture of a rock to be positioned in front of the original drawing, taking on the role of imagined defendant. Evans explores the way things in the world relate to each other – policing to sentencing, police officer to artist, sculpture to drawing, rock to defendant.*

Writing previously on his work Will Bradley remarks that:

> *unlike the politically motivated artists of the last generation [Evans] doesn't ask that art give up any of its connection with personal, poetic or imaginative investigation. Instead he throws these things directly into the path of bureaucrats and institutions, office workers and passing strangers. Very few people actively aspire to being part of a society that's simultaneously oppressive, amoral and dull, but most of the corporate or state structures we sustain have at least one of these characteristics. Evans's work amplifies this paradox. It's like hearing a really good joke and being trapped inside it both at once.*

Evan's working methods are in direct contrast to those of public works discussed in the previous chapter, but there is nevertheless a necessary engagement with a non-art person in order to complete a work. 'I was thinking of how to force the issue, to up the ante, imagining how artworks could aspire to warping relationships between art and non-art institutions from the outset. Relational aesthetics in reverse with a dose of faux-naivete.'

Left: Chris Evans, *Three Sculptures for Marseille* (Detail: The Stranger), 1998.

WILL BRADLEY

For a decade now, one part of your practice has involved an unusual approach to the dynamics of public art. The conventional way to proceed is to imagine – or even poll – a representative public to whom the work is offered, either as audience or, as is now common, participants or collaborators. It seems that you would rather explore the motivations of the patrons and the funders, the sponsors and the politicians. How did this interest begin?

CHRIS EVANS

'The Speaker', 'The Visitor' and 'The Stranger' were the first public sculptures I made, in Marseille in 1998. They were child-friendly generic modernist abstractions, copied from existing sculptures found outside local schools. I placed them outside vacant office buildings around the city and assigned futuristic, fictitious organizations to the empty offices: 'All Horizons Syndicate', 'Friends of the Divided Mind' and 'One Voice Federation'. I photographed the sculptures and left them in situ, imagining they would, in some way, determine the kind of company or organization that would come to occupy the offices in the future.

WILL BRADLEY

These works were made and sited without collaboration, in fact without permission, but they appeared in the city as if part of some mysterious, larger plan connected to business development. I'm interested in what led you to make this particular connection, to imagine the works as totems for new organizational structures, and I could suggest some obvious possibilities.

Looking back, the ideas in play in the UK art world at the time were a combination of a lingering post-market crash DIY spirit and Thatcherite entrepreneurial thinking. Aesthetically, the tail end of neo-conceptualism was giving way to an interest in design, architecture, music and film, while the canonical works of relational aesthetics and the attendant consumer-participant-victim problematics were making their way into the London galleries. Regeneration funding, property development and corporate partnerships were also becoming important to the political economy of culture, and there was a sense of boundaries shifting, with art and artists swept up into the new social force of the creative industries.

The Marseille work seemed to sketch out a plan for taking an unauthorized role in these developments, a way to participate without signing up to the programme.

CHRIS EVANS

'Three Sculptures for Marseille', was made the year after New Labour came to power. Their Soviet-red logo had become a pink rose and first through the door of Number Ten were Liam Gallagher and Vivienne Westwood, as Labour considered how best to cosy up to the mainstream of cultural dissent. Nicolas Bourriaud's ideas made sense for those considering how art could be co-opted as a social ameliorative. At the time I was thinking of how to

force the issue, to up the ante, imagining how artworks could aspire to warping relationships between art and non-art institutions from the outset. Relational aesthetics in reverse with a dose of faux-naivete.

WILL BRADLEY

This faux-naivete seems to mean pretending to take the demands of the institutions at face value, but pushing those demands towards their inbuilt absurdity. It's a strategy that could be called 'over-identification'. How did that inform the projects that followed, for example the Gemini Sculpture Park?

CHRIS EVANS

'Over-identification' – yes, I would identify with that. Giving a voice to those who already have a voice, but then filtering it through the limited means I had available. Like listening to a high-definition DAT recording through a pair of cheap, tiny speakers.

For the Gemini Sculpture Park, I made a position for myself as a consultant for a cluster of companies on a business park in the outskirts of Leeds, and worked with them to come up with sculptures that would represent their companies' ideals. But if over-identification had been the main aim in this situation, the project would have backfired. This was a humble estate, an undernourished red-brick affair, where the CEOs were driving around in cars that weren't much bigger than my own. I had imagined each company would try and outdo the others, to make a sculpture park that would resemble a war zone. But instead they were pragmatic, and realistic about their standing. They were most worried about how their businesses would survive being broken into by marauding gangs of thieves from a nearby estate. One company had recently been ram-raided and wanted a sculpture that would act as a defensive wall. Another was a debt-collection agency, whose CEO wanted a life-sized sculpture of a Venus flytrap but was concerned about it being stood on and crushed.

WILL BRADLEY

It seems that you felt some strange kind of solidarity, that perhaps your work as an artist/ consultant and your clients' position as struggling small businesses in the new service economy made you both somehow precarious outsiders. Did the final proposals satisfy them? Was there a real space for agreement?

CHRIS EVANS

I think we both played our roles to perfection, with low expectations and modest results. Part of the process is that everybody involved operates more or less as usual, they perform as themselves. A good example is 'Cop Talk', a series of recruitment presentations by national police forces that I've organized for students at art academies in various countries. Though each one is different, still the students play at being students and the police play their time-honoured part. I was initially concerned it would come across as ironic, when my intentions

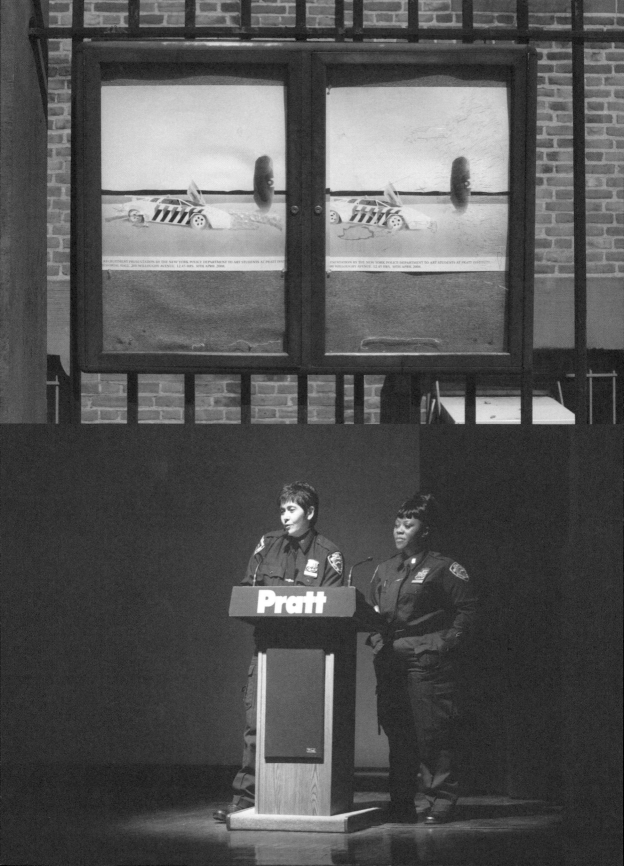

are sincere, but the results convinced me to continue. It feels like holding up a double-sided mirror.

WILL BRADLEY

I like this image of the double-sided mirror. Much recent interventionist practice seems to employ the model either of negotiation or of an address to an imaginary or indifferent public. Your projects take a different approach, depending on the difficulties of communication between different ideological positions, different social needs or desires. There is a synthesis in the work, but the positions of the participants are not integrated. The result can function as critique, but only from certain viewpoints – often not from the standpoint of the participants, for example, who see the image of themselves that they freely contributed.

You talk about the sincerity of your intentions, but sincerity also functions on the level of the image. As Bob Hope put it, the key to success is sincerity, and if you can fake that you've got it made. What seems more important is the idea that you 'played [y]our roles to perfection'. It seems that you often approach potential collaborators knowing that they are entrenched in their own social position, and so you can count on them performing in particular ways. I'm thinking here of, for example, the executives of multinational corporations who designed sculptures for your Radical Loyalty sculpture park, which will be realized in Jaarvakandi in Estonia. One subject of that project as a whole seems to be the way that individuals inhabit the corporate ideology they work for, but that is clearly not the way the participants saw it. How did you approach them, and what did you ask them to do?

CHRIS EVANS

In interview situations I think I'm a bit like the guy that warms the crowd before Terry Wogan comes on, better than Terry Wogan because he has to be, through sheer desperation. It can take so long to set something up that it cannot and must not fail. I polished my shoes and whored myself to get each CEO to warm to me, to let their guard down a little. I asked them to talk about their individual perspectives on loyalty and how they might envisage these loyalties as being radical. I asked them to speak for themselves, not on behalf of their companies, hoping in fact for the chance of them losing something of their public social identity and opening up onto the underlying motivations. They were anxious at first but with time got enthusiastic. In my own mind, I was envisioning Adam Smith's 'harmony of interests' and how this might succeed but only in the form of a sculpture park. Estonia was perfect for this, just as it was joining the EU. The companies wanted Estonia and Estonia wanted them back. Hotel discos with cracked-out dancers on stage; old European businessmen dancing and getting close; new old Europeans on the balconies looking down and right through them to the money.

Left: Chris Evans, *Cop Talk*, event part of Hey Hey Glossolalia, New York, 2008.

WILL BRADLEY

EU integration has worked both ways. If new markets, new enclosures of public property and a new supply of cheap labour are desired by Western capital, the new 'tiger' economies of the former East are also a threat in terms of inter-state competition. The swift acquisition of the much of the banking system of the former Eastern Bloc by financial institutions in countries like Sweden or Austria also means massive exposure to the potential collapse of these aggressively deregulated systems.

The Radical Loyalty project does something unexpected. It produces artworks that give material form to the ideologies of the corporate market, rather than show, as many art corporate collections do, the artworks that the market produces by its financial influence.

This leads us on to your project with the Stedelijk in Amsterdam, and also back to the earlier discussion of New Labour policy in the United Kingom. Since the rise of the liberal bourgeoisie under nineteenth-century capitalism created the myth of the independent artist, it has become a truism that state funding undermines creativity, while competition fosters it. State arts funding, in many vestigially social-democratic European countries, has as its premise the idea of redressing the inequalities of production and access that the market creates – in other words, of ensuring that the thing called art is not made only to the taste of the rich or reserved for their enjoyment.

And there is an argument often made in countries with a strong state-supported culture – for European examples, the Netherlands, Denmark or France – that this protects weak work from the peer-review of the market, even that it makes artists lazy, or creates an unproductive cultural client-class.

The Amsterdam project – 'Militant Bourgeois – an Existentialist Retreat' – seemed again to be based in an over-identification with this kind of rhetoric. And yet, it was a success on its own terms. You initiated a state-sponsored residency which offered artists the chance to suffer the deprivations, the depredations, of an almost nineteenth-century, freezing-in-a-lonely-garret existence. Once again, your sincerity was accepted, and artists seemed keen to get the chance to play out their traditional, mythical role. Did you really see a breakdown in state agency? Were you trying to save artists from the state, from the market, or from themselves?

CHRIS EVANS

Artists are asked to perform. It's good to be asked, it makes you feel like you've got a job. But when your line-manager is the state and starts paying your wages directly, without at the same time paying much attention to what you're up to, you might start to lose trust, to question not just their motives but your own. Militant Bourgeois was a retreat which offered Dutch artists little except the experience of being abandoned. An opportunity to condemn yourself to freedom, a self-imposed boot camp scenario, but one where the only person you have to answer to is yourself. There was no stipend, just a live-work space in a black Portakabin beneath Amsterdam's peripheral motorway, furnished with a single bed, a table and a wood-burning stove. The stove was inefficient; function was not the main aim in its

design. Its construction followed a conversation with Baron Jan Six, direct descendent of the Jan Six who was a patron of Rembrandt. I asked him to consider a sculptural form that would accentuate an existentialist experience. 'Only with Rembrandt do "lonely" artists begin to appear', said Clement Greenberg. In harking back to this myth, of the solitary artist-genius working on the periphery of society, it felt like I was countering doubt with conviction.

I didn't expect anybody to sign up for the retreat. I imagined artists would perceive the whole scenario as being anachronistic, and that that they'd feel like pawns in someone else's work. So I was surprised that it was booked up from start to finish, with artists wanting to submit to their inner angst. The first resident reflected on his mother having died at the age of thirty – the same age as he himself had just reached. He told me that he'd endured horrific nightmares in the retreat. These found expression in a number of drawings and one that I particularly remember is a coloured pencil sketch of him locked outside the cabin trying to fight his way back in. Plausible perhaps except that, in the drawing, his trousers have dropped to his ankles. The second resident burnt wood in the stove, then gathered the ashes to use as a pigment to tattoo herself with. It seemed like the resident artists knew about the wider context of Militant Bourgeois through the show I'd made at SMBA (Stedelijk Museum Bureau) a few months prior to building the retreat. They were aware of the wider picture and were, regardless, keeping themselves busy, choosing to get out of it what they could for themselves.

WILL BRADLEY
So this project somehow produced some conventional works, drawings or performances. But who, from your point of view, is the audience for the work as a whole?

CHRIS EVANS
Realistically, a few truckers on Amsterdam's orbital motorway, and then the art audience that we know could easily fit into a supersize theme pub with room at the bar.

WILL BRADLEY
Of course, when a work is split over many sites, times and situations, there is no way for any audience to see the whole. There is no easy way to define either the boundaries of the action or even some essential core of experience or information that might stand in for it. But, inevitably you have to deal with the question of how to publicize the work at the time or represent it afterwards. Do you feel something is lost? How do you deal with documenting or interpreting what happens?

CHRIS EVANS
I once gave a talk at Goldsmiths, a nightmare of a talk. It started to go wrong when one of the students asked a question that lasted ten minutes, which I didn't understand, so I asked him to repeat it. Then another student asked if I thought I was passive aggressive. This is something that has stuck at the back of my mind for years. Forgetting the 'aggressive',

what are the consequences of appearing to be passive? The artist Padraig Timoney came close to answering this, telling me about the Italian conversational expression 'Non so se mi sono spiegato' – 'I don't know if I've explained myself' – with its reference to a just-made conceptual point, idea or description. It's a saying that's mostly introduced unsolicited, a point to compare notes on the state of transfer, and to quote Padraig,

> What's interesting is the crafty inversion of power implicit within it – at first it seems utterly humble and mannerly, as if the only possible reason for the listener not being fully informed is the poverty of the explainer's linguistic skills – a personification of the limits of language. But it also heralds an invisible yet clearly envisaged concept to which the speaker alone is partial.

Timoney compares it to 'an 8 megapixel idea seen on the back of a 2 megapixel camera'.

Perhaps there is some distinction to be drawn here between storytelling – navigated through a practice in which objects function like images in a rebus to be resolved – and cinematic narration, which functions in parallel to a flow of given images. There's an apparent passivity, because the narrator does not disrupt the unfolding of the action, they can only respond. But, at any point, and regardless of whether you have followed the drama from the start, the narrator's words situate the image, override it and open the possibility that there's another viewpoint, that there's more to know.

Chapter 3

Case Study One: Adam Dant's *Operation Owl Club*

Helen Sumpter

Three projects commissioned by Artists in the City, Reading have been chosen as subjects for case studies. The art writer Helen Sumpter has been invited to undertake research with the commissioned artists and their respective participants and collaborators in order to gain an insight into the benefits of working respectively with young children, amateur singers and reality TV personalities (the 'art publics' of the title), and conversely to understand something of the value of the experience for those 'publics' who are drawn into the work. Each project was selected because of the artist's engagement with a particular group of individuals who live in the town of Reading and its surrounding area. The first focuses on a commission from Adam Dant, best known for his drawings which explore and expose the underbelly of well-known institutions creating his own alternative psycho-history of the subject. Dant has also undertaken occasional projects which draw others into closer participation with the work – most notably a performance at the Institute of Contemporary Art, London which incorporated buskers from the local streets, and the publication of a French dictionary comprising new words generated from a Parisian street poll. For Operation Owl Club *he specifically requested to work with a group of children who he felt would bring a fresh approach to the notion of organizing cities.*

The Project

Operation Owl Club: Reading Children's Police Force (2004) was a commission to highlight and contribute to the new signage system in Reading city centre. Artist Adam Dant collaborated with 60 10–11-year-old children from two Year 6 classes at Caversham Primary School. Taking as his starting point Reading's extensive CCTV network and the original Greek idea of the citizen and the city state, the 'Polis', Dant asked the children to think of ideas for an imaginary Reading city children's police force, encouraging the children to be as inventive and fun as they wanted. This involved the children filling in workbook-style logbooks, drawn by Dant, in which the children imagined a Greek-style Polis for an area of their own city, including what the area should be called, what its rules should be and how it should be governed. As part of this process the children also spent an afternoon creating a human CCTV system by observing people in different locations in Reading and taking photographs using disposable cameras. Dant then incorporated the children's ideas and drawings into panels which became part of nineteen new information units in the town. A prize for the child who completed the best notebook was to have their design for a police force uniform made up into a real garment. Taking inspiration from the project, Dant also designed an alternative fold-out map of Reading town centre, which was distributed by the Tourist Information Centre.

The Artist's Experience

Adam Dant's drawing-based practice takes the form of complex cartoons or maps that incorporate text and images and act as structures to contain information which describes an absurdist, humorous or satirical take on life. His projects can involve historical or investigative research as well as anecdote and invention. Several previous projects involved members of the public, among them a performance by a found orchestra where Dant literally invited musicians on the streets of London to perform with him at an event that evening at the ICA. For a project undertaken in Paris in 1997 Dant invented 1,000 new French words and asked students to go out on the streets to record what people thought that the words meant. From 1995–2000 Dant produced a daily, handwritten pamphlet called *Donald Parsnip's Daily Journal*, which he photocopied and distributed free. He won the Jerwood Drawing Prize in 2002.

What influence did the children's creative input have on the way *Operation Owl Club* developed?
It was my decision to create a children's police force but I initially imagined the children filling out the log book, designing a uniform and coming up with some operations for the police force to undertake. The idea for the children to go out on the street and set up a surveillance system was inspired by the ideas from their notebooks, so even though the concept was in place, other activities or elements to the project came from the work that the children produced.

How did you select which of the children's ideas you would use?
If I had chosen randomly from all of the children's ideas, there would have been a lot more policing to do with fashion – particularly shoes and trainers – and hairstyles. I wanted a diversity of ideas and in particular those that were more unconventional, which is why pigeon-only regions and the requirement to swing round every lamppost in the area were two of the ideas included. Although there was no agenda relating to what the children came up with, I was hoping that their ideas generally might be more transgressive and I did encourage them to be imaginative. In the initial stages of the project I gave a talk to the children about the Polis and the city state and emphasized that they could use things from their wildest dreams.

How do you view authorship or ownership of a project like this, where the public has a more creative, rather than just participatory input?
It can be hard to define. I have used anecdotes and other people's stories in projects before, but because my work becomes visual, that material is translated in a pictographic way. The children as a group and the school were of course credited but it's not like theatre or a performance where someone's specific input, as an actor for example, is individually acknowledged. It's not like an industry either, such as advertising, where creative ideas are

OFFICIAL INFORMATION SITE OF THE

READING CHILDREN'S POLICE FORCE

THIS AREA OF READING TOWN CENTRE HAS BEEN SURVEYED BY THE READING CHILDREN'S POLICE FORCE AS A PART OF...

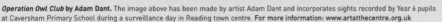

...OPERATION CHEERY-FACES

WHILST IN THIS AREA KNOWN AS **HAPPY BISCUITS** BY THE READING CHILDREN'S POLICE FORCE'S 'SMILE SQUAD' THE PRACTICE OF UNPROVOKED LAUGHTER AND SMILING IS ENCOURAGED THROUGH PUNISHMENTS IMPOSED FOR GLOOMINESS. THANKYOU.

THE RULES AND REGULATIONS GOVERNING THIS DEPARTMENT OF THE READING CHILDREN'S POLICE FORCE HAVE BEEN DECIDED UPON THROUGH THE PROCESS OF **GRINOCRACY**

Operation Owl Club by Adam Dant. The image above has been made by artist Adam Dant and incorporates sights recorded by Year 6 pupils at Caversham Primary School during a surveillance day in Reading town centre. **For more information: www.artatthecentre.org.uk**

Adam Dant, *Operation Owl Club*, 2004.

owned by an organization. In a project like this the children's creative input perhaps should be seen more like a form of research, but research in which the children are both the subjects of the work and creators of it.

Are there other considerations when working on a project involving the public in this way?
It can be very time-consuming and involve a lot of administration. I do still work with groups of people in this way but my work is probably now more studio-based. In projects like this where, as the artist, you are relying on input from someone else, there is always an issue of the quality of the material that you are going to get; is it going to be interesting or amusing enough? And it is important to remember that it is an artist's project and not a sociological exercise, so you are also looking for an element of entertainment. That can sometimes be difficult but if you don't get something interesting back, you're not going to use it.

The Participant's Experience

Ann Bryan is a teacher at Caversham Primary School. She was the teacher of one of the Year 6 classes who participated in *Operation Owl Club*.

Why did the school decide to become involved in the project?
The school is generally quite open to new or different ideas so we were happy to be involved because we thought it would be fun and creative and it was an opportunity to work with an established artist.

How much input did you as teachers have into the work that the children produced?
Not a lot really. Obviously we supervised the children on their afternoon spent in town but after Adam had explained what he wanted from them, the children were left to come up with their own laws and rules. And I think his talk obviously appealed on the children's wavelength because they came up with lots ideas.

What are your thoughts on the children's ownership of the work?
The children were obviously aware that their drawings and ideas were going to be used and adapted for a public project and that the ownership of the project would be shared. Also the work was just one element on the information panels. Unfortunately we weren't able to find out what many of the children felt about the final work. There was a ceremony for the launch to which the children were invited, and some of them came, but by the time the information posts were installed, the children had moved on to secondary school, so we weren't in direct contact with them as their teachers.

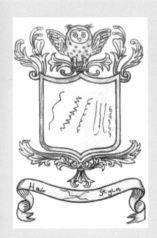

Adam Dant, *Operation Owl Club*, 2004.

How do you feel personally about the project?

It's quite interesting because if I'm taking people who are new to the area around Reading, I always point the work out and say that my school did that. I do feel quite proud of the project and it does still have an impact on me. When Adam first came to the school and I saw some of his original work, I thought that his ideas might be a bit over the children's heads because they can be quite complicated. But I think that the children found his work fascinating. I remember he had one drawing of *The Mona Lisa*, but showing her from behind so that you could see all the people in the gallery looking at her. I thought that was quite amazing. What Adam was asking the children to think about was quite abstract in a way – for example what would a pigeon have as its rules. But I think that the children really responded to the fact that he had a very different way of looking at things.

What do you think makes a project like *Operation Owl Club* successful?

I think that you have to make sure that the project is well organized, as you might have problems if the children felt that they didn't know what they were doing. But I think that a lot of it is down to both the work and the artist being engaging enough. If something's creative the children will normally run with it. You have to be able to sell an idea to children though for them to want to become involved. There was the novelty factor of an afternoon out of school, which is always going to appeal but Adam had a good rapport with the children and I think that they really enjoyed it.

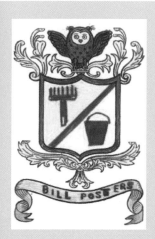

READING CHILDREN'S POLICE FORCE

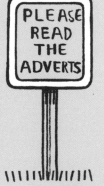

THIS AREA OF READING TOWN CENTRE HAS BEEN SURVEYED BY THE READING CHILDREN'S POLICE FORCE AS A PART OF...

... OPERATION BILL STICKER

WHILST PASSING THROUGH THE **POSTERY AREA** AS THIS ZONE IS CALLED BY THE READING CHILDREN'S POLICE FORCE'S 'AD-SQUAD', PEDESTRIANS MUST MAKE SURE THAT THEY HAVE LOOKED AT & READ ALL THE ADVERTS THOROUGHLY

THANKYOU

THE CODES OF CONDUCT THAT GOVERN THIS DEPARTMENT OF THE READING CHILDREN'S POLICE FORCE HAVE BEEN WRITTEN ACCORDING TO THE PROCESS OF **PUBLICITOCRACY**

PLEASE READ THE ADVERTS

Operation Owl Club by Adam Dant. The image above has been made by artist Adam Dant and incorporates sights recorded by Year 6 pupils at Caversham Primary School during a surveillance day in Reading town centre. For more information: www.artatthecentre.org.uk

Adam Dant, *Operation Owl Club*, 2004.

Chapter 4

Who Speaks? Who Listens? *Het Reservaat* and *Critical Friends*

Sophie Hope

As a curator, academic and artist-enabler, Sophie Hope questions the assumptions we make for public art projects in relation to the position of the commissioned artist, the curator, the participant (the public) and the evaluator. She focuses on two recent projects in which she has been centrally involved. For Het Reservaat *in Holland she tests out new relationships between artists and participants – as an artist, wherever possible, taking a back seat in proceedings, and allowing those living and working in the site of the work to adopt a commanding role in developing the detail of the project. In* Critical Friends *for the Greenwich Peninsula in London, a collectivized approach to evaluation is devised and executed by the people that the project aims to include. In much of her work Hope demonstrates by practical example that it is possible for 'participation' to be seen as an open process, filled with democratic possibility, drawing together on an equal basis amateurs and professional artists, people with a range of skills and experience, who congregate and collaborate, shifting their previously fixed positions, becoming alternately producers and spectators, viewers and evaluators.*

About twenty parents and children cycle by on their way to a sporting event, half of them are wearing blue, the other half orange T-shirts. Young people living in different parts of this town are already beginning to compete against each other.

In May 2006 I made my first trip to the new town Leidsche Rijn, on the outskirts of Utrecht, Holland. I was hosted and funded by Beyond, the publicly funded art agency that was commissioning art as part of a new housing development (http://www.beyondutrecht. nl/). What became clear to me during my first few days of being in 'residence', hearing about all the art that had taken place in Leidsche Rijn, was that I wanted to work with the people who had inadvertently paid for me to be there. It was difficult to meet that public, however, without a dog or small child. They were the main things I saw in the many parks; there were no pubs in Leidsche Rijn. Life went on in the private homes, surrounded by fences. I had to find a way of being invited in to people's homes if I wanted to start working with the residents.

A common model of commissioning art is to parachute artists in to work in a location for a given amount of time. The artist then makes some work and moves on to their next project somewhere else. In this text, I want to explore the issues relating to public participation for the project in Leidsche Rijn. I suggest that the role of the artist in the form of a paid commission inevitably negates the extent of co-authorship. It might be that the contradictory roles and agendas of artists, commissioners and so-called 'participants' ignore the role of the

spectator. In the search for for 'co-authorship' and 'collaboration' a natural conclusion may be to abolish artists' commissions which rely on the separation of (unpaid) 'participants' from (paid) 'artists'. I go on to introduce *Critical Friends* which investigates some of these problems and possibilities.

The masterplan for Leidsche Rijn was completed in 1997. By 2007, the town, still only half-complete had accumulated over 15,000 residents, makeshift supermarkets, plenty of primary schools and a Leidsche Rijn anthem. Built on agricultural land, numerous archeological sites and incorporating two existing villages (Vleuten and De Meern), Leidsche Rijn is not merely a suburb but the largest 'new' town ever to be built in the Netherlands. Leidsche Rijn is an extremely popular place to live. Houses are sold before they are built. The first families to move there had experienced the urbanization of the landscape and were ready to move on to pastures new, expectant of fresh beginnings in the pristine new-builds and ordered, fenced-in lawns.

I started to ask myself, what would happen to Leidsche Rijn in the future? Will its apparent success continue? How will such experiments in ideal living pan out over the centuries to come? I was imagining the innocent sporting events turning sinister as the different parts of Leidsche Rijn became more gated, resources more scarce and battles commencing between these communities. Often the urban experiments of yesteryear are laughed upon today. We are in perpetual motion, inventing, responding and surviving.

I began asking these questions through a series of workshops and conversations at Number 19, the artists' residence where I was staying on the edge of the new development. It was like a temporary spaceship structure set apart from the rest of the housing development. These workshops, informal conversations and two projects in local primary schools run by local artists focused on the next thousand years of Leidsche Rijn using themes such as the environment, education, family-life, work, culture and religion. Thinking about the future of a newly built town was a way of unveiling the different ideologies and perceptions people have of today, allowing us to imagine the future triumphs and failures of such an ideal place to live. I worked with local journalists, politicians, schools, a teenage rock band, tai chi class, the local vicar and staff at a local second-hand shop, most of whom then 'performed' in a one-day outdoor live action/event on 15 July 2007 which attracted over 800 'spectators', mainly residents of Leidsche Rijn.

The performance was called *Het Reservaat* (meaning 'open-air museum' in Dutch) and was made possible because of the collaboration between local residents. I had decided to spread my three month contract over a year and was travelling to Leidsche Rijn every other month for a week or two at a time. The project needed co-ordination on the ground and through Beyond I met Daphne De Bruin and Joost de Groot who Beyond paid to help

Top left: Sophie Hope, *Art is Useless*, staged protest outside Het Reservaat, 2007.

Middle left: Sophie Hope, *Dead in Leidsche Rijn*, 2007.

Bottom left: *Critical Friends*, front cover of magazine, 2008.

co-ordinate the performance. Joost and Daphne live in Leidsche Rijn and had extensive experience of producing community performances, something I had never done before. They were instrumental in developing the concept of the performance and working with me and the other participants to turn the ideas into a realistic format.

The idea was to create a dialogue with the past, present and future in Leidsche Rijn. Our open-air museum was set on the site of Castellum Hoge Woerd, a Roman Fort, now a public park and orchard. It was a re-enactment of life in 2007 by and for people living in the year 3007. We wanted to look again at today with fresh eyes as if we have travelled in a time machine from the future back to the present. The press release read:

Het Reservaat: Back to the Present
Where time stood still for a thousand years, a place of wonderment where everyday moments of 2007 have been captured in time for future generations.

This world Heritage site is the most well preserved picture of life in 2007. It has come to be known as the 16th wonder of the world. For one day only you can experience how people lived, worked and played in the Leidsche Rijn of 2007! The beautiful town of Leidsche Rijn was built in the beginning of the 21st Century, over a thousand years ago. Opening this summer (for one day only!) is a re-creation of life as it was when the town was still being developed in 2007. Now underwater, the creators of *Het Reservaat* give you the chance to tour a part of the old authentic town and talk to some of the children and families who populated this amazing experiment in living all those years ago at a time of great expectations and new beginnings.

Taste the unusual food people used to eat (for energy but also pleasure!) and find out what a fluffy animal named a 'sheep' was used for. Visit a reconstruction of a 'family home' and find out what happened in a 'kitchen'. Our experienced and professional archeologists recently excavated an ancient 'automobile' – one of the most revered objects in the early 21st Century. Come and learn what it was used for! Meet children from 2007 and talk to them about the strange ideas they had for the future. Discover how wrong or right they were! Listen to live performances of sounds (often called 'music'). Discover how 'politicians' of 2007 explain 'democracy' and their plans for our future (you can judge how wrong or right they were!) and learn about how 'religion' informed the life-styles and survival of the people of 2007. And lots more!

We had to convince the visitors arriving on the Sunday of the performance that they were from the future. They entered a 'time tunnel' and listened to a soundscape explaining the context. Everyone was given a pair of swimming goggles so they could see on the seabed the archeological remains of this settlement dating back to the early twenty-first century. Upon exiting the time tunnel into the sunlight of the open-air museum, the visitors were greeted by guides dressed in white overalls and blue goggles and shown around the museum and introduced to the re-enacted life of this ancient 'new' town. The guides were from a local acting-improvisation club and improvised their way around the museum, creating weird

and wonderful stories about the role of old people, farmyard animals, petrol and rock bands. There were mixed reactions from visitors to the museum, from amusement to bafflement – some visitors were angry that the guides had got it wrong, arguing life was different in 2007; others played along and asked questions as if they were from 3007. To a certain extent the 'spectators' were becoming the 'performers' in the event.

The fifteen simultaneous 'scenes' were devised and 'performed' by the different interest-groups, who carried out their everyday activities, such as practicing tai chi, discussing 'democracy', performing music, playing board games and drinking tea. Putting these everyday scenes together, slightly exaggerating or misinterpreting them, and combining absurdity with celebration, provided a way in for people to question their own lives. For example, the visitors were told the band were bigger than the Beatles in 2007 and every hour they would screech around the park in an orange jeep followed by paparazzi (a group of local photography enthusiasts) and the guides warned the visitors not to approach the older people ('grandmas and grandpas' playing board games) as they may be in danger of being hugged and might not let you go. Some of the guides remarked after the event:

What I also remember vividly, is the great atmosphere among all the people who were helping in this way or the other on Sunday. Everybody was cheerful, and everybody was very pleased with what was accomplished that day. And their enthusiasm really helped to stay focused and in high spirits all day. Wonderful!

All in all, it was a great art project. Unlike most art projects I know of, actually. It was very accessible, and last Sunday I think that we really brought art to a lot of people, who normally would not have shown much interest in it. That deserves many compliments!

Het Reservaat was an opportunity for visitors to consider their own ideas for the future – politically, environmentally, socially and economically. This one-day museum aimed to be a site bustling with contradictory views, ambitions and ideologies with the combination of visitors, performances, props and interventions triggering both laughter and puzzled looks.

Het Reservaat was trying to be more than a fun day out for all the family. But to what extent did people experience 'critical engagement'? Did the intention to create a critical art project that 'got people thinking' and that was beyond a 'fun day out' actually occur and if so, how? Did it need an artist for this to happen? How can the project have encouraged critical and/or political thinking (and action) when it was being funded by the government through the taxpayers I was trying to engage? How does this affect people's relationship to the artist they have inadvertently paid to be there?

As commissioned artist I wanted to incorporate a critique of my own role within the project as a characteristic of early twenty-first century culture that could find a place in the museum. I decided to erect a staged protest outside the entrance to the museum, using cardboard placards tied to lampposts, using statements from the local media about earlier Beyond art projects in Leidsche Rijn, such as, 'waste of money' and 'art is useless'. The protest

could have been directed at the event, pre-empting some of the visitors' comments, or a part of the performance itself. Apart from being approached by the police while installing the placards, I did not hear any feedback from this part of the performance. Indeed, it is symptomatic of such commissions that the artist moves on and life resumes as before. By temporarily coming together we created a collective moment that may or may not have lived on in different ways. I heard later, for example, that many of the children who came to the event carried on wearing their goggles to school for some time afterwards. There was no formal evaluation or feedback from the event, besides informal conversations and local press coverage and it is difficult to ascertain the different meanings and experiences of 'critical engagement' with *Het Reservaat*.

More recently, in 2008, I wanted to continue to explore what a collective reflection on a process of commissioning art might be like – how can the collective process of making/ performing be continued and reflected in the critical analysis of what it means to commission art that is 'participatory'? How are the so-called 'participants' involved in this critical reflection? While I still hope to revisit Leidsche Rijn to carry out such a reflective process, I have begun a project in another area of urban development – the Greenwich Peninsula in South-East London, where I am working with a group of past and present 'participants' of 'collaborative' art projects to develop a critically reflective approach to questioning the role of art on the Peninsula.

Critical Friends is a small group of staff and associates of Stream, an arts organization based in Greenwich, London (http://www.streamarts.org.uk/). It is a cross between a steering committee, a focus group and an informal collective of local residents, staff and associates. I initiated this group with my colleague Rebecca Maguire in autumn 2008 after an invitation to evaluate the next series of art commissions Stream are planning for the Greenwich Peninsula. I evaluated the last series of projects, *Peninsula*, in 2005–2007. Rather than undertake an independent evaluation this time, I wanted to see if we could evolve the process of evaluation as a collectivized approach that is devised and carried out by the people the projects aim to include. The idea is for this to be a study group and not a group being studied.

They have devised some key questions they would like to ask of past, present and future art projects on the Peninsula and are currently carrying out interviews and observations as a way of starting to address their questions. A magazine (http://en.calameo.com/ books/000013925ebd57db8363a), private blog and regular meetings are sites for the group to share findings, re-address their questions and feed into the process of commissioning art at Stream.

Critical Friends is a way of revisiting art commissions from the perspective of people linked to Stream. As a method, it aims to address the imbalance of those who critique, commission, decide and retell the experience of art by recognizing and building on the diverse expertise of those involved:

who has the right to ask whom what questions?; Who has the right to answer?; who has the right to see what?; who has the right to say what?; who has the right to speak for whom?[1]

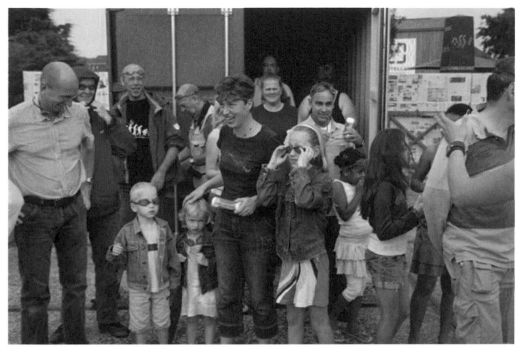

Sophie Hope, *Het Reservaat*, exiting the time-tunnel into the museum, 2007.

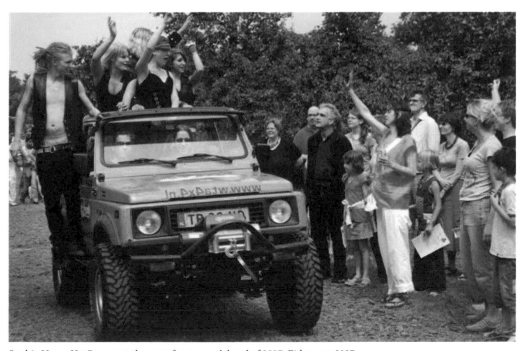

Sophie Hope, *Het Reservaat*, the most famous rock band of 2007, Eitherway, 2007.

Critical Friends is simultaneously adopting the method of a socially engaged art process while at the same time interrogating these methods. The research is the responsibility and preserve of each of those involved. I have my agenda and motives as do others in the group. The power structure cannot be ignored however, as Rebecca and I are paid facilitators and others in the group are volunteering their time at the moment (this may change depending on how it develops). The format of *Critical Friends* is open enough at this stage to define its own purpose and direction with Rebecca and me working as facilitators of that process. So far this has been about encouraging people to pursue their existing critical knowledge of the commissioning process. Two contributors are 'serial participants' who are perpetually consulted by artists and often take part in art projects commissioned by *Stream*. They are the unofficial, unpaid experts of the area. They have a unique view of commissioned art from that perspective. We are discussing with the group how they might document and research their inquiries and feed in to the process. For example, someone is writing a diary of her observations of a youth radio station and another has interviewed her neighbours about rumours of a current art project being developing in the area.

Both *Het Reservaat* and *Critical Friends* are examples of collective research and performance that I am facilitating and analysing. At times I am more in control while at other times, other people involved take control. The process evolves because of this shared input. In writing this text now, I am the one, yet again, who is speaking and writing. To open up the narrating would be the next step for *Het Reservaat*, just as we are trying to do with *Critical Friends*. The re-presentation of socially engaged art rarely reflects the supposedly collaborative aspect of the work. Lea Kantonen raises the issue of power plays in her essay on shared expertise in fieldwork, research process, artistic presentation and representation:

> Participatory research isn't symmetrical. The researcher wants to get knowledge about the community in question, she strives towards a close relationship with members of the community, and formulates the knowledge both by listening to them and by relating to the traditions of the academic institutions. Though dependent on her collaborators only she is rewarded for her accomplishments in the academic community. She is applauded for 'refraining' from her authority and 'sharing' her expertise with the researched. The same asymmetry concerns community-based art. The artist shares the authorship with the community, but only the artist is rewarded and recognised by the art community.[2]

Barbara Heyl also acknowledges that 'researchers have considerable control over the "reporting" and the outcome, while still striving to empower the respondents through respectful listening'.[3] I think *Critical Friends* and *Het Reservaat* are guilty of Kantonen and Heyl's assertions because they still rely on a model of commissioning art that privileges the artist. By collectively re-presenting some of the issues raised through these projects I would like to explore ways of redistributing to a wider audience the roles, resources and responsibilities of such work. This means finding new ways of drawing on aspects of

performative social science such as 'ethnodrama' as well as socially engaged art practices and evaluation.

Ethnodrama, developed by Jim Mienczakowski, is where 'co-performers read performance scripts based on fieldwork and interviews conducted in the fieldsetting'.[4] It is about 'giving the text back to the readers and informants in the recognition that we are all co-performers in each other's lives' (ibid.). The idea is that 'informants' control the text and its representation.

> Ethnodrama sits within an extant school of theatre which searches for social change but differs from other forms of similar theatre in that it adheres to the principles of formal and recognisable ethnographic research methodology, above and beyond the artist's demands of aesthetics, in its attempt to produce a cultural critique.[5]

Mienczakowski suggests that performed ethnography might be more accessible than traditional written reports. *Critical Friends* and *Het Reservaat* as ethnodrama, for example, involves the performing of scenarios as a way of reporting and communicating to a wider audience. The act of storytelling, reflecting and proposing is redistributed among the group and the experience is co-authored as a result. The roles of artist, commissioner and participant become blurred and reclaimed in a performative act that challenges traditional approaches to commissioning art, rendering the search for the spectator obsolete.

Critical Friends currently includes:
Rachel Gibson
Isabel Lilly
Rohini Malik Okon
Anthony Nicolaou
Andy Robinson
Bre Stitt
Rich Sylvester
Anne Webb

Het Reservaat included:
Pieternel van Amelsvoort
Daphne de Bruin
Dries van Dyke
Joost de Groot
Marielle Hendriks
Wouter de Heus
Gerben Joustra
Jan de Jonge
Pim van der Meer

Petra Mijjer
Arie Nico
Mike Ocon
Brigit Postman
Hans Sakkers
Jacobi Verheul
Herre Wynia
Staff of Emmaus
Students at Monterssori Arcade School
Students at de Achtbaan School
Eitherway (band)
De Maan Theatre Group
Jan Griffioen's tai chi class
Theatre Sport group

Notes

1. N. Denzin, 'The Reflexive Interview and a Performative Social Science', *Qualitative Research*, 1(23), 2001, p. 23–46. Quoting Anna Deavere Smith (26).
2. L. Kantonen, 'Shared Expertise in Fieldwork, Research Process, Artistic Presentation and Representation', *Geist*, 11, 12, 14, 2007–2008, pp. 182–196 (184).
3. B.S. Heyl, 'Ethnographic Interviewing', in eds, Atkinson et al., *Handbook of Ethnography* (Thousand Oaks: Sage, 2001), p. 376.
4. Denzin, 'The Reflexive Interview', p. 26.
5. J. Mienczakowski, 'Ethnodrama: Performed Research – Limitations and Potential', in eds, Atkinson et al., *Handbook of Ethnography* (Thousand Oaks: Sage, 2001), p. 470.

Chapter 5

Tell Me Your Story: An Interview with Artist Harrell Fletcher

Marisa Sánchez

Harrell Fletcher and Jon Rubin, *Garage Sale*, Gallery HERE, Oakland, CA, 1993.

On 4 August 2007, Marisa C. Sánchez sat down with Harrell Fletcher at his home in Portland, Oregon to discuss his art practice. For over a decade, Fletcher has encouraged a rethinking of the sites of artistic production by moving towards an expanded view of the artist's studio as well as supporting a much broader understanding of the role of the artist. His socially engaged approach repositions art into the public realm and he hopes to build communities through the exchange of art that can take many forms including storytelling and shared experience.

When Sánchez met with the artist to talk about the formation of his working process, Fletcher was anticipating the inaugural semester of the Art and Social Practice MFA at Portland State University, Oregon. Fletcher's efforts to establish an experimental, interdisciplinary and non-traditional programme within an academic institution were about to be realized.

The following is an excerpt from a longer conversation that took place that day. Sánchez talked with Fletcher about his work as an artist considering a range of projects from the early 1990s, when he was a graduate student at California College of Arts and Design, through to his current practice that engages diverse audiences and participants, as in the website project Learning to Love You More.

MARISA SÁNCHEZ

I want to begin by asking, how or at what time did you think that your approach to making socially engaged work was possible for you? I know you made certain decisions in graduate school about how you could develop your work in the public realm and now, sixteen years later, you have shaped that practice. Let's begin there.

HARRELL FLETCHER

When I arrived at graduate school I was surrounded by artists who were going off to their studios to make work, and that is what I had been looking forward to for a long time, but what is ironic is that when I got that opportunity it was no longer of interest to me. I asked myself 'what am I doing?' – going off to make work and then expecting people to look at it seemed slightly egotistical. That is not a slight on people who do that, it's just my own personal feeling for myself. I was also meeting people who were working on things that were socially activated – needle exchange programmes and the like. I was looking at them and then looking at us, my fellow MFA students; it made me think I didn't want to retreat to my own isolated spot and think my strange thoughts and make my little things and then hope people would buy them. I began thinking about how I could connect my interest

in documentary practice with visual art, and use it as a way of making work for galleries and museums, and I guess I just made the simple conclusion that I could in fact do that and focus on a group of people specific to the area surrounding a venue as the subject/ participants.

MARISA SÁNCHEZ

It's of interest to me that your socially engaged approach is not necessarily about the creation of a discrete object or a traditional studio-based practice, and yet the work often remains connected to conventional frameworks of exhibiting the 'product' in a commercial gallery or an art institution. Can you talk about your ideas for creating work which involves people who are not trained in art making, and how the work can then exist in those venues?

HARRELL FLETCHER

If I had been trained as something else, as a sociologist or a writer, my venue would have been different. Trained as I was, I had access to these venues and I saw myself as a facilitator for getting people's work into venues normally reserved for specialists and for people who were trained and official in that way, artist people.

MARISA SÁNCHEZ

Did you ever make objects?

HARRELL FLETCHER

Yes I did, ever since I was a kid I have made all these objects and drawings and I love that. But a funny thing happened when I came out of undergraduate school. I was very absorbed in the art world at that point, but mostly people seemed to be motivated by the need to have a review in *Artforum* or getting into the Whitney Biennial or selling in a commercial gallery. But I wound up working in a grade school in the Santa Cruz mountains for a year. My purpose was to make art with the kids and I was fascinated by their motivations, especially the young ones in kindergarten. They needed to make things because they really had something to express. They would have an interest in whatever it was – an insect or lizard – they would do some drawings, show them to someone, and they would be fulfilled by that. I realized that was my own motivation too when I was a kid, but that simple system had been worked out of me and I started having these ulterior motives that were really not about that expressing and sharing anymore, or being excited about something. Instead I somehow got tied into these other things. In a sense I distrusted myself, I did not want to be the one generating that work any more. When I do work for a public gallery I want it to be not just about myself for myself, I leave that stuff at home.

MARISA SÁNCHEZ

When was the first time you can remember working that way? What was the first thing you made?

HARRELL FLETCHER

I suppose the first thing was a book. I made a lot of books, first individual books, then Xerox books, and then an interview with my great aunt Grace. I put this book together, just a transcript of the interview. It was very simple, just capturing the moment and letting people into it. But funny things would happen, people would show their mom, and tell me their mom loved my work and I thought 'Wow, do I want someone's mom to like my work?' I realized I did, and this has led me into doing more projects for people's moms and all sorts of other kinds of people as well.

MARISA SÁNCHEZ

It seems to have had a circular effect for you by allowing you or even inspiring you to create work that encourages others to make the private public.

HARRELL FLETCHER

Yes, reality TV wasn't around when I started to make this work. There were precedents like Frederick Wiseman's films or *An American Family*. I think the way that reality TV went was the opposite to my work, so it is funny that the private/public thing has occurred in this other form.

MARISA SÁNCHEZ

When people contribute to *Learning to Love You More* (LTLYM) some of the submissions have a confessional quality. Do you feel reality TV has informed the process?

HARRELL FLETCHER

I think in some of them, but not all. In *Learning to Love You More* it's not the primary interest to get confessions. There are 63 assignments at the moment and what we are looking for is a range of experiences – a few of them are confessional or very personal, a lot of them are about stepping out of yourself and engaging with other people.

MARISA SÁNCHEZ

One in particular that sticks in my mind is the assignment which asks the participant to record the sound that keeps them up at night. In some ways, the engagement with the website sets up an interaction where the camera, the lens, is brought into the home. That intimate, private space is then offered for display on a public site so that others can engage with it, viewing and reading about another person's experience.

HARRELL FLETCHER

…yes, and sympathize with…It's horrible if there is some kind of sound keeping you up. I've been through it, and it's nice to be able to share what you are going through with other people.

MARISA SÁNCHEZ
Can you talk about some of the responses to that particular assignment?

HARRELL FLETCHER
There are normal ones like traffic outside, cats making a lot of noise, there are babies, there are all sorts of different generator sounds, a whole range of things like that.

MARISA SÁNCHEZ
Do you often have interaction with people who submit work?

HARRELL FLETCHER
No not really, but there are over 8,000 participants at the moment. There is most notably Laura Lark in Texas, who we have done an event with and a few others who have approached me, but the vast majority we don't know who they are, except through their reports.

MARISA SÁNCHEZ
Recently, you have been collaborating with the Oliver family, who live in Seattle and are attempting to complete all of the 63 assignments on LTLYM in two months. How did this challenge come about? Did you know the family or did they simply sign up on LTLYM? Did you place a call for entries to families interested in participating?

HARRELL FLETCHER
Well, first of all we were asked to take part in the Bumbershoot Festival held in Seattle, Washington from 1–3 September 2007. We were reluctant to pursue it because we were pretty stretched at the time, but I think there is always a solution to every problem. So Miranda (who I work with on that project) and I had a phone conversation, and the idea was to invite a local family so that people felt connected to it. We had already talked to the organizer and he then said 'Well I know a family who live next door to me', and they were perfect for it. They were paid a fee so I suspect that might have been some of the motivation but they are enthusiastic about it too, although we have never met them. We have emailed them and we shall meet them on the final night of the exhibition.

MARISA SÁNCHEZ
They keep an active blog (http://oliverlove.blogspot.com/), so viewers can read their progress as they complete assignments and watch how they are doing throughout their journey.

HARRELL FLETCHER
It was just an experiment, in that we don't usually make the assignments obligatory for anyone to do, so it was quite a stretch to ask them to do all of them. I felt that would make an interesting show, but no one has actually done it before. Usually it is about the range of people, this is just a different take on it. The family comprises a mother and father and four

kids, two boys and two girls. The oldest is twenty and I think the youngest is six, and they are involving their friends as well.

MARISA SÁNCHEZ

In many ways, this project is taking shape outside of your control. As part of your practice, you place a lot of trust in other people to realize your ideas. You establish a structure and they create the work. Do you feel a responsibility to the audience and participants for their contributions?

HARRELL FLETCHER

Well, it varies in that there is one extreme, when we work with vast numbers of people and we create a very tight structure into which they put their content. The other extreme is when I work with an individual very closely. For example, I worked with a young boy in France and asked him if he were to make a sculpture for a sculpture park what would it be? There was no guarantee that I would do it but the content was all his. He came up with something really interesting, which I would never have thought of, to make a turtle out of gold and

Harrell Fletcher, *Corentine's Turtle*, Domaine De Kerguehennec, Brittany, France, 2006.

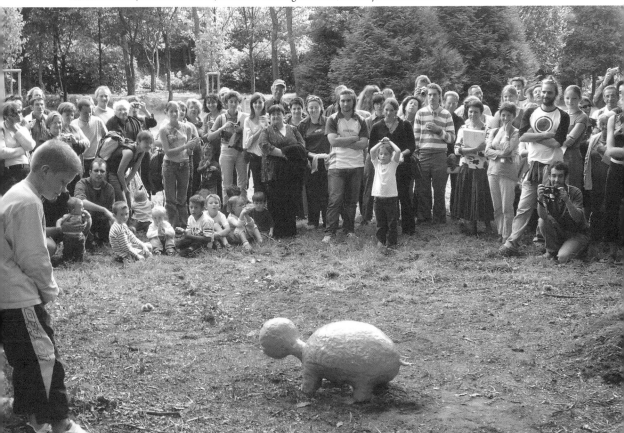

paint it green. I was so excited about it that I was determined to realize it, because I had offered the project out to a lot of people and got different proposals and that is the one that I went with. I worked with him over three summers and I became his assistant. In some ways what I do is offer structure or support to a point where people can realize a project – a framework in which to contain it. With the turtle piece, he is offering me a lot; giving me this idea, and of course I give him credit as I do on all things, giving me his time, but I also give him a lot; offering him the access to the sculpture park, materials, a budget, to enable him to realize something that otherwise he would not be able to do. It's a reciprocal relationship.

MARISA SÁNCHEZ
Can you talk about the garage sale, an early work you created in collaboration with another artist and people from the community?

HARRELL FLETCHER
It was a really early piece that I made with another artist Jon Rubin, who was a year ahead of me at graduate school. We spent a year and half doing things that were about the area, and one of the things that was happening were garage sales. We decided to do a show about garage sales. First we opened a gallery in a vacant store. We contacted the people who owned it and asked them if we were able to use it for exhibitions, and they let us for free. We very specifically wanted a store in order to be on street level with windows and in a place were people would be able to just walk in, rather than being in a warehouse area or upstairs which would instantly physically deter people from coming in. Rather than curate a show with pieces from various garage sales, we put an ad in the paper and asked people to contact us if they were going to have a garage sale. Jon and I would display the items for sale and invite the families back in to tell us the stories behind each object and we would type those up and put them on tags attached to the objects. The audience just assumed it was a store, and walked around, read the stories and learned about the families through their objects. The show was up for a week and on the weekend the families came in to sell off the objects as if it were a normal garage sale. We would then do another one the next week, and we did a series of them that way.

MARISA SÁNCHEZ
And the family was given all of the proceeds from the sale?

HARRELL FLETCHER
Yes. The stipulation was that they had to sell their stuff for the same price they would have if it was just in the garage or front yard. They couldn't just hike up the prices because it was in a gallery. People would try to buy from us during the week and we would say 'Listen we don't own these things, its not ours, come back on the weekend and it will be like 50 cents', but they would try and entice us with 40 bucks for a lamp or something and I would say 'I can't do that'.

MARISA SÁNCHEZ

Do you think this confusion happened because the experience began to be understood as a contemporary art project and the sale was in a gallery context with objects showcased on shelves?

HARRELL FLETCHER

It's something that I have learned in general when you take almost any object and put it in a museum or gallery it is going to look a lot more valuable than in a thrift store or on the street. To a large extent the art world uses that, something made in the studio as art looks a lot better in a gallery, and it turns out you can do that with almost anything. At that time, we didn't really have any fame value so I don't think that is the point of why they wanted to buy it. It was more that they really liked something and they wanted to get it and didn't want to wait till the weekend.

MARISA SÁNCHEZ

You made that work early in 1993 and, at that time, you were already collecting personal histories. A strong part of your practice is listening to the oral histories of the people you work with. Why are you interested in other people's stories?

Harrell Fletcher and Jon Rubin, *Garage Sale*, Gallery HERE, Oakland, CA, 1993.

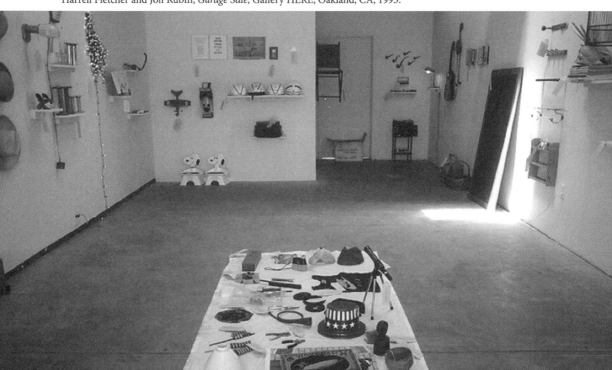

HARRELL FLETCHER

I think it goes back to the piece I did on my great aunt Grace which was a pretty straight oral history, with a few surprises. I wanted her to talk about the good old days, but she wasn't interested in that. I like that it becomes a way to learn about things, in a first person way. In the three blocks that was the gallery neighbourhood in Oakland, I could walk around and learn about the Second World War from a man sitting in his apartment courtyard, and the Turkish Atrocity from the guy who owns the rug store across the street, and Japanese concentration camps from the principal of the middle school, and hip hop from some kid who lived down the street. This vast amount of information is readily available, but no one knows how to access it, and in most cases it just disappears. We did a show about the World War II man and his garden, and he died six months later. Many of these things are lost too, but realizing that was a huge discovery for me. Once I figured out I could work in this way, the world opened up to me, and I could go anywhere, and there is this vast amount of knowledge and skills, talent and interest, that on my own I would not be interested in necessarily, but because I have decided to be someone who is interested in people who are interested in things, that opens up a whole host of other things, which includes for example Star Trek and Ulysses, subjects I would never have encountered on my own.

MARISA SÁNCHEZ

Were you ever surprised by an individual's willingness to offer so much information to you?

HARRELL FLETCHER

I was at first, but I think I am now used to it, and if you show interest in people they are generally very generous, gracious and willing to talk. It may just be a normal human attribute that people want to tell you about their life and things they care about, and if they sense you are genuinely, a sincere person they are willing to do that with you.

MARISA SÁNCHEZ

Have you ever been in the situation where someone has refused to share? I know you wouldn't force anyone to contribute, but have you ever encountered someone who was clearly unhappy with what they shared and then approached you after they saw it on the website or after it was included in a show?

HARRELL FLETCHER

That is a reaction that everyone always assumes will occur, but it is not obligatory to take part and I never twist anyone's arm. In the case of *Learning to Love You More*, we are not using some kind of stealth software to learn about the lives of people and then publish what we find. The participants are willingly contributing, so it has never come up in that way. There have been a few cases where people have contacted us and asked us to take things out of their submissions but later changed their mind. It might be that their circumstances had changed in some way or they just found it too revealing and then we would just remove it.

One report that was really amazing was slightly painful to take off, but we just did it because that's what the participant requested. Working with Jon Rubin on a project with this guy Anthony Powers, who told us an amazing story, and he then said he did not want that to be part of the show we were doing with him, so we deleted it and there were a million other things to work with.

MARISA SÁNCHEZ
In some cases you are working with a community, but in other instances like in the video, *Sunglints* (2000), created in St Paul, Minnesota, you document your appreciation of the small, everyday wonders you discover. Do you do this simultaneously with the community-based practice and do you choose to exhibit these works in a gallery and/or museum?

HARRELL FLETCHER
After leaving graduate school I didn't work with commercial galleries for ten years so I got out of that frame of mind. I wasn't automatically making things to be sold, which I think most artists do. After ten years of resistance I could think about it again and I felt okay about showing things that are for sale. There are also residual things from my projects which commercial galleries are interested in, but that is really a tiny part of my practice.

MARISA SÁNCHEZ
You are equally prepared to work with the Whitney, a commercial gallery in London and a man down the street. It's clear that within your practice you want that fluidity of experience and you do not limit yourself to any hierarchical structure.

HARRELL FLETCHER
Yes I think that is something I have pursued. You are taught that everything should be according to a hierarchy. You start showing at a bookstore or something like that (though some artists resist that), then you work with an obscure gallery, then you switch to mainstream gallery, then into museums and once you have done that you don't go backwards; you don't return to those earlier venues, unless it is a very special occasion. My sense was I should work across a horizontal field which could include the Whitney, a commercial gallery or someone's front yard or any other context. My hope was that things could be interesting and useful in any of those situations and in some way it would benefit institutions in that they had access to a rather unorthodox approach. There are a bunch of conditions institutions have to deal with each time they work with me and I hope this opens the door for more people to work in that way.

MARISA SÁNCHEZ
At the university where you teach I imagine students ask 'How do you operate in the public realm and how do I find my niche in this contemporary art context?' I wonder how do you encourage them to pursue their careers as artists or art practitioners?

HARRELL FLETCHER

It varies from individual to individual, but I think I have to show them that they don't have to just try travelling down the traditional path to art stardom. There are lots of other ways for artists to function in society, most of which I haven't tried myself, but if they are open to opportunities and are really creative, not just in the art objects they make, but in a larger way, the world can open up to them.

Part II

Sonic Openness

For many artists sound has offered an attractive option as a means of producing work, but it is not just for its sonic quality that it holds sway. This section considers the many ways in which artists have used sound as a means of opening up their work to collaboration and participation, drawing people in through the spoken word, song, oral recollection, computer technology, found and recorded sound, and occasionally, though often unrehearsed, with orchestral instruments.

Chapter 6

Open Sounds: On the Track of the Dissolving Audience

David Briers

Scratch Orchestra Cottage, Alexandra Palace, London, August 1971. Left to right: Michael Chant, Bob Cobbing, Cornelius Cardew.

In this brief analysis of participatory sound work over the last century, David Briers is responding to Umberto Eco's essay The Poetics of the Open Work. *Eco's thesis is predicated on a small number of musical compositions which exemplified his ideas about the 'open work', allowing the performer an unusual degree of freedom to shape the work, but where performer and audience were firmly fixed on opposite sides of a rigidly divided professional line. Briers considers what evidence there is of compositions designed to enable musically untrained people to perform a musical/sound/action work, possibly to the degree of the disappearance of the idea of an 'audience'. He finds activities that may be so described, though initiated by professional composers, have largely been realized in a relationship with the world of the visual arts. His essay touches on some works by John Cage, then those of people he taught, such as LaMonte Young and the Fluxus artists. In the United Kingdom, Cornelius Cardew's Scratch Orchestra (of which Briers was an untrained member) exemplified this tendency and in the early 1970s the phenomenon of 'art school orchestras' such as the Portsmouth Sinfonia, positively embraced the democratic idea of 'doing something badly'. As communal sound-making activity loses its impetus Briers proposes a number of contemporary artists whose use of sound to reveal the acoustic qualities of our built environments gives participating audience members an opportunity to direct their own aural experience.*

A t the beginning of his 1962 essay *The Poetics of the Open Work*[1] (one of the texts anthologized by Claire Bishop in her book *Participation*), Umberto Eco cites four musical compositions, written between 1956 and 1958, as referents for his thesis.[2] Three of these compositions, works for solo performer by Stockhausen, Berio and Boulez, exemplify Eco's ideas about 'open' works of art that allow the performer a hitherto unusual amount of latitude (within the Western concert tradition at least) to shape the work: 'In primitive terms we can say that they are quite literally 'unfinished': the author seems to hand them on to the performer more or less like the components of a construction kit'. But equally they maintain absolutely the traditional hierarchy between the spectacle of the highly skilled (even virtuosic) performer, and a non-professional audience of passive auditors and observers.[3]

There is evidence of a tributary of sound compositions designed to be performed by musically untrained people, and to destabilize or even dissolve altogether the idea of a separate 'audience'. The activities that may be so described, initiated by professional composers and 'first generation' sound artists, have predominantly arisen adjacent to the world of the visual

arts and art education. And yet they are referred to only infrequently in current discourse related to the participatory dimension of art in the public domain. The purpose of this text is to furnish in outline a description of a particular stream of activity for the reader not necessarily versed in the history of contemporary music – to trace its historical lineage and to open up the subject for further investigation and discussion.

This lineage arguably begins with some of the works of John Cage, then those of artists he taught and subsequently European composers and artists who have been influenced by Cage's aesthetic. Cage's compositional praxis during the 1950s is well known, involving chance procedures and graphic scores, concerned with the parity of sounds and silence. His *Concert for Piano and Orchestra* (1958) was certainly an 'open work' as predicated by Eco (though it didn't come within Eco's Eurocentric purview), consisting of 63 pages of graphic notation 'to be played in whole or in part, in any sequence' (or even in combination with other compositions by Cage) by fourteen solo instrumentalists. For this piece Cage also scored a part for an optional conductor, who extends and moves his arms around like the hands of a clock, but at varying speeds. These independent physical actions interpenetrate with the sounds produced by the instrumentalists, and do not influence them. They can be undertaken by someone without any experience of orchestral conducting, and do not require an ability to read a conventional score. The orthodox relationship between the conductor, musicians and audience is further displaced by Cage's suggestion that the players should sit spaced apart around the auditorium, some perhaps even in the audience.[4]

During the 1960s Cage explored increasing degrees of openness in the *Variations* series (1958–1966), elaborate sound installations most of which are scored for 'any number of players, any sound-producing means', and occasionally 'for any number of people performing any actions'. The culmination of this aesthetic was probably the more modest composition *0'00"* (1962), a 'solo to be performed in any way by anyone'. Even here, however, as in all of Cage's works, this extreme freedom of action is accorded to the performer conditionally, that it be carried out within a conscientiously disciplined framework.[5]

The idea of blurring or even removing the demarcation between the performers and the audience was accomplished with *33 and 1/3* (1969), an installation of unfixed duration for 'twelve turntables, twelve stereo amplifiers, twelve pairs of speakers, and any 300 records' with an 'audience of participants'. At the first performance of the score, in a hall at the University of California, discs randomly selected from the university record library were piled on tables placed between the turntables. Visiting members of the public selected records from these piles to play in whole or part, at the same time as other records were being played in different parts of the room, or not.[6] 'For a long time, I had been looking for a way to bring about what people call audience participation', said Cage. 'But I didn't want people to sit down at the piano to play if they had not studied it. On the other hand, you can let anyone play a phonograph'.

Cage's younger associate Christian Wolff, in less spectacular ways and usually for smaller forces, intermittently accommodated within his practice as a composer a concern with 'collaboration, non-hierarchical forms of social organization'. A significant number of his

compositions could be performed by amateurs or 'people not necessarily trained in music'. Describing this aspect of the music of Christian Wolff, Frederick Rzewski has said that 'Anyone with will and a certain understanding can do it. This idea of music as something you do, rather than something that is done to you, is both ancient and forward-looking'.[7] This became the era of what has been variously termed 'prose music', 'word-scores' or 'event scores'. Wolff's works were often composed 'with verbal instructions only', and a *Prose Collection* (1968–1974) of pieces for any number of players includes, for example, *Stones* (which uses rocks found on the beach as a sound source) and the unusual *You Blew It*, for voice or voices, a superficially simple but subtly articulated piece of musical sound poetry.[8]

The composer La Monte Young, for a while associated with Fluxus (an international radical collective bent on blurring distinctions between art and everyday life), also published a collection of very short prose scores. The best known of these (dedicated to the artist Robert Morris) is *Composition 1960 #10*: 'Draw a straight line/and follow it'. Young's *Poem for Chairs, Tables, Benches, Etc.* (1960) requires a group of performers to drag or push furniture across the floor according to a pre-established timeframe.

The artist George Brecht (also a Fluxus member, and a student of Cage) refined the genre of the 'event score', often comprising a very short text printed on a small card. The titles of many of these suggest the framework of a musical composition, although none of the scores requires musical skills. *Solo for Violin* (1962) instructs the performer to polish the violin, while in *Piano Piece* (1962) the performer places a vase of flowers on the top of the piano. Both actions are to be carried out with complete seriousness, possibly in evening dress. More intimate than those of Cage, Brecht's scores suggest a solo performance, which is how they are often performed, though many of them allow in the score for realization by groups of multiple performers. The score for Brecht's *Concerto for Orchestra* (1962) consists of one word, 'exchanging'.

Another Fluxus artist, Mieko Shiomi brought a particularly deft sensibility to the genre of 'event scores' and diagrammatic notation. In her *Disappearing Music for Face* (one of a series), performed in New York in 1964, she conducted a non-vocal 'choir', so that according to her directions smiles gradually disappeared from their faces.

'The need to bring a large number of non-specialist people together as doers, rather than watchers', wrote Michael Nyman in 1974, 'had seemingly become urgent by 1968 or 9'.[9] In the United Kingdom in 1969, Cornelius Cardew originated the idea of the Scratch Orchestra, initially around a corpus of his composition pupils at the Royal Academy of Music, and students from the Experimental Music Class he had been conducting at Morley College (an institution born of the late nineteenth-century workers' education movement). The latter group included musical amateurs, and visual artists without any musical training, drawn to the course by their interest in the visual scores of Cage, or those of Cardew himself, whose major score *Treatise* (1963–1967) consisted of a completely graphic *tour de force* with no musical instructions. One of the initial precepts of the Scratch Orchestra was that membership did not require any formal musical training (John Tilbury has described the membership as 'an assortment of people from various walks of life, some of them with

considerable artistic talent, who loved and needed music'[10]). Nevertheless, the orchestra's Draft Constitution was duly published in the staid *Musical Times*.

Some members played conventional orchestral instruments, others used musical instruments associated with non-classical traditions, and many brought along toy instruments and portable non-musical objects (like domestic utensils) capable of making sounds, or just their voice.[11] Described at the time by composer Tim Souster as an 'amorphous anti-orchestra',[12] the Scratch Orchestra did perform formal public concerts in front of an audience, although, as has been observed, the orchestra was often greater in numbers than the audience. Just as important were the weekly meetings at which the orchestra members performed particular works, or each improvised independently but in parallel from pieces in the orchestra's collection of 'improvisation rites', *Nature Study Notes* (1969). However much an element of improvisation entered into these performative meetings, 'notated' scores were always used and sounds were never made haphazardly. These scores might consist of nothing more than a short phrase or a little drawing, or they might take the form of elaborate diagrams or several pages of detailed textual instructions. The scores were produced not only by orchestra members (including Cardew himself), but also by international composers and artists, some of them Fluxus artists. According to Michael Nyman, Cardew 'always conceived of notation…not as an end in itself or a means of unlocking sounds, but as a way of engaging the most valuable resource of any music – people'.[13] Seated informally on the floor around the edges of a rehearsal hall, there was only occasionally any sense that these performances were in preparation for a forthcoming public event. Many were of the opinion that the orchestra's performances for itself were its best ones. The idea of an audience had been dissolved, rendered irrelevant.[14]

When the Scratch Orchestra did perform in the public domain, it made efforts to do so outside the conventional concert hall context. In 1970 the orchestra toured to rural Cornwall and Anglesey, playing in village halls. At this time too, the design of 'environmental events' entered the practice of the group, including ambulatory concerts around Richmond and Primrose Hill, and an environmental event without audience on the Dorset clifftops. Other such events included a performance on the concourse of Euston railway station, a day of random appearances on the London underground (called *Scratch Below*), a demolition site event for children and an event in which the orchestra tried to 'merge with Highgate cemetery'. A series of 'Journey Concerts' was planned in which each orchestra member was called upon to plan their own journey and document it in the form of music, sounds or action. One such concert (performed at the Queen Elizabeth Hall in 1970) was titled *A Pilgrimage from Scattered Points on the Surface of the Body to the Brain, the Inner Ear, the Heart and the Stomach*.[15]

Alongside the Scratch Orchestra in the early 1970s the phenomenon arose of 'fine art orchestras'.[16] These were the consequence of the employment of experimental composers to teach Complementary Studies in the art departments of polytechnics (for example, Gavin Bryars and Michael Nyman, both strongly influenced at the time by Fluxus).[17] These ad hoc groups included the DipAD Orchestra at Leeds College of Art, and Foster's Social Orchestra

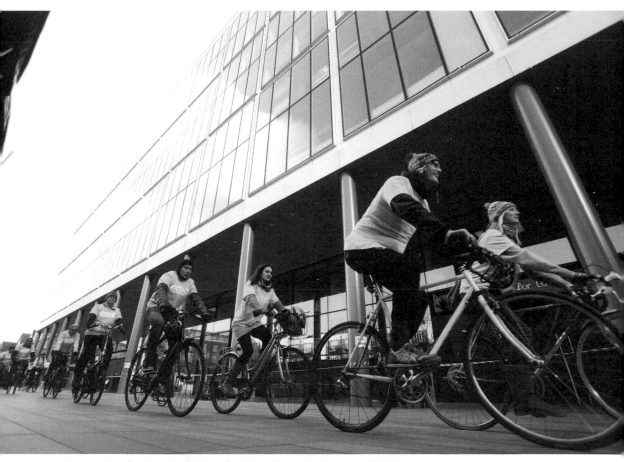

Mauricio Kagel's, *Eine Brise* ('A Breeze'), 1996, performed at 'East Festival' 2009.

at Nottingham Polytechnic, but most prominent among them was the Portsmouth Sinfonia, founded by composer Gavin Bryars with staff and fine art students from Portsmouth Polytechnic. The Sinfonia played a repertoire of the well-known parts of popular classics, positively and democratically embracing the idea of 'doing something badly'. Trying very hard to perform these scores accurately, the performances were inevitably conditioned by the fact that the musical training of many of the orchestra members was very limited or non-existent. Like Florence Foster Jenkins, the discrepancy between intention and actuality produced a hilarious outcome, demolishing the 'skill-gap' between orchestra and audience. Fluxus artist Robert Filliou's 'principal of equivalence' came into play, conferring equal status to actions that were well done, badly done or not done at all. Or as Cage wrote, 'A "mistake" is beside the point, for once anything happens it authentically is.'[18]

Unusually within the related parallel international phenomena of concrete poetry and sound poetry, the British concrete poet Cavan McCarthy developed a genre of poem-scores for 'mass performance' (possibly knowingly in the lineage of the 'simultaneous poems' for speaking voices of the Dadaists, and the ritualistic sound poetry of Bob Cobbing), as a response to his dislike of conventional poetry readings. Particularly successful (but now forgotten) was McCarthy's equivocally titled *Music* (1966), a poem which was read at live events not by its author but by his audience. The poet held up a random sequence of twenty shuffled cards, on each of which was printed a simple non-verbal symbol. These served as a 'score' for audience members to interpret as hand claps, shouts (possibly words) or by remaining silent.[19]

This particular stream of communal non-professional sound-making may be said to have petered out since then. But some of its impulses have fed into more recent time-based artworks sited in the public realm, that reflect our current preoccupations with the acoustic qualities of our built environments, and how as urban flaneurs we encounter and experience them. An example is the composer Mauricio Kagel's piece *Eine Brise* (1996) a 'fleeting action' for 111 massed cyclists riding around a city ringing their bells according to instructions in a textual score. Characteristic of Kagel's extraordinarily fertile aural and visual imagination, the work is described by the composer as a 'musically enriched sporting event'. When the piece was performed as part of the 2003 Aldeburgh Festival, Tom Service described it as 'an evanescent, mobile performance of honking, whistling and singing'.[20]

A reference within this context to Janet Cardiff's work *Forty Part Motet* (2001) might seem at first misplaced. But this reworking of Thomas Tallis's 1575 *Spem in Alium*, opens up an otherwise exclusive organized sound world, allowing the listener to direct the nature of their own aural experience, to indulge their aural curiosity, and to get as close to a piece of music as it is possible to be. The sounds of a 40-part choir recorded in real time (including the attendant preparatory vocal hubbub of the assembling singers) issue from an array of

Top right: Janet Cardiff, *The Forty Part Motet*, 2001.
Bottom right: Choir recording.

40 small loudspeakers positioned around the perimeter of a discrete public space, allowing the listener to focus in close-up on each single voice as well as the whole ensemble. The experience is quite different from listening to the same work performed in the concert hall, or on the radio. Cardiff invites you literally to choose your own path as you move around the space, like walking through a piece of music. It is a visceral experience, despite the digitally replicated nature of its recorded sound material.[21]

Another musical composition inviting the auditory and ambulatory participation of its audience is *In a large open space* (1994) by the American composer James Tenney. At a well-received performance of this piece during the 2007 Huddersfield Contemporary Music Festival, in the non-concert hall setting of a disused textile mill, the professional Quatuor Bozzini string quartet was complemented by twelve or more student and amateur performers, some playing instruments from outside the concert traditions, such as a Celtic harp. Seated at various points around the space, they played softly sustained notes from a range specified by the composer while the audience either chose a seat in the midst of the players (rather than in rows in front of them), or walked around during the performance, experiencing the space full of sounds from different perspectives.

The German artist Christina Kubisch trained originally as a musician, and she considers her ongoing 'work in progress' *Electrical Walks* (2003–) to be 'a kind of composition'. Members of the public are invited to take a walk around a particular external environment with which they may be familiar on an everyday basis. While undertaking the walk they wear a pair of headphones developed by the artist to detect and render audible as electronic impulses the invisible presence of electromagnetic fields generated by a wide range of public utilities and private commercial devices, from security devices and lighting systems to cash machines and surveillance cameras. The nature of the resultant transcribed sounds varies from place to place and country to country. A suggested itinerary (researched by the artist) is given to each participant, but they are equally encouraged to discover their own sonic route, on their own or in a group. According to Kubisch, 'The perception of everyday reality changes when one listens to the city in another way…Nothing looks the way it sounds. And nothing sounds the way it looks.'

The aesthetic of Cage's notorious 'silent' work for unplayed piano, *4'33"* (1952), which establishes a frame through which to listen attentively to any sounds in our immediate environment, in turn nourished the idea of the 'soundscape' and the 'soundwalk', devised by the Canadian composer R. Murray Schafer in the early 1970s.[22] Coming full circle, the 'soundwalk' has lately been revived in this country by composer and sound artist John Levack Drever. In what he describes as the 'classic' form of the 'soundwalk', Drever leads a group of people in single file silently and at a leisurely pace for an hour around a trail that he has researched in detail in advance within the urban hinterland. The experience is focused entirely upon 'encouraging the participant to listen discriminately', and the ensuing informal discussion is often revelatory.[23]

Tony Harris thinks that we 'run the risk of laying experimentalism to rest within the canon of music history – the very canon experimental music strived to resist. The British

experimental music of the sixties and seventies is now a "genre".[24] In one way, the Scratch Orchestra is now situated discretely in its period as a characterful vignette of those times. However, some aspects of its legacy – in particular its published notebooks – are still viable, as are the scores of composer-artists like George Brecht and Mieko Shiomi. They remain an underused source of models for public projects involving non-musicians in the activity of thoughtful organized soundmaking. Whether the resultant experiences are framed taxonomically as experimental music, sound art, acoustic ecology, polemical action or an exercise in mindfulness, is for someone else to decide.

Notes

1. U. Eco, 'The Poetics of the Open Work', in ed., C. Bishop, *Participation* (Whitechapel Gallery; MIT Press, 2006) p. 22.
2. Later in the essay, Eco considers the varying degrees of 'openness' of works in other mediums, but does not employ examples more recent than Mallarme and Joyce in literature, and the sculptural mobiles of Calder in visual art.
3. Eco's exceptional referent is Henri Pousseur's *Scambi*, an electronic composition of interchangeable, superimposable recorded sections, intended to be ordered by the listener beforehand (although Pousseur's composition preceded the development of the technological means for this listener participation to take place in other than special circumstances).
4. Nyman, M., *Experimental Music: Cage and Beyond*, 2nd edn (Cambridge: Cambridge University Press, 1992), p. 65.
5. Revill, D., *The Roaring Silence, John Cage: A Life* (London, Bloomsbury, 1992), p. 203. The textual score reads: 'In a situation provided with maximum amplification (no feedback), perform a disciplined action'. Cage's own first performance of the work comprised the highly amplified sounds of handwriting this instruction.
6. Dinwiddie, J., 'Mewantemooseicday: John Cage in Davis, 1969', *Source*, 4(1), 1970, pp. 22–26 (24).
7. Wolff, C., *Cues: Writings & Conversations* (Cologne: Edition MusikTexte, 1998), p. 12.
8. Wolff, *Cues: Writings & Conversations*, pp. 468–480.
9. Nyman, *Experimental Music*, p. 131.
10. Tilbury, J., 'Cornelius Cardew', *Contact*, 26, 1983, pp. 4–12 (8).
11. To quote the Fluxus composer Giuseppe Chiari: 'one can play with a chair or a rock or a sheet of paper with the same logical and emotional behaviour with which one plays a violoncello or a guitar'.
12. Souster, T., 'Great Britain', in ed., J. Vinton, *Dictionary of Twentieth-Century Music* (London: Thames and Hudson, 1974), pp. 282–284 (284).
13. Nyman, *Experimental Music*, p. 115.
14. There are, in other traditions, plenty of examples of music performed without an audience: the isolated shepherd playing a pipe, the liturgical ritual behind the rood screen of a church.
15. Ely, R., 'A History of the Scratch Orchestra 1969–72', in C. Cardew, *Stockhausen Serves Imperialism* (London: Latimer, 1974).
16. Lampard, J., 'Fine Art Orchestras', *Musics*, 12, 1977, pp. 10–13. The Scratch Orchestra spawned its own spin-off groups. Of these, the Harmony Band and Private Company in particular featured

players who were not musically trained, or incorporated non-musical activities such as concrete poetry and 'spontaneous painting' in their performances.

17. Christian Wolff's *Prose Collection* described above was, he later said, 'made so as to provide material for performances which could include non-musicians, mostly at the time art students in Great Britain'.

18. As Jolyon Laycock has since noted, 'The shelf-life of the Portsmouth Sinfonia was limited by a process of creeping proficiency as members got better at playing their instruments. Since its *raison d'etre* lay in harnessing musical ineptitude, the orchestra eventually started to lose its point, an intriguing reversal of the skill-gap.'

19. A copy of Cavan McCarthy's own mimeographed publication of his poem *Music* can be found in the special collections of the Brotherton Library at the University of Leeds. A better designed edition of *Music* (also conceived as a pocket-size pack of cards) was subsequently published by Brian Lane, Gallery Number Ten, Blackheath, London.

20. Service, T., 'Aldeburgh Festival, 2003', *Tempo*, 57(226), 2003, pp. 67–68.
 Whistling is a musical activity (usually solo) that can still be widely heard, although it is not as common as it used to be. It has hardly ever been incorporated into formal, notated music for groups of performers, other than by the renegade Percy Grainger.

21. Briers, D., 'Janet Cardiff: NOW Festival', *Art Monthly*, 252, 2002, pp. 45–46.

22. Schafer, R. Murray, *The New Soundscape* (Ontario: BMI, 1969).

23. Briers, D., 'Two Soundwalks: A Subjective Account', *Earshot*, 5, 2007, pp. 58–60.

24. Harris, T., 'Continuing the Experiment', *New Notes*, February, 2004, pp. 1–2 (2). Published accounts (partial and impartial) of the mutating relationships and tensions between the 'musicians' and 'non-musicians' in the Scratch Orchestra, and its final embrace with Maoist thought, can be found elsewhere, and is the subject of current historical research.

Chapter 7

Eagles are the Best: Juneau Projects in Conversation

Ben Sadler and Phil Duckworth

In 2008 Ben Sadler and Phil Duckworth (the two artists who make up Juneau Projects) set up a temporary studio at the New Art Gallery Walsall and cut an album with some amateur songwriters and musicians they had met through an ad in the local paper. 'We don't have any preciousness about the songs we write and we're constantly reworking them anyway so collaboration is very natural for us', says Sadler. Juneau Projects' positive attitude to participation has become a central tenet of their practice. Much of their art is generated by an open process, setting up situations in which untrained musicians can contribute to the repertoire. The duo has an enduring interest in nature and they use images of birds and animals to tell stories about our relationship with the natural world in the twenty-first century. Their approach to this subject is combined with a skill base that ranges from musical talent, to harnessing the latest computer technology, to crafting objects in the folk tradition using digital means. And it is this combination of interests that touches many people's lives and draws them, especially the young, into their work. Art audiences have become familiar with the results of this activity, but here for the first time the artists have been invited to reveal some personal responses to the experience of working closely and collaboratively with a group of young children.

The following text describes the appeal of sharing authorship with unpredictable contributors and incorporates some of the results of that process. Duckworth and Sadler discuss the contributions made by children to a project entitled Stag Becomes Eagle which was commissioned by Thurrock Council, Commissions East and the Royal Society for the Protection of Birds (RSPB) in 2005. The project was based on an estate next to the Aveley Marshes in Essex. Sessions were offered each week over a period of three months for children aged between seven and eleven. Reference is also made to an earlier project with Grizedale Arts, the Grizedale Roadshow, where children wrote and composed songs which entered the Juneau Projects repertoire.

PHILIP DUCKWORTH
Have you got a favourite song from the *Stag Becomes Eagle* project?

BEN SADLER
I think my favourite is 'Secret Light Sky' by Holly.

PHILIP DUCKWORTH
What was your involvement with it?

BEN SADLER
I helped Holly with the music for it. We discussed something that might fit with the lyrics she'd written. I felt quite involved in the whole process of working with Holly. Over the three months we ran the project she wrote a good fifteen or twenty songs. 'Secret Light Sky' is one of my favourites lyrically.

There was a little girl	She said she'll
Sitting up on	Never
The rooftops	Tell
Looking at the stars	Anyone
But she couldn't	For Ever
Believe her eyes	She said
There was a secret light in the sky	It's my secret light sky

PHILIP DUCKWORTH
It's interesting; she was one of the youngest kids involved in the project but also one of the most productive.

BEN SADLER
She was very prolific.

PHILIP DUCKWORTH
Can you remember how old she was?

BEN SADLER
She was eight. Her brother Kyle was there as well, he was a bit older, maybe ten or eleven, but he didn't quite enter into it in the same spirit as Holly, although he did come to every session.

PHILIP DUCKWORTH
We often say that there's quite a good age range for projects like this.

BEN SADLER
There is. Holly's at the lower limit of that maybe, seven or eight, and Kyle's maybe reaching the upper age range, eleven or twelve.

PHILIP DUCKWORTH
It seems to be an age where young people aren't as self conscious as when they get older but they've also got a bit more facility than younger children and are able to write and think about things like song lyrics but at the same time have no real idea about what should be in a song and why.

BEN SADLER
I think with a lot of them it's the age where they're starting to get interested in music but they don't really have any ideas of coolness about the music so they can quite happily like a song that's in the Top 40 as well as a song their mum and dad might play in the car or a song from a children's programme. They're non-judgmental in terms of the music and the lyrics they listen to. They also seem to have quite a barrier to interpreting the lyrics they listen to – you'll hear them singing quite an adult R&B song but without any conception of what they're singing because they're just not interested in that at that point I suppose.

PHILIP DUCKWORTH
One of the projects that we'd produced just before this was on the Grizedale Roadshow where we were getting people to write and record songs on the spot to music we had written, but this project, *Stag Becomes Eagle*, at Aveley Marshes in Essex...

BEN SADLER
...it was the first project where we'd worked over an extended period of time with a group of young people wasn't it? Like you say, the roadshow was a different process; people would just drop by and spend about half an hour working on it, whereas we went back to Purfleet repeatedly for *Stag Becomes Eagle* .

PHILIP DUCKWORTH
Having said that, although the project was over a longer period of time I think we'd imagined that they would go back over songs and work on them but in practice they probably spent about half an hour on each song from writing to recording and then moved on to the next one. But it was a regular meeting they could come to and if they didn't get anything done one week they knew they could come back and do some recording the next week.

BEN SADLER
It was quite a slow process in a way. For example, I remember Charlie made a piece of music on a laptop and the intention was always that he would put some lyrics over it, but in the end he was happy with his piece of music just as it was. It's one of the harshest pieces of music I've ever heard. He spent a good few sessions working on it. It was a really dense, loud, harsh, industrial sounding piece of music. It is quite difficult to listen to but he would sit there laughing every time he played it.

PHILIP DUCKWORTH
We were using laptops as the main tool for music and composition. It was something that all of the young people seemed to get on with quite easily. Charlie's piece was made from using normal drum and instrument samples but he had put the tempo up to the highest number possible, which I think is 999 beats per minute, which made the short loops he was making into strange slabs of sound.

BEN SADLER
And he seemed very happy with that result. It goes back to them being at that age where these slabs of sound can equally be music to them. He seemed to be mainly into hip hop and had intended to make a hip hop track but he was much happier with the aural assault that was his final piece of music.

PHILIP DUCKWORTH
He never recorded any of his lyrics unfortunately but they were quite particular.

BEN SADLER
They were almost like haikus really.

In the world we see everything
Good bye world, I never see you again
All the thing I will see is the star above

I'm going to the moon to not see everyone
I said to my mate
Tell my family good bye

I remember thinking after reading those last lyrics that he seemed to be the happy-go-lucky one of the group and yet he wrote those lyrics.

PHILIP DUCKWORTH
What was strange about a lot of the songs, in particular Holly's and Charlie's, is that there was a melancholy to them that I think we really picked up on as it became part of the content of the piece. I don't think they were aware of the sense of sadness or melancholy that they were writing about.

BEN SADLER
At the 'Searching for the Spectator' conference Jonathan the chairperson said that in his opinion the results of collaborative projects of this nature often never lived up to the

intentions. I think if I had been more prepared I would have liked to have said that it is the reverse for us with these songs. The results often far outweigh the initial intentions we had for the project. This project is a really good example, particularly in terms of what you were saying about the sense of melancholy coming through. That's one of the facets that was really interesting about the project for me and I think for you as well.

PHILIP DUCKWORTH
Something we often talk about is that we want to set up situations where people can quickly interact or get on board, with almost as little input from us as possible. Obviously there is the input of the music with projects like this one. We produce most of the music for most of the songs that other people write in projects like this, so that may influence them to some extent, but we don't try to teach songwriting.

BEN SADLER
This was one of the initial sticking points with this project. We'd learnt that the best results came from stepping back and letting the kids find their own way into how they were going to write a song. We had to try and get the adults we were working with to leave the kids to work at their own pace. There is an urge to push them into getting the song written and recorded…

PHILIP DUCKWORTH
…and to make it fit into the idea of songs and rhyming and phrasing. The lyrical content as well…

BEN SADLER
…and to get them to quickly pin down a theme and even a character and place makes it more like schoolwork perhaps. Often the results aren't the same as those you might otherwise get where things become more personal. The more melancholy songs always come from the kids that write them on their own, like the first song we recorded as part of *Stag Becomes Eagle*.

Just sitting here by myself and I can't stand
 living here alone but I'll have to get used to it.
But time goes on I'm thinking of you but I hate surviving.

I'm living here on my own but I hate to survive yes I do.
I'm alone and thinking what can I do.
When I have lived here alone yeah what am I gonna do?

PHILIP DUCKWORTH

Although that's not to say that having a collection of sad songs was our intention and there were several that were quite joyful.

BEN SADLER

Completely. I'm thinking of Patrick's song from Grizedale in which he'd written about the film *2 Fast 2 Furious* which probably wouldn't have happened if he'd been guided as to what to write his song about.

Get in your car
Turn it up – the radio
Let's go!

Too fast, too furious
That's how we like it
You go slow, you go home
Fast is good, slow is no

You're playing with the big boys now son
Your mummy's not going to save you now
You, you are on our streets, it's our rules
Don't like it? Go home

You go slow, you go home
Fast is good, slow is no
You go slow, you go home
Fast is good, slow is no

Let's go!
A little bit faster now
Pump the clutch, it's your turn to shine son
Win that race – come on – turn it up
Put the clutch in – double clutch
Come on, faster – get one – get two – that's it, into five
Win that race

You go slow, you go home
Fast is good, slow is no
You go slow, you go home
Fast is good, slow is no

PHILIP DUCKWORTH

From *Stag Becomes Eagle* in particular, there are a lot of animal related songs which I think grew out of the association with the RSPB and also the project title. It indicated a direction for a lot of the songs but I think there were several interesting interpretations, they focused on some of the more exciting creatures available rather than what I think the birdwatchers call LBJs (Little Brown Jobs).

An Eagle comes flying by
Making a whoosh of wings
And a slash of claw
He gets his prey and whizzes away

An Owl is hiding in the trees
Making a fierce hoot

And the evil eye of an Owl is watching us
And the evil eye of an Owl is watching us

His want is – protecting his nest
He's giving a great flap
And a big whoosh
While guarding the nest
Guarding the nest
Guarding the nest

And the evil eye of an Owl is watching us
And the evil eye of an Owl is watching us

BEN SADLER

I think there was a big focus on animals and birds that could kill things, along with a vague knowledge of how and what those animals might kill. The animals were generally quite evil and might kill you. I imagine an eagle is a scary prospect at that age. However, there is also a song 'Eagles are the Best' which is a nice illustration of what we've quite often found in our work – that most people's experience of nature is a second-hand experience. Even these young people who live next to a bird reserve were quite removed from the natural world around them in terms of how they understood and interpreted it.

Eagle is flying above the clouds
Looking down at the world below
Killing everything in its path
Taking it back to the family, yeah

Eagles are the best
They're better than the rest
Better than the rest, yeah
Flying to the mountain nest

To feed the little
Babies
An Eagle is trying to do his best
To keep them out of danger

Eagles are the best
They're better than the rest
Better than the rest, yeah
Flying to the mountain nest

He swoops down to the sea
Watching for the fishes
For his evening meal
Before he rests his head

Chapter 8

Case Study Two: Melanie Pappenheim in Reading

Helen Sumpter

Melanie Pappenheim was chosen as the second of three case studies, because of her wealth of experience and continuing commitment to working with non-professionals. She has devised and produced two previous projects in Reading triggering a groundswell of interest among local amateur singers who are keen to build on earlier successes. The invitation for Pappenheim to return a third time was in part a curatorial decision, yet significantly influenced by the public's perceived interest in participatory choral opportunities. Helen Sumpter's interview with an untrained participant demonstrates the need for clear artistic ambition to guarantee rewarding involvement and continuing commitment from the public.

The Project

Ambulatiuncula (2006) was a series of fifteen soundworks, commissioned by seven contemporary artists and musicians, in response to Reading's historically rich Victorian park, Forbury Gardens, and the nearby Abbey ruins. The works were experienced by taking a sonic walking tour through the site, listening to the compositions through headphones on a Dataton audio set, which was available from the Museum of Reading shop. Singer, composer and performer Melanie Pappenheim's three short compositions, using voices, music and ambient sounds and produced in conjunction with sound designer Giles Perring, took as their starting point three text inscriptions located on the site: the names of the fallen on the Maiwand Memorial (a cast-iron lion erected to commemorate men from the 66th Berkshire Regiment who died during the Second Afghanistan Campaign 1878–1880), a sign in memory of local Victorian Joshua Vines Esq and an engraving in the Abbey ruins. For the opening of *Ambulatiuncula* Pappenheim was commissioned to create a new choral work *Primrose's Dispatch*, with words by Adey Grummet, which was composed for and performed unaccompanied by local amateur singers, under Pappenheim's direction.

The Artist's Experience

Melanie Pappenheim has extensive experience composing and devising work in the fields of singing, music, art and performance, working with both professional performers including DV8 Physical Theatre, the Jocelyn Pook Ensemble, choral band The Shout and for film and

119

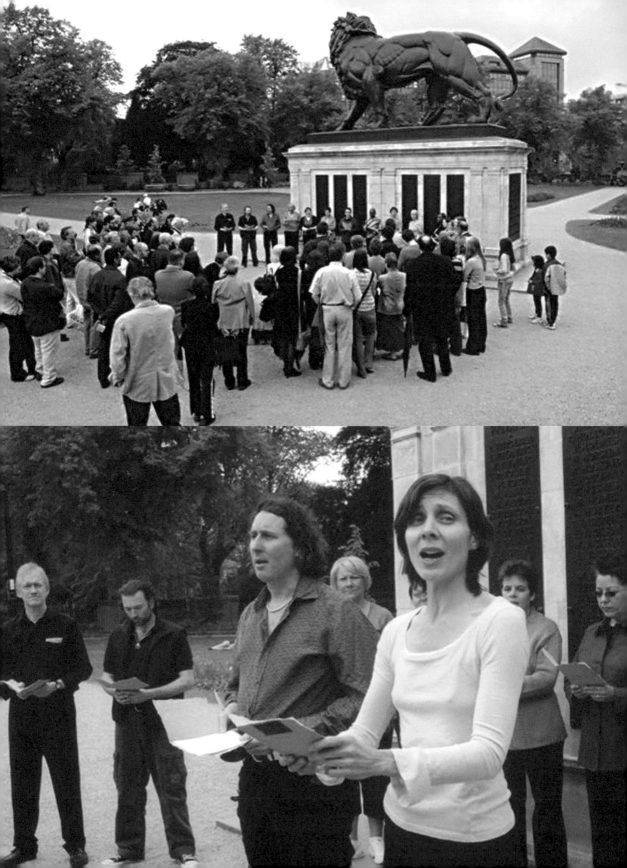

television, as well as working with non-professionals. In collaboration with composer and artist Simon Rackham, Pappenheim devised a previous work *The Holy Brook* for Artists in the City in 2003. This was a vocal and instrumental piece performed by a combination of professional and non-professional musicians and singers, in celebration of one of Reading's hidden waterways.

What are your main considerations when creating a work not just for but with the public?

For a commissioned live work such as *Primrose's Dispatch*, my ideal would be to meet the participants well ahead of the performance date in order to assess the group's level of ability (can they hold harmonics for example) and with luck unearth any exciting idiosyncrasies (unusual voices, interesting languages, anecdotes), then go away and tailor the piece for that particular group of people. This can of course be a risky strategy if the amazing Afghan singer who turned up at the workshop had to leave the country before your first rehearsal. In the event I was asked to come up with this piece quite late in the day so I had to arrive with more or less the finished work at the first rehearsal. We had relatively little time to rehearse so the music wasn't particularly difficult but I distributed the parts in such a way that small groups of singers were 'exposed' (positively, I hope) and this also helped foster their sense of 'ownership' of the work. I spend a lot of time in rehearsals trying to generate a collective sense of the story we are telling and it is a very moving one in the case of *Primrose's Dispatch*. The story belongs to Reading and to these people and if one can harness that feeling it can make for a very powerful performance – it can also help push performance anxieties to one side. For *Primrose's Dispatch*, I invited the wonderful Tamil singer and fellow Shout member, Manickam Yogaswaran to improvise during the final bars of the piece to hint at the place where all those soldiers had lost their lives. His vocalizing is a fantastic inspiration to all singers, amateur and professional, but I was careful to ensure his sound didn't dominate the piece. When working with amateur groups, it is notoriously difficult to get the same group of participants for every rehearsal or even every performance if there is more than one and if you have a lot of rehearsals it is difficult to keep up the momentum. I try to keep the music simple and effective and take a lot of care over how the performers appear – encourage them to memorize the score, where to focus, etc. – I like to create small pieces of music theatre.

What issues can arise regarding authorship and ownership?

Authorship and ownership of a work can be something of a minefield. In my professional capacity I may be involved in devising material in a guided improvisation which may then be later exploited say for film or television. Sometimes I have rights over that material but more often than not I don't. I know that some theatre companies who produce devised work insist that the performers hand over the rights to any work devised during the rehearsal period

Left: Melanie Pappenheim, *Primrose Dispatch*, performance, 2006.

to the company. This wasn't an issue with *Primrose's Dispatch* because the composition was complete before rehearsals began, and the work was not filmed; just recorded for archive purposes.

Why do you choose to work with non-professionals in this way?
I enjoy the enthusiasm of non-professional performers and the way they can really give of themselves. People seem to me to be much more open-minded than say ten years ago when putting together a devised work was much more difficult. I suppose it also helps that I now have a bit of a track record so people are perhaps more prepared to go along with my ideas. Sometimes non-professionals are more open in the way they talk about the material, they are more direct. However, it can also be a risky business as I don't tend to audition people so it's important to be both well prepared and flexible! But it can also be hugely rewarding, particularly when you come across genuine talent. I have met so many people over the years who could quite easily have become professional singers or performers. I recently heard a wonderful Serbian singer who runs a café in Hackney, North London and I've asked him to be involved in other projects. It's great that I can help provide an occasional platform for such singers.

The Performer's Experience

Kerry Duggan was both a performer in *Primrose's Dispatch* and *Holy Brook*, as well as being co-organizer and administrator of both projects for the Artists in the City programme. She had no previous musical or singing experience before taking part in the projects. She has since retrained as an art teacher and has a particular interest in participatory and socially engaged practice.

How did you come to be a participant as well as a co-organizer of these projects?
I saw it as a great opportunity to be involved in something musical in an enjoyable way and to be creative in an area that was outside of my comfort zone. The *Primrose's Dispatch* performance was really commissioned as a result of the success of *The Holy Brook* because everyone who took part enjoyed the experience so much. In fact more than half of the amateur singers from *The Holy Brook* returned to take part in *Primrose's Dispatch*. I would never find myself in the position of being employed to sing publicly but because participation in the project was invited from all interested local singing groups and music students and because Melanie was able to find, work with and encourage talents in everybody, we all felt able to take risks.

Right: Melanie Pappenheim, *Primrose Dispatch*, performance, 2006.

In the case of *Primrose's Dispatch*, what are your feelings about ownership of the work?
I don't feel the need to say that it's in any way my work. I was a participant in the work and very proud to be so but the work was by Melanie Pappenheim. As performers our roles were very clearly defined. It was very much us performing the ideas that Melanie had written and within that Melanie allowing everyone's individual talents to shine through, so that we all felt that we had brought something unique to the project. *Primrose's Dispatch* was particularly moving because in a way it had been conceived to give voice to local people who had died, so it felt even more fitting that it was also performed by ordinary local people.

As a non-professional participant, what did you feel were the project's strengths?
I think that the high quality of the work and the ability of the artist to get people motivated and committed and to bring the best out of everyone were key factors. We had to rehearse for six weeks and obviously show up on the day, so the time commitment was quite considerable. The fact that the project was well structured was also important. Everyone had their specific part to sing and we were very tightly directed and conducted. When projects like this are not quite so successful or rewarding for the artists and participants it is perhaps when there isn't enough structure. People may think that might be good because it allows greater flexibility but I think that if you are working with non-professionals without a tight structure, more often the result is that the project just doesn't come together.

Could participants feel used or exploited in a project like this?
I think that they could if perhaps the process involved was the most important thing and the aesthetic quality of the work was secondary or perhaps not considered at all, which might then result in the final outcome being unsatisfactory for all concerned. I think that in both *The Holy Brook* and in *Primrose's Dispatch* there was a very strong aesthetic, and because the compositions themselves were so good, everyone involved felt proud of the part that they had played.

Part III

The Emancipation of the Spectator: The Viewer Completes the Circuit

This section looks at the way in which the viewer has become an integral and significant element within the artwork, crossing the border between the outside and the inside of the piece. Each of these three texts demonstrates that unless the spectator enters into the work, the work does not exist. The 'entering in' takes many forms. For Hirschhorn it is a question of responding to choices, selecting and matching material on offer. For Miller the spectator is not only the subject, the participant and the viewer but also the final determinant. In many of London Fieldworks' projects the spectator is the physical link that completes the circuit and allows the work to 'be seen'.

Chapter 9

Headless in Hirschhorn's Classroom

Jonathan Lahey Dronsfield

The Swiss born, Paris-based artist Thomas Hirschhorn is a leader in the art/participation field. He sees theory, practice, philosophy and art as equals, but most relevantly for this publication, he considers 'the viewer [to be] inside the work', allowing the spectator to make personal choices about the connections between the theory and the art on offer. Jonathan Dronsfield has a longstanding interest in Hirschhorn's work and and in the materiality of theory and philosophy.

I

Thomas Hirschhorn's *Anschool* (2005) is both a school and not a school. It is not a school because it is art, and Hirschhorn holds tightly to the autonomy of art. Yet as art it presents itself as a school, but one which according to the press release does not seek to set up a space in which teaching and learning can take place in the conventional sense: '*Anschool* rejects analysis, training, and the creation of a "school"'.[1] On the other hand, *Anschool* wishes to exhibit the values we might associate with the student, the scholar and the teacher: '*Anschool* stands for courage, curiosity and perseverance' (ibid). But while it is not a place of teaching and learning, *Anschool*, which we might translate as 'non-school', does not, in so doing, reject pedagogy, it does not foreswear guidance or a certain instruction. It is not 'institutional critique'. On the contrary, it is precisely by remaining art rather than purporting to be teaching or critique that *Anschool* can show us something about pedagogy, something critical about it. Were *Anschool* to have proposed itself as a school in the form of a space in which teaching and learning and study could take place, it would have forfeited its ability to raise essential questions about pedagogy.

An entire wing of the Bonnefantenmuseum is transformed into a school, divided into classrooms organized according to the spatial logic of lectern, desk and chair. Into, around and through these are dispersed and threaded and tacked on already-existing works by Hirschhorn. Interspersed throughout the whole is 'pedagogic' material: 'printed matter, Hirschhorn's own texts and other documentation and videos related to previous exhibitions. Everything is mixed up together – "kopflos" in the artist's own words – purely according to Hirschhorn's internal logic' (ibid.).

This 'headlessness' is Hirschhorn's refusal to distribute and divide up his material on the basis of hierarchies. *Anschool* cannot be a school because it does not cleave to the pedagogical

Images on pages 130–131, 133 & 134: Thomas Hirschhorn, *Anschool*, 2005 at Bonnefantenmuseum, Maastricht.

myth of progress, it is not a space which presupposes a progressive educative process leading to equality on the basis of training and qualification because the artist-teacher does not presume to be in possession of knowledge to be imparted. On the contrary, to strive towards equality on the basis of progress is recognized by this work as a principle of *in*equality. Rather, Hirschhorn seems to be holding to the idea, expressed most forcefully by Jacques Rancière in his book *The Ignorant Schoolmaster*,[2] and which forms a guiding principle of Rancière's recent writings on politics and aesthetics, that equality is the point of departure rather than something to be attained, the supposition being that we are all always already equal, the teacher a participant in equality rather than a superior equal.

Now, the hierarchies resisted by Hirschhorn include those of theory and practice, and of philosophy and art. Theory is a central material element of Hirschhorn's practice. Not just in *Anschool* but in other large museum exhibitions,[3] gallery shows,[4] 'monuments'[5] and 'landmarks',[6] Hirschhorn has worked with a philosopher, Marcus Steinweg, who writes philosophical texts which he offers to Hirschhorn to do with whatever the artist wishes. 'I can do what I want with these texts' says the artist.[7] Hirschhorn treats them as material, refusing to acknowledge their autonomy as pure theory. Steinweg's texts become as much a part of the artwork as any other material constituent of it: Hirschhorn cuts them up, photocopies them and distributes them around his works, reduces and enlarges them, extracts from them, cites from them, uses their propositions as slogans and illustrations and makes images of their words and phrases. On the other hand, Steinweg's texts are made available as printed matter for the viewer to take away. They are finished and intact yet able to be divided and distributed to form part of the material unity of works of art. According to essays published by Steinweg independently of his work with Hirschhorn and to interviews both have given on the subject they are 'integrated texts' which at the same time can be read 'on their own'.[8] For Hirschhorn the artist and the writer work separately,

each being responsible for what they produce, but what they produce is available to both equally. What attracts Hirschhorn to Steinweg's texts is the writer's insistence on the sensuousness of ideas and concepts, including the concept of responsibility, and the emphasis given affect in the explication and presentation of them – in this way philosophy can be *seen* as art.

This is nothing less than an attempt to liberate the potential of theory from the constraints of any order of dependence it might have to practice, whether that order be dictated by theory (where practice would be reduced to illustration) or by practice (where theory would be reduced to something to be applied). It is what Gilles Deleuze, referring to the films of Jean-Luc Godard, calls in the first of his *Cinema* volumes a 'pedagogy of the image', a pedagogy that makes explicit the function of the frame to record visual information, to teach that the image is not just to be seen but to be read.[9] It is not for nothing that Deleuze cites Godard; more than any other filmmaker Godard has tended towards inscribing his images with text and, like Hirschhorn, with handwriting, and to accompany his images, often disjunctively, with a soundtrack meditating on the act of reading them, where the source of the questions posed about seeing and reading, and the subjugation of the hand to the eye, emanate from the writings of philosophers: Heidegger and in particular Wittgenstein. By writing across images and making the surface of their work opaque with writing both Godard and Hirschhorn seek to slow down the spectator, giving him time to think, but not to allow the viewer to stand back and take a distance with respect to what there is to be read – Hirschhorn wants the viewer inside the work.[10] Both Hirschhorn and Godard, both of whose education is part Swiss, part French, and both of whom have exchanged France for Switzerland and vice versa, and it should be added political activism for an a-political politics, want to provoke the activity of thinking, but not to educate the viewer, on the contrary the presumption is that the viewer is 'overly-educated', as Hirschhorn remarked about the 'art audience' in his written report, part of *Anschool's* 'pedagogic' material, on the

Bataille Monument.[11] Both artists 'make connections' and pragmatic associations between what there is to be read rather than establish an argument that would lead to the imposition of a – single and unified – ideology. 'As an artist it is up to me to make such connections visual' says Hirschhorn in *London Catalogue*, again part of the exhibition's printed matter.[12] The emphasis in making connections is on multiplying the differences and on releasing potential.

Hirschhorn's headless dispersion of theory and the saturation of his work with it impacts on the viewer in such a way as to shock and stupefy them with its materiality. It is an insistence on the textual materiality of theory which at once disenables the viewer to grasp what the theory says as, simply, theory, yet leaves him unable to let go of it. According to Giorgio Agamben this is the lot of he who studies. The *st*- root of *studium* indicates a crash, the shock of impact: 'those who study are in the situation of people who have received a shock and are stupefied by what has struck them'.[13] Indeed, it would appear to lead nowhere this acephalic headlessness, this conflagration of ideas (one part of *Anschool* shows a burnt-out table having been weighed down by the fire of its constructions). The viewer is at once subject to, put upon by the questions raised by the theory, a questioning which the spectator can only undergo and suffer, questions about the relation of art to philosophy for instance, of the autonomy of both, of both to truth, questions about the subject, whether there is such a thing, what might come after it and so on; and at the same time given the very resources to 'escape' this subjection and to become the subject of new and unheard of associations between ideas and their materialization, to undertake to realize the potential of the work and to act on the matter there presented. It is a doubly genitival circle of endless return, where 'return' becomes the shared material nature of the differences provoked.

Thus there is too in Hirschhorn a Nietzschean affirmation. One can see this in the endless appeal to 'Energy yes! Quality no!', and the insistence on 'courage, curiosity and perseverance'. It is as if the artist is heeding Nietzsche's call to educate the will before anything else. Nietzsche writes (in 1888):

> Our absurd pedagogic world, before which the 'useful civil servant' hovers as a model, thinks it can get by with 'instruction', with brain drill; it has not the slightest idea that something else is needed first – education of will power[14]

And while affirmation is opposed to criticism, or at least is only reluctantly or at best parenthetically linked to it, this does not mean that one follows every impulse. The Nietzschean affirmation of the will involves the education of the will…to learn *not* to react. And to learn not to requires an education in seeing. Learning to see requires an educator says Nietzsche in *Twilight of the Idols*, one who through making visible will educate the eye to calmness, to patience, to letting things come to one.[15] But energy is no less required for calmness and slowing down than it is for action. So the 'no' of Hirschhorn's 'Quality no!' must not be seen as a negation. It too must be seen as an affirmation. The affirmation of the transvaluation of the value of quality over energy: henceforth quality is no longer to be seen in opposition to energy unless it be an obstacle to it.

The imploration to affirm energy can be found too of course in one of Hirschhorn's preferred theorists, Gilles Deleuze. Part of what attracts art students to the ideas of Deleuze is the energy, the intensity that is the excess of the materiality of those ideas beyond the way in which they might be put to use in an argument or a proof, or fixed beneath definitions, such that in the artist's appropriation of it the idea, in its material actualization, will always exceed or flee any function or use. Theory can be actualized in art, but without being reduced to practice, or vice versa. This is what Hirschhorn seeks to do (and to do so on a 'colossal' and 'obscene' scale with his in the end, or perhaps as yet, unrealized *The Road-Side Giant Book Project* of 2004, where the idea was to erect a huge book, Deleuze's *Mille Plateaux*, volume 2 of *Capitalisme et Schizophrénie*, by the roadside in Minneapolis, a book which would act as a place of study, in homage to the giant eateries to be found in the United States which one can only enter by 'confronting their disproportion' as Hirschhorn puts it), but the materiality of the artwork will always be in excess of the subsumption of matter to the form of the idea. It is a 'uselessness' and an excess which has been affirmed by philosophers throughout the twentieth century, from Heidegger through Adorno, Blanchot and Derrida to Deleuze. And it's this useless material excess which artworks anyway perform beyond any use the artist-student will have for philosophical ideas and art theory in that work, no matter how literally they might want to show it.[16]

II

'Humans are political animals...because we have the power to put into circulation more words, "useless" and unnecessary words, words that exceed the function of rigid designation'.[17] By 'materializing' it, by incorporating it as one more material and by doing so headlessly, *Anschool* and *Utopia, Utopia* utilize theory without putting it to use; instead

they confer on theory a uselessness which allows it to escape the classification and the rigidity of designation to which it might be put by the philosopher – but not at the expense of its necessity. Rather, there is a power performed for the spectator, the power to make connections, to try out relations between words of theory and things, words of theory and ideas, words of theory and contexts, words of theory and images and words of theory and the ordinary, to the extent that these exhibitions can be taken to be what Hirschhorn calls 'manifestos' in the sense that they enact this connection-making as power, at its simplest the power to speak, and as one which everyone can exercise. The proliferation of words is precisely what is contested by 'those who claim to "speak correctly"', 'masters of designation and classification', who in denying the power to speak wish nothing more than to 'retain their status and power' (ibid). Presumably this is what Hirschhorn has in mind when setting his work against 'overeducated aesthetics'.[18] In any case, the contestation of the fundamental capacity to speak is to be resisted by affirming the disjunction between image and text, between the visible and the sayable.

However the connections are made possible, a 'possibilising' made visible, by the making material of the words of theory, by making visible the materiality of the words, by alienating them from the context whence they come. Although it is a process aided no doubt by the ways in which the texts they are drawn from themselves allow for a certain chance, a certain excess. For instance, we might say that Deleuze's texts perform the problems of which they speak rather than simply write 'about' them, thus producing a material excess to the concept, or at least allowing for the chance of a material slippage in the work the concepts do which eludes the text, one which is not reducible to or masterable by an intention. Hirschhorn 'sees' this material excess and allows it the chance to visibly write itself out. De-naturalizing concepts in this way, dissolving any hierarchical relation to images through material juxtaposition with them, is to bring into the realm of the sensible, the aesthetic realm, a widening of the options, a freeing up of the possibilities. 'Only chance is strong enough to overturn the instituted and incarnated belief in inequality'.[19] For Rancière the relation of image to text is a matter of *justice*. As can be seen from a recent catalogue essay on James Coleman, matters of justice are matters of the visible and the visibility of what is visible.[20] Art has a special place in the realm of the visible in that it allows for a 'going back over' the elements of what is represented (ibid., 15), a playback in which words resound beyond themselves (ibid., 17). It is a going back, a playback, a re-sounding the effect of which cannot be anticipated, because it is a breaking both of the causal link the word might once have enjoyed in the theory 'itself', and the causality which sees ideas as the endpoint of a process of intentionality, and thus it is as much and at once an immaterializing of the word. The causal link is broken because words are 'happened' as text rather than thought, are given headlessly in a capacity to produce rather than issued as the productions of a causal process begun in the head. Causes are 'possibilised' through invention rather than given in advance,[21] and the spectator is acknowledged in her emancipated condition of being able to make links, a power which, in being irreducible to the distinction between looking and acting, precedes the active/passive distinction.[22]

What *Anschool* and *Utopia, Utopia* represent, then, are productive possibilities between word and image of disjunction and conjunction, association and disassociation, chance and detour, where words of theory are allowed to resound beyond themselves, but not such as to overwrite the images they are connected to or disconnected from or associated with or held up against or made equivalent to. Rather, these exhibitions put the question of the order of dependency between word and image on another footing, a visible one. These works are 'manifestos' because they put words of theory to work for no other use than to be seen to be equal. No attempt is made on the part of the artist to claim to 'understand' the theory or to explicate it for the spectator – the theme most exhaustively played out in Rancière's *The Ignorant Schoolmaster*. Rather, theory is given a chance of comprehension otherwise denied it 'in itself'. The materiality of the word becomes the force of a new comprehensibility.²³ Under the name of equality the relations between word and image are shown to be of a nature shared between all things (ibid., 26–27), where theory becomes no more or less a material thing than any other thing acting as a 'bridge of communication between two minds' (Rancière quoting Jacotot, ibid., 32), and where the artist asks what can be done 'under the supposition' of equality (ibid., 46).

Godard once remarked that text was his 'royal enemy', his 'number one enemy',²⁴ but this did not stop him from continually 'textualizing' his images, or making explicit the always already implicit legibility at the heart of them, or to show the power of an image to speak 'incorrectly' of its received condition. In the film *Notre Musique* (2004) we are told that the Jews have become the stuff of fiction, the Palestinians documentary and we hear Celine lament that facts no longer 'speak for themselves', because, and we are talking about 1936, 'the field of text had already covered the field of vision'. The implication is that text 'invisibilizes' what might otherwise be seen. But this is precisely the 'difficulty' with justice, for Rancière, that it is allied 'with a certain invisibility, with a non-being and non-visibility', obliging one 'to make a choice, to take a step forward into darkness'.²⁵ 'The Palestinian people exist and don't exist' he says. The artist does not shy away from this contradiction of the visible to the invisible; instead he turns text to the advantage of asking where in the visible lies the invisible, showing how that very contradiction can be an ally of justice. Such is Hirschhorn's headless lesson.

Notes

1. Bonnefantenmuseum (2005), *Anschool* press release, Maastricht.
2. Rancière, J., *The Ignorant Schoolmaster: Five Lessons in Intellectual Emancipation*, trans Kristin Ross (Stanford: Stanford University Press, 1991).
3. Hirschhorn, T., *Utopia, Utopia = One World, One War, One Army, One Dress* (Boston: Institute of Contemporary Arts and San Francisco: CCA Wattis Institute, 2005).
4. Hirschhorn, T., *Unfinished Walls* (London: Stephen Friedman Gallery, 2004).
5. Hirschhorn, T., *Bataille Monument* (Kassel: Documenta XI, 2002).
6. Hirschhorn, T., *The Biljmer Spinoza-Festival*, Amsterdam, 2009.
7. An interview with Alexander Klein. Undated, but included in the pedagogic material for the exhibition *Anschool*, *Anschool* (Maastricht: Bonnefantenmuseum. Part II, Porto: Museu Serralves, 2005), answer 8.
8. Steinweg, M. (2003), 'On the Integrated Texts', trans Michael Eldred, for Hirschhorn's exhibition *Double Garage* (Berlin: Arndt & Partner, 2003).
9. Deleuze, G., *Cinema 1: The Movement-Image*, trans Hugh Tomlinson & Barbara Habberjam (London: The Athlone Press, 1986), p. 13.
10. Hirschhorn, T., 'An Interview with Benjamin Buchloh', *October*, **113**, 2005, pp. 70–100 (95).
11. Hirschhorn, *Bataille Monument*.
12. Hirschhorn, T., *London Catalogue* (London: Chisenhale Gallery, 1998), p. 9.
13. Agamben, G., *Idea of Prose*, trans Michael Sullivan and Sam Whitsitt (New York: State University of New York Press, 1995), p. 64.
14. Nietzsche, F., *The Will to Power*, trans Walter Kaufman & R.J. Hollingdale (New York: Vintage Books, 1968, p. 484.
15. Nietzsche, F., *Twilight of the Idols*, trans Judith Norman (Cambridge: Cambridge University Press, 2005), p. 190.
16. Part I of this essay appeared first in Swedish: 'Kopflos I Hirschhorns Klassrum', *Paletten*, 266(4), 2007, pp. 50–53. Since its publication Hirschhorn himself has written a short prose piece extolling Rancière's book *The Ignorant Schoolmaster* – it encourages him, the artist says, to 'make of each artwork a manifesto' (Hirschhorn, T., 'Eternal Flame', trans Jeanine Herman, *Artforum*, 45, 2007, p. 268.
17. Rancière, J., 'An Interview', with David Panagia, trans David Panagia, *diacritics*, 30(2), 2000, pp. 113–136 (115).
18. Garrett 2004: 90.
19. Rancière, *The Ignorant Schoolmaster*, p. 133.
20. Rancière, J., 'From the Poetics of the Image to the Tragedy of Justice', trans Charlotte Mandell, in *James Coleman* (Dublin: Irish Museum of Modern Art, 2009), pp. 11–32 (11).
21. Rancière, *The Ignorant Schoolmaster*, p. 64.
22. Rancière, J., 'The Emancipated Spectator', *Artforum*, 45, 2007, pp. 271–280 (279).
23. Rancière, *The Ignorant Schoolmaster*, p. 20.
24. Godard, J.-L.,'La Curiosité du Sujet', *Art Press*, Special Issue 4, 1985, 'Godard', pp. 4–18 (5).
25. Rancière, J., 'Overlegitimation', *Social Text*, 31/32, 1992, pp. 252–257 (255).

Chapter 10

LINKED

Graeme Miller

i suppose i'm one of those people that the past's the past and that's that get on with the future

Artist and composer Graeme Miller lived and worked in Leytonstone, East London over a ten-year period. He was evicted from his house to make way for the extension of the M11 motorway. Years later he returned to the area and created a soundwalk, a celebration of the community that was uprooted. What follows is a memoir, a personal narrative, of the experience of making that work. It portrays a landscape peopled with memories, a place into which Miller is 'drawing the listener [and] where they are almost tricked into contributing their own history to link with that of strangers – offering someone a red wire and a black wire to hold, hoping they will complete the circuit'.

L*INKED* is a work 5,000 metres long by 100 metres wide running from Hackney Marshes to Wanstead. It is about that space and inhabits it. Open since 2003, it also positions itself in time, looking back 100 years to the time when the 500 houses, demolished to make the road that now runs there, first appeared in green fields and market gardens. It looks forwards 100 years to the time when the guarantee runs out on its twenty transmitters.

LINKED is a work of extended radio. Its transmitters, positioned along the littoral of the M11 Link Road, broadcast fragments of narrative spoken by the former residents of buildings demolished to build the road. The scale of the work, the labour invested in its making, reflect something of my awe at the fact of anyone else's life, let alone the lives of whole communities. The significance of the local, the unique and the unrepeatable seemed to require a large investment and this despite, rather than because of, the fact that I myself lived in one of those houses for a decade of my life.

159 Grove Green Road was a five-bedroom house built in the 1890s. It had been a chemist's and a doctor's and an artists' studio. Drugs featured in its history. In my years there

just couldn't sit down I don't think I sat down all night I never sat down once all night

it formed part of an ersatz community of artists, squatters and young and marginal folk who inhabited the strip of homes earmarked for demolition. These play-houses formed a ribbon development of furious creativity – strip-bohemia – running through the somewhat proper East London suburbs. The hedges told the story of two cultures – on one side of the street military privet clipped into tight cubes behind brick walls, on the other free shrubs reaching for the sky, tumbling into the road, blocking the windows of houses inhabited by strangers-to-shears.

I eventually bought a pair. Something happened during my ten-year residency.

A lot happened during these ten years. I found my voice as an artist, found partners and lifelong friendships, my son was born and I bought some shears. The shears arrived with a collection of gardening tools in the back room at 159 around the time my son's life drew me into contact with the wider community. The gap between my neighbours and me was narrowing. I sat often in the little office room that looked out across Grove Green Road towards the tiny Methodist church opposite and its church hall. Over ten years on the phone I watched a pair of red-haired twins, who attended the church and played cricket in the garden, turn from little boys to tall men. Words never crossed the road – we never spoke, the church people and I.

1992–1994 were the blight years. The slow violence of steady demolition, only discernible towards the end, and as an aftershock, when they had all been torn down, the imperceptible entanglement of lives with buildings, lives with lives, buildings with buildings, was revealed. It took the steady and traumatic dissolution of the adhesive properties of an inhabited locality to reveal the pathological processes of connection at work. It finally took the erasure and sterilization of one side of the street – my side, the scruffy, impolite privet side – to reveal that one side of the street holds the other in place. This is true of both the buildings and its inhabitants.

When I returned in 1995 to the space, now a deep trench, where my decade of life had taken place, I was unable to fit my recent story into a space that had been scoured clean of narrative time – history. The remaining side of the road, including the church, leaked into space its opposite had once inhabited. It had lost its witness. While not speaking with my more conventional neighbours, they and I had been somehow witnessing each other – triangulating, surveying, being surveyed. These daily actions left a thread and, pathologically, we had been building a web. We had been making each other up. We were co-composers.

st light dead quiet rustling of the leaves animals climbing about birds flapping about chestnuts are coming into fruition all we've got to do is lean out of the pick treehouse pick some chestnuts and cook them over a cooker and you've roasted che for break

The idea of the landscape as a narrative tissue made sense of the insidious trauma felt by the almost daily removal of buildings to the demolition company. They were falling off their rows like teeth in a bad dream. A man leaving Leytonstone station on his daily commute stood agape with disbelief as he looked at the flattened space that once held a grand and decaying house surrounded by mature trees. It was not the simple loss of a building that so upset him. It was the loss of the corner of his journey – it was the corner, the cliff, the bluff and the roost of his narrative and now that narrative was homeless to a degree as he walked back to his own home. Tissue damage.

Break down on the side of a motorway and wait among the shredded tyres for the breakdown people. You will sense the unique lack of history in this zone. Human history has leached out of a place where, although still alive with people and events, no cross-referencing, no triangulation, no witnessing can take place. Too fast – it is a sterile zone. I was told that even though birds hunt and feed along the green banks of motorways they do not nest within a hundred metres. Human histories too.

In December 1994, 30 police and bailiffs broke down my front door with a battering ram and in helmets and body armour stormed the house as we were having breakfast. A day later, as we rescued the last of our possessions we witnessed a machine claw the building to the ground in three bites. It was an end to my decade that left my nerves shredded and my family in homeless disarray. I was nervous of traffic wardens because of their uniforms and didn't want to return to London E11 for months. *LINKED* could have been fuelled by revenge.

In fact it was the idea of narrative ecology that set the project in motion (ok yes with a hint of revenge). It was a revelation of what I had been unwittingly part of – a glimpse back over ten years of my hourly, daily, weekly collusion with the space I co-inhabited, despite my poor efforts at communicating with my neighbours – that gave me the frame to make this piece and an understanding of its function. I would rebuild the houses in words. The words would reside *in situ*. The material of this rebuilding would be with the magnetic or digital husks of spoken words that would broadcast every minute of the year for decades.

It took six years from this decision to make the work until the moment when sufficient funding was in place. There began a series of interviews conducted not by myself, but by a team of interviewers who returned with hundreds of hours of recorded speech. Interviewees were asked to visualize events from their memory, hold the image and report back, in the

roof has come off the library in Leytonstone High Road and books are flying around everywhere

present tense, like someone on the mobile phone in a cinema telling their friend about the film. Many of these present-tense elements ended up in the broadcast. The words often detached from their full context, digitalized and encoded onto special non-volatile chips, retain the power of evocation, bringing into being. These statements – 'I can see John in his trundle-car' – create a persistent present reality in the mind of the listener that confounds their own present, defies what is in front of their noses as they listen on a street corner looking at the motorway. Still somehow John *is* in his trundle-car.

Detached from the interviewees, detached from my neighbours, detaching words and phrases; is it my suburban upbringing that leaves me so semi-detached? Editing and preparing the broadcasts, listening to the hours and hours of material, reducing and reducing to near abstraction I found myself at some point with every piece in a state of overwhelmed compassion – a mixture of grief, panic and awe at the sheer fact of real lives. Strangely by throwing out so much, reducing to fragments, setting at a great distance, I felt I was getting closer to the momentary and fragmentary weave of the lives of others in time and place. It was a rite for the audio butcher staring at the words on the screen, transformed into little mascara-brushes, to be suddenly overwhelmed with emotion for his victims before stitching the body parts together again. It was an almost visceral threshold that signified a transition from history to pattern – a kind of scattering that would continue to pour out through the transmitters ready to implicate the walker and listener as witness.

There is a view of *LINKED* that it is a monument to a community torn apart. It's an understandable, but complete mis-reading.

Many stories of the latter years of these houses are of a community torn together – unlikely alliances, streets re-inventing themselves in the ideal of an East End street. More than that, it seems there never will be a reading of an area's narrative authentic enough to make a monument from it – monument of what? This is not just a question of accurate representation of what a place is like, but a facet of a world in which witnessing, sensing, negotiating space constantly alter that space and make it new. Places are read/write surfaces; we contribute by observing; we are written into them by listening; we are measured by measuring them. The human landscape, acutely complex in cities, is an act of co-composition and *LINKED* was designed to alter the flow of that composition by inviting witnesses into the flow. It might seem that transmitters broadcast narrative outwards, but in a sense they draw it in. The half-finished stories invite completion. I am drawing the listener into a place where they are

light is changing and it's starting to get dark and the television people have gone home and the police have gone home and the security guards are left wondering what they're doing i gu

almost tricked into contributing their own history to link with that of strangers – offering someone a red wire and a black wire to hold, hoping they will complete the circuit. The frayed edges of the motorway contain more bare ends of stories than other, more intricately woven landscapes in the city. The twenty transmitters of the work are there to create a dam against leakage that requires nothing more than a steady trickle of listeners. Like the 1,300 'redbird' New York subway cars, cleaned and sunk to the seabed off the Delaware coast, *LINKED* is an artificial reef. It is there to alter the ecology and participate in the landscape it might seem to describe. It is a cultural structure, there to change its whereabouts over the coming decades in unpredictable ways.

LINKED is a submerged structure echoing the path of the motorway, it is built from the skeletal digital remains of words once spoken by people – words removed from their whole story to become things – part of a steady outpouring of verbal objects charged to make unknown connections spark random acts of faith.

d the whole of London the whole of London
was on fire

and it was burning from and you could smell
stem to stern

and you smell the burning
the burning flesh

and you cold and he was just
feel the heat watching this

and this fire engin
come along

Chapter 11

London Fieldworks: *Polaria* and *Little Earth*

Bruce Gilchrist and Jo Joelson

The work of London Fieldworks is pertinent here for two reasons. The artists, Bruce Gilchrist and Jo Joelson, are open and generous collaborators. Over many years professionals from a great variety of disciplines have been drawn into their projects. Physicists, mountaineers, composers, kite flyers, computer programmers, geologists, writers and architects, to name but a few, have all made significant and influential contributions to London Fieldworks' practice. In this way the very publics that the work is addressing are placed at the centre of the artistic experiment. In some projects London Fieldworks embrace the public still further. A random visitor to the Polaria installation will find that they are not only witness to the work, but a necessary and active component in its completion as Gilchrist remarks 'more importantly for an experiment in the mediation of experience, the process of its making and reception was literally coupled through the physicality of the user'.

L ondon Fieldworks' collaborative and multidisciplinary practice oscillates between an East London studio and the natural landscape. Projects typically engage with the notion of ecology as a complex interworking of social, natural and technological worlds.

Their projects demonstrate a particular mode of engagement that blends aspects of art and science in ways that link a variety of domains of knowledge that are typically kept distinct. In their work, narrative, truth, fiction, scientific data and hypotheses, life stories and ecological histories are intertwined in productive and socially pragmatically useful ways. (Ferran/Ratto, 2007)[1]

In prospecting various sites of production and experimenting with the course of reception, there is often latitude in the way relationship to 'audience' is defined: spectator, voyeur, witness, user. Implicit within this is an interest in problems around intersubjectivity and interrogation of the authenticity of the mediated experience – especially experience of place. This is perhaps significant in terms of comprehending empathy: how can we experience another body as a subject, and not just an object among objects; and by extension how can we empathize with nature?

The two projects cited here, *Polaria* (2002) and *Little Earth* (2005) share a relationship to extreme landscape but are juxtaposed in terms of modes of production and reception. *Polaria* is an example of an artwork that translates objective fieldwork data into an intimate

participative experience. It involved a month-long field trip to north-east Greenland in order to record light and physiological data, subsequently used to create an interactive virtual daylight installation for gallery exhibition. Gallery visitors are regarded as both users and components of the work, 'electrified' by the installation interface in order to trigger the work. *Little Earth* demonstrates multiple collaborations and social and cultural engagement across a variety of spaces and was conceived in two parts: a civic ceremony that twinned two mountaintop sites and the creation of an expanded projection work for a touring multi-channel video and sound installation. The *Little Earth* installation encourages the viewer to become a satellite circumventing the work, while continuing to foster a non-passive form of engagement, an approach adopted for the immersive mode of *Polaria*.

Polaria: A body half open

We are conscious of our bodies drawing in and expelling physical material from the external environment through cycles of respiration and food processing. In this way, there is an enfolding of inside and outside through the physiology of the body. Aspects of the environmental context, through being drawn in, momentarily become indistinct from the subject. The dichotomy of 'out there' and 'in here' is obscured and the porous body can be thought of as something half-open through which the environment flows. As well as physical material we are also open to information in the form of sound and light. We are used to the idea of patterns of light entering the eye and being made meaningful by the mind. Science is still getting to grips with the implications of light channelled from the eye interacting with the biological clock within the mid brain. It appears that our deepest rhythms originate from the sun: light enters the eye and synchronizes the body clock. But not only are we solar-dependent rhythmic beings, science also suggests we are like plants: we photosynthesize. There is evidence that other organs, notably the skin and the nervous system, are also involved in the assimilation of incident light (light reflected from the environment). A neurological connection to light has been substantiated: light entering the eyes is not just for the purpose of vision but is sent to the mid-brain to influence the body's regulatory centres as well as the immune system.[2] The discovery of the non-visual function of light is a link that bonds us with the natural environment.

The *Polaria* project involved the invention of an interactive interface connecting light and physiology and took its cue from the skin's ability to absorb light. *Polaria* is a conflation of words denoting geographical poles, electrical polarity and the solaria from ancient Mediterranean cultures that harnessed light as a curative.

In August 2001, with the help of the Cambridge Arctic Shelf Programme we travelled to Hold with Hope Peninsula in north-east Greenland. A month was spent there experiencing and measuring the 24-hour daylight regime and its gradual transition towards sunset, signalling the onset of winter. We adopted a rigorous methodology that employed instruments (a spectroradiometer and range of biomonitors) in an attempt to 'capture' the arctic light

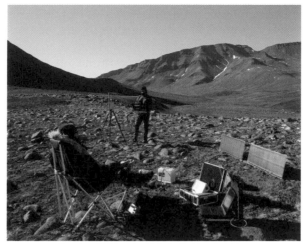

London Fieldworks, *Polaria Fieldwork*, 2001.

and the body's response to it. The artist's body was therefore employed as a sensor. This evoked the ethnographer, Marcel Mauss' notion that the body is our first technology and the Chilean biologist and cognitive scientist, Francisco Varela's idea of the body as portable laboratory, a set of instruments to generate knowing.

The Greenland fieldwork was conducted with a longer-term interest in how we might re-present the recorded data for an audience to experience and interpret. By mimicking

London Fieldworks, *Polaria Installation Interface*, 2002.

methods of applied science we could explore how a reductive method might communicate a sense of place. While making the field recordings we didn't have a conclusive idea as to how we would construct an interface, but there was a sketch of an idea: the installation user would inherit the role of transducer from the artist in the field and, through their own bodily responses, trigger representations of the arctic daylight. In this way a circuit of production and reception would be completed. In the event users of the installation interfaced with a database of the field recordings via bronze electrodes thereby closing an electrical circuit.

This physical and direct connection with the work 'made explicit the idea of the body as technology in itself: both the source and receptor of data as well as its transducer.'[3] The nature of the connection also introduced the experience of being colonized by technology: interaction was invasive and literally flowed through the body of those who chose to engage with it. But more importantly for an experiment in the mediation of experience, the process of its making and reception was literally coupled through the physicality of the user.

In an essay on science and society[4] the critic Frank Kermode is cited as arguing that one of art's greatest attractions is that it offers 'the sense of an ending'. The sense of completeness that can be projected by a work of art is found nowhere else in our lives.

We cannot remember our birth, and we shall not know our death; in between is the ramshackle circus of our days and doings. But in a poem, a picture, or a sonata, the curve is completed. This is the triumph of form. It is a deception, but one that we desire, and require.

Little Earth

> 'The wonder of the world conjured into view –
> By our mediums, the machines.'[5]

The ideas underpinning the *Little Earth* project started to ferment when we discovered the existence of two historic mountaintop observatories in Scotland and northern Norway and two visionary Victorian-era scientists who were associated with them.

As a prelude to the creation of the *Little Earth* installation London Fieldworks approached the Highland Council and Alta Kommune in Finnmark to propose the twinning of the observatories. The former Ben Nevis Observatory[6] and Haldde Mountain Observatory were formally twinned in a ceremony hosted by the West Highland Museum in Fort William, Scotland in October 2004. Both mountains and surrounding communities were represented through a series of speeches and musical tradition central to each culture. Musicians from both places dressed in costumes of the Sami and Gaelic traditions, performed joiks – a sami songstyle, and played the highland bagpipes. The twinning agreement was created by the artists and signed by the keepers of the mountains and the official community

representatives. It exists as both a symbol and evidence of the event. In summarizing the twinning event Nigel Hawkins of the John Muir Trust said:

> John Muir after whom our trust is named, is really the pioneer, the father figure of the modern conservationist movement, and he argued for a holistic approach in the management of wild and beautiful places. That holistic approach is not just concerned with the natural heritage, the natural world, but the cultural, the scientific, the humanistic, and the relationship of people with the land. These ideas come together at the twinning ceremony here today.

Of prime importance was the fact that both scientists in question were conducting observations of atmospheric phenomena in extreme mountain environments. The fact that they relied on naked-eye observation and that their engagement was acutely physical as well as intellectual harked back to an earlier scientific tradition. The outcomes from their work at these extreme sites led to the development of radical apparatus that would impact on their scientific fields and help to usher in the age of modern big science. Scottish physicist C.T.R. Wilson briefly worked at the Ben Nevis Observatory in Lochaber, Scotland investigating electricity in storm clouds and his experiences there would later inform his work on subatomic particles using his *cloud chamber* instruments. The Norwegian physicist, Kristian Birkeland, studied aurora phenomenon at the Haldde observatory in Finnmark, Northern Norway. His mountaintop observations and measurements led to a new understanding of

Cllr. Olwyn Macdonald JP signing the Little Earth twinning agreement, 2004.

solar terrestrial relationships. He built his *terrella* instruments to visually communicate the knowledge that led to the demystification of the auroras. 'While Wilson focused on the subatomic and Birkeland on the planetary, both scientists provided new means for making previously little-known natural phenomena perceptible and understandable to the scientific community'.[7] But for the rest of society, the lay public, the era of big science with its complex instrumentation has perhaps rendered the understanding of nature more remote and intangible through its abstraction and mathematical representation.

We were struck by parallels between the two stories and collaborated with the writer Jim Flint to produce a narrative through which we could play out a fictional dialogue between the two characters. We imagined these figures situated at an historical cusp bridging the romantic and the pragmatic.

'Ideas, mere reflections of man, placed behind the majesty of the everyday operations of matter.'[8]

The dialogue reflected their scientific legacies and formed the basis of a script. This script was eventually narrated over performances that were filmed at both mountain sites. In order to access and spend time at both observatories, London Fieldworks relied on

London Fieldworks, *Polaria Installation*, 2002.

assistance from local people including climbers and mountain guides. As well as helping with the logistics of the video shoots on the mountains, the Norwegian historian and guide Arvid Petterson performed the part of Birkeland, while the Scottish mountain climber and guide Ian Thomson performed the part of Wilson. It was not so much personifications of Wilson and Birkeland we needed to capture, but embodied representations of place. The involvement of these two men (Petterson and Thomson) with their in-depth local knowledge and mountain experience helped to create a dialogue between people, places and events that link ecology, imagination and paradigm shift. 'Rejecting didactic and documentary techniques for the idioms of contemporary music and literature, *Little Earth* is an audiovisual poem reflecting how the last of the *natural philosophers* became the first of the *big scientists*.'[9]

The sculptural form of the *Little Earth* installation was in part inspired by radar installations designed to study earth's upper atmosphere. We spent time on the Island of Svalbard documenting the SPEAR installation for the RSPP Group.[10] This gave us access to radar dishes that we could move around to create footage for Little Earth. We later collaborated with architect Ed Holloway to draw on our source material and realize the design of the installation structure.

Part of Birkeland's legacy can be found in the European scientific project named Cluster – a constellation of four spacecraft flying in formation around Earth that relay the most detailed information ever about the ways in which the Sun and Earth interact in three dimensions. This inspired our visual strategy and the form of the sculptural installation: a four-sided object onto which four concurrent views of a scene are projected and around which the audience are encouraged to orbit in an attempt to take in the whole image. We collaborated

London Fieldworks, *Little Earth* Production Still, Ben Nevis, 2004.

further with space physicists translating data from Cluster into an animation depicting the earth's magnetosphere. This is included in the video work and represents an up to the minute visualization of the Victorian-era scientists' explorations. A representation of machine remote sensing rendered as a mathematical model of the earth that definitively relegates the diminutive naked-eye observer to the dim and distant past.

Francis Bacon, instigator of the scientific method, articulated mankind's thirst for supremacy and violence when he spoke of "'stalked' nature "put in chains" and considered it the task of scientists to "extort its secrets through torture".[11] Conversely, *Little Earth* renders a view of the scientific investigation of nature where mind is malleable and nature calls the shots. We sought to re-introduce human scale into the abstract wake of scientific narrative by re-imagining the mountaintop experiences of Wilson and Birkeland as cognitively site-specific.

London Fieldworks, Fixed 42m UHF parabolic antenna Eiscat Svalbard Radar, Frontiers, 8. 2004.

> Thoughts, as well as species, require particular environments to exist. Can thoughts be considered 'indigenous' to particular landscapes? In remarkable places, the imagination is urged differently. The self emerging from contact with these places is not the same self that approached them.[12]

Polaria represents an extreme distillation of the artists' 'investigation' presented to its audience as a sensory experience without interpretation. Primary experience of *Polaria* requires being at its centre as a transducer, becoming part of a visual image. Secondary experience of the work involves looking at the installation as a container with a person inhabiting it. Primary experience has elicited responses from users that describe indistinct boundaries between public and private space. Seeming to occur at the edges of intellection, some users have reported feeling as if aspects of the self were being exteriorized from the

London Fieldworks, *Little Earth Installation*, Wapping Hydraulic Power Station, London, 2005.

body (in the form of visible light), which led them to question where the private space ended and the public space began. In most cases, the described disruption of the boundary between inside and outside is a disturbing one. Within the framework of *Polaria*, where production and reception are intentionally confused, we understand this 'disturbed feeling' as something brought about by the chasm of mediation. Here we are reminded of the observation of the poet-forester Gary Snyder, 'that's the way to see the world, in our own bodies'.[13]

Notes

1. Ferran, B. and Ratto, M., 'Artists and Scientists as Extremophiles: Extreme Environments and Ecology', MutaMorphosis: Challenging Arts and Sciences. Prague, Czech Republic, 8–10 November 2007.
2. Liberman, J., *Light: Medicine of the Future* (Santa Fe: Bear & Company, 1991), p. 20.
3. Warr, T., *London Fieldworks: Syzygy/Polaria* (London: London Fieldworks, 2002), p. 7.
4. Banville, J., *Essays on Science and Society: Beauty, Charm, and Strangeness. Science as Metaphor, Science*, 281(5373), 40, 1998 [DOI: 10.1126/science.281.5373.40].
5. Extract from the Little Earth script by Jim Flint, in Little Earth: London Fieldworks (London: London Fieldworks, 2005), pp. 32–47.
6. The former Ben Nevis Observatory on the summit of Ben Nevis is a ruin. For the purposes of the video shoot, as a stand in for the original observatory interior, we used the Charles Inglis Clark Memorial Hut (CIC), opened 1929 and situated on the north side of Ben Nevis by the Allt a'Mhuilinn. According to the Scottish Mountaineering Club it is probably uniquely the only genuine alpine hut in the country.
7. Ferran, B. and Ratto, M., 'Artists and Scientists as Extremophiles'.
8. Extract from the Little Earth script by Jim Flint, in Little Earth: London Fieldworks (London: London Fieldworks, 2005), pp. 32–47.
9. Extract from Little Earth Press Release, 2005.
10. London Fieldworks spent time with the Radio and Space Plasma Physics (RSPP) group at University of Leicester documenting the installation of a Space Plasma Exploration by Active Radar (SPEAR) antenna near Longyearbyen, Svalbard (Spitzbergen) in 2004. The collaboration with the RSPP group was supported by the Arts and Humanities Research Board and Arts Council England through the Arts and Science Research Fellowships Scheme.
11. Portoghesi, P, *Nature and Architecture* (Milan: Skira Editore S.p.A., 2000), p. 5.
12. From notes taken at 'Passionate Natures: Ecology and the Imagination'. Conference at Faculty of English, West Road, Cambridge in June 2007.
13. From notes taken at 'Passionate Natures: Ecology and the Imagination'.

Part IV

The Art Object Reaches Out: Dissolves, Embraces

This section considers artists' ever-changing relationship with the art object. Disaffection with the art object is not in itself a new departure. Since the arrival, in the early 1960s, of installation, performance and time-based work into artists' repertoires there has been plenty to knock the art object off its proverbial plinth. Back then those actions and their related formal experiments were often linked to a political desire to undermine the commodification of art. The political drivers are here now too, and artists recognize that, by giving voice to those outside the art community who wouldn't otherwise have a platform from which to speak, they are conferring a greater democratization on the art project.

Chapter 12

A Fair Event: Considering an Action by Nina Beier

Vincent Honoré

In Nina Beier's work we find that the artist's hand is rarely visible. It is the hands – the actions and sometimes the barely perceived presence – of a community of others who make the work manifest. Beier sees each project as an opportunity to challenge traditional structures within the art world: the single, authored work, its antipathy to collaboration, the barriers between private and social worlds are all unravelled. In their place she proposes collective activity where human labour is both the medium and the subject, establishing what Vincent Honoré describes as 'co-presence' – interaction between participants, between participants and publics – process and memory defining the work. Honoré explores the way in which these working methods underpin and reinforce a strong political message.

A simple act of resistance

The Zoo Art Fair, in 2007, provided me with a crucial encounter, which hugely influenced my practice as a curator. Since then, in most of the exhibitions I have organized, I could not help but include some works by Danish artists Nina Beier and Marie Lund. Born in 1975 and 1976, they have been working collaboratively since 2003 but maintain an individual practice in parallel with their collaborative projects.

I didn't know their works. Our encounter came at a time they were maturing some of the strategies at the core of their recent exhibitions – an approach that already governed works such as *Common Objects* and *Reminiscence of a Strike Action*. We could – briefly – call it a strategy of resistance. *Common Objects*, a series conceived by the artists in 2006, are wooden or leather objects designed with a function that is not disclosed to the viewer. They address the difference between intention and reception, and the cultural decoding of objects. As they have declared

> The *Common Objects* can be considered as abstract objects or metaphors for spaces between people. We are interested in the objects as carriers of a meaning or history and with this work we are looking at the space between their intention and their reading.

During the Zoo Art Fair, I found myself bound to a fellow Tate curator, tying up one of the *Common Objects*.

One specific video work attracted my attention: a simple close-up of middle-aged people, an event-based work. Six older revolutionary friends have been asked to keep their eyes closed for 'as long as everyone else does it'. As Ben Borthwick [1] writes,

Reminiscence of a Strike Action is a video about the desire for change through collective action, and a melancholic reflection on the hopes and failures of radical politics. The six participants are cited as 'old revolutionaries' who would have been youthful in 1977, perhaps they are even old enough to have been part of the 1968 fervour. They have to keep their eyes closed for as long as all their comrades. The piece is about trust, but it is a Sisyphean task premised on a tautology that can never result in anything but failure. Even if achieving the result is impossible, the process is itself charged with desire and possibility. As much a reflection on the failed aspirations of utopian politics, it highlights the commitment to a set of values that once held utopian promise even if the possibilities seem exhausted and the ways in which a set of actions at a particular moment – by revolutionaries or artists – unfold over time and *might* just have unforeseen consequences.

The same year (2007), Beier and Lund produced another video work that can be seen as the counterpart of *Reminiscence*: *Les Sabots*. Again the work is based on an event. One can see a very minimal act on the black and white video: young people are gathered to make a face towards the camera for the duration of a roll of film. The video alters the tradition of the photographic group portrait, by adding a temporal and generational layer of criticism. The individuals gathered for the work are all children of the '68 generation. The title refers to the semantic French origin of the word sabotage. By making a face to the camera, the group sabotages the photographs, creating an act of resistance to the ideal representation of the group. The face however seems a weak rebellion compared to what the previous generation, their parents, did: the video eventually questions the possibility of carrying the political contestation and its transmission.

I included *Reminiscence of a Strike Action* in a group exhibition I curated in New York, *From a Distance*. The show gathered artworks and events which encapsulated a certain narration and resistance to its transmission. For this exhibition, Beier and Lund proposed a second work: *All the Lovesongs*. The object consists of two speakers, joined together, face-to-face, and a song that symbolizes a past, broken relationship, muted by the 'closed loop' of the speaker cabinets, plays continuously. The work transforms communion into confrontation. As is often the case, a form is reworked, transformed and mutates into another work expanding and adapting on the way. This particular work, one of the first in which the artists use sound as a tool for transmissions and alterations, can be traced as the origin of an installation they show in the exhibition *Past-Forward* in London in 2008. *I wrote this song for you* is based on an event consisting of eight recordings, shown as an installation with eight speakers. Each speaker emits a tentative version of the same song, a love song written by a young songwriter but never released. Upon hearing it for the first

time the participants were recorded singing along to it. Following their own assumptions of the song's melody and words, the various singers reflect different takes on the generic language of love songs. Somewhere amid the eight different attempts at conveying the song, the original can be discerned. The work explores the mechanisms of interpretation, the links between objectivity (the score written) and subjectivity (the eight different interpretations), and the 'infra-thin' structures of perception.

The medium and the message

These works are symptomatic of an in-depth research into the idea of resistance, applied to the very act of transmitting a meaning, a historical moment, a form and its alterations. The strategy had of course many links to a certain political background, but remained mainly formal and playful, addressing political transmission more in terms of education and generations. When I invited Beier and Lund to show their works at the David Roberts Art Foundation, a not-for-profit foundation based in London, we already had a somewhat dense history of collaborations. This can help artists to propose some projects more freely. They immediately replied to the invitation, writing: 'Hierarchical structures and their multiple forms of resistance together with their emergent productive processes within an artistic framework are the themes or rather challenges that this exhibition wishes to address.' The exhibition resulted in a process where the originally invited artists invited other artists to gradually replace their works. At the end of the process, Beier and Lund's presence was almost imperceptible, erasing both the original situation, resisting the project of the hosting institution and originating the artwork in a collective venture.

This project, entitled *All the Best*, coincided with the Zoo Art Fair where Nina Beier (this time on her own) had been commissioned to create a performance. The work, *All Together Now*, required the collaboration of all Zoo Art Fair's interns. They were asked to whistle (or hum) the *Internationale* (the socialist workers' anthem) when performing tedious tasks during the installation, public opening and de-installation. In her proposal for the work, Nina Beier [2] wrote:

> I would like to ask the interns to whistle when it feels remotely natural, when they are in their own thoughts preparing things. They should do it with authority, as something they would do while working at home, and only do in a public space if they feel very much at home. They can do it together or alone, but it should be privately instigated and it is important that it is not performed as entertainment for anyone. It can take place even behind closed doors if they are working in the office or the storage room, or it can be quietly done with backs turned, looking down, etc.

This performance in some ways is in dialogue with and completes the performance Beier, together with Lund, staged in Zoo Art Fair in 2007. In *The History of Visionaries*, a young,

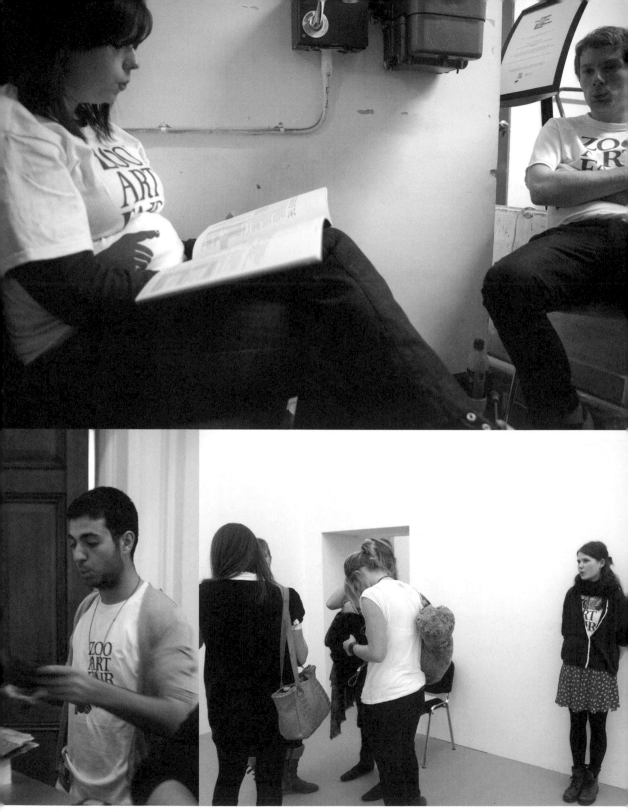

Nina Beier, *All Together Now*, Event, 2008

newly reformed socialist is paid a salary to be present at different times throughout the exhibition to discuss his conviction with any person who might approach him. The acute visionary conviction points towards an idealized past, as well as visibly pronouncing the agency for times to come. So as the title *History of Visionaries* indicates the character contains both the history of all the ideologies and theories thought out before him, and maybe their failed attempts to make their mark in society, and the unquestionable conviction that is needed for ideas to be developed. By leaving any exchange up to the visitors, the idealist's presence in the exhibition creates a tension: the intrusion of an external element in an art situation (the political activism) and simultaneously the use in an artistic context of political idealism.

De-building

Zoo Art Fair, like many art fairs, could not happen without the army of interns it uses to organize, monitor, invigilate, install, etc., etc. the event. They are unpaid, highly qualified young workers, often travelling to London and working for the fair for what is called a 'rewarding learning experience' which commonly ends in standing for hours in a cold corridor, watching the art people sipping their glasses of champagne. Much of the so-called creative industries are supported by a cadre of people working for free. Where an internship was conceived as a short period of gaining work experience prior to paid employment, extended periods of internship, free or poorly compensated labour – often supported by precarious work in the service sectors – has become the norm.

Beier selected *The Internationale* (*L'Internationale* in French) as it is the most famous socialist song; one widely recognized around the world, translated into many languages and immediately recognizable. The original was written in French in 1870 by Eugene Pottier (a member of Paris Commune). It was originally to be sung to the tune of *La Marseillaise*, another revolutionary anthem. Pierre De Geyter wrote the score in 1888, which soon after became the song not only of communists but also (in many countries) of socialists or social democrats, as well as anarchists.

The performance infiltrated the whole experience of the fair: the many unnoticed interns working there were suddenly activating a humble, somewhat desperate, often invisible (lost in the crowds) but penetrating, haunting and radical gesture. It must be stressed that the event was also directed not only to collectors, curators, artists ('professionals') or the general audience, but also to the gallerists, the fair's managing hierarchy and the interns themselves, as they were asked to perform even in the hidden parts of the fair or during de-installation, for instance. This innocent yet contagious act infiltrated both the soundscape and the visitors' mental space, finding themselves adding the lyrics in their minds or maybe even humming the song on the way home. The act in its manifestation (solitary unnoticed worker whistling on his/her own) refers as much to the political movement as it does to more general work songs and even, to a certain extent, to slave songs.

As some working conditions become more compulsory in tandem with an economic downturn, the precarious nature of cultural workers can in certain respects be conceptually and strategically aligned with other service providers. However, and despite this political and social background, the performance still bears, because of its lightness, some humour (in contrast to most of the performances by Santiago Sierra, for instance). The work is full of casualness and humanity. Let's not forget, after all, that the interns working for free at Zoo Art Fair are usually studying art, well educated and most often from a bourgeois if not wealthy background. The event simply stressed the paradoxes and contradictions of the situation in which it takes place. Beier [3]declares:

> Our work tends to push the contexts in which it exists. This is also the case when we do sculptural work or situation-based work with specific groups of people, so when producing work directly for the exhibition framework we usually can't help ourselves commenting on that in quite a direct way.

It is in a playful de-creation of a given context, as Beier experimented with Lund for their exhibition *All the Best,* that the event finds its strength. It follows what Giorgio Agamben [4]declared in a lecture on *International Situationism and Video Work*:

> One cannot consider the artist's work uniquely in terms of creation; on the contrary, at the heart of every creative act there is an act of de-creation. Deleuze once said of cinema that every act of creation is also an act of resistance. What does it mean to resist? Above all it means de-creating what exists, de-creating the real, being stronger than the fact in front of you. Every act of creation is also an act of thought, and an act of thought is a creative act, because it is defined above all by its capacity to de-create the real.

More than a construction, the event indeed exists in a de-construction of an existing status quo, structure or mechanism. It is powerful because it is unveiling the paradoxical source or basis of the given structure: the fair, dedicated to rich collectors, would not exist without unpaid labour. This is also why Beier uses the *Internationale*: she is using an existing form that had been created at the start of international worker movements and socialism.

The performance succeeds in raising multiple and complex concepts, with somewhat minimal means: notions of space and time, the inseparable relationship between observer and observed, relativity and multilayered physical and conceptual reality. The work proposes a deep, rich and responsible implication for signs and roles in the social world. *All Together Now* draws attention to the behavioural processes linking thinking and doing. It addresses multiple degrees of human freedom in the relationship between private and social worlds, recalling the phenomenological studies on the body as a performative instrument in the world. Exploring the nature of existence, the artist engaged an exploration of human labour as a material condition that can potentially produce meaning. The simple gesture of whistling or humming recalls codes of memorial, visual and social representation communicating in

dense, simultaneous and multiple modes, and has more impact than the immediacy of the image or the linearity of the narration. The work uses active bodies as a conscience emerging into the world, suggesting a re-appropriation of the human condition and reformulating the intersubjective conditions which enable us to rethink the social environment. In the context of a commissioned artist for an art fair *All Together Now* proposed an original model of rediscovery of the transitory value attached to actions and objects. It gave an alternative structure to the performative game, as much for the actor of the performance as for its audience: the problems of the Being (static objects) and the Becoming (acting subjects) fluctuates between audience and performers, opening a moving grid of questions/answers, actions/reactions…Hence, the action which only exists in a social context (the art fair) persisted in a lived space (memory).

You say: the real, the world as it is. But it is not, it becomes! It moves, it changes! It doesn't wait for us to change…It is more mobile than you can imagine. You are getting closer to this reality when you say as it 'presents itself'; that means that it is not there, existing as an object. The world, the real is not an object. It is a process.[5]

That is where the potential stands. The group of performers, without denying the individual freedom (interns are free to whistle or not whenever they want) generates a considerable force or productivity. One of the social dimensions of this performance, which draws a distinction with other performative or visual artistic practice, is the issue of the co-presence: the subject to subject relation in the exchange of information, where Beier succeeded in making it simultaneously, social, sensible and historical by her clever understanding of the situation and careful formal choice. This intersubjective aspect is what establishes the deeply philosophical and political nature of this work.

Notes

1. « Isn't Punk Brilliant ? », pp. 111-112 in Past-Forward, edited by Vincent Honoré, Zabludowicz Art Projects, London, 2008.
2. Nina Beier, unpublished : note for Zoo Art Fair project
3. Nina Beier, interview with the author
4. « Repetition and Stoppage – Debord in the Field of Cinema », Giorgio Agamben, in In Girum Imus Nocte et Consumimur Igni – The Situationist International (1957–1972), JPR-Ringier, Zurich, 2007
5. John Cage, quoted by Chirtopher Shultis in « Silencing the Sounded Self: John Cage and the Intentionality of Nonintention », Musical Quarterly, Oxford University Press, 1995.

Chapter 13

Case Study Three. Gillian Wearing *Family History*

Helen Sumpter

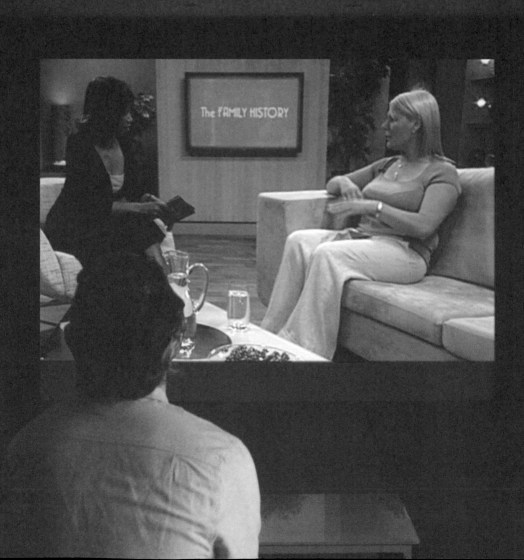

Throughout her career as an artist Gillian Wearing has created opportunities for so-called ordinary people, often working class, to reveal something of themselves. Since she was a teenager, she has been fascinated by reality TV and its similar capacity for exposure. This case study looks at the relationship between the artist and Heather Wilkins, her collaborator for Family History, *to reveal the impetus for this way of working and to understand how the film intertwines a biographical survey of the collaborator with a partial autobiographical portrait of the artist.*

The Project

F*amily History* (2006) was a joint commission between Artists in the City and Film and Video Umbrella, in association with Ikon Gallery. It took the form of a two-screen video installation which explored the nature of celebrity and reality television, through the artist's personal response to the first British fly-on-the-wall documentary series, Paul Watson's *The Family*. The original documentary featured the daily life of the working-class Wilkins family from Reading and was first screened on BBC1 over a twelve-week period in 1974. One of the central family members was fifteen-year-old daughter Heather Wilkins. Although the ten-year-old Gillian Wearing was five years younger than Heather, when she watched the programme from the front room of her Birmingham home, it was the feisty teenager Heather with whom the artist most identified. A major part of Wearing's installation was an interview with Heather, then in her late forties, conducted by daytime TV presenter Trisha Goddard and filmed in a TV studio set-up. In it Heather speaks about her current life and some of the issues raised for her personally and more generally by the original documentary. *Family History* was first shown in an empty flat in the then new Forbury Hotel Apartments, in the centre of Reading, and is accompanied by a hardback publication.

The Artist's Experience

Gillian Wearing's photography and video-based work often uses a documentary approach to uncover aspects of individual identity, expression and disguise, and in so doing investigates the nature of the documentary format itself. Early works include *Confess All on Video*

Left: Gillian Wearing, *Family History*, 2006, installation view, Forbury Hotel Apartments.

(1994), where respondents to an advertisement in *Time Out* magazine were invited to make confessions on camera, while masked; and *Sixty Minute Silence* (1996), where actors dressed in police uniform are seen in real time, posing as still as possible in a group photograph, for the entire duration of the work's title. In the more controversial three-screen installation *Drunk* (1999) Wearing filmed a group of hardened street drinkers in her studio, in various states of inebriation, whom she had got to know over a period of several years. Her later work has become more autobiographical and includes *Album* (2003) where the artist was made up to resemble other members of her family to recreate existing family snapshots. She was awarded the Turner Prize in 1997.

How did you come to work with Heather Wilkins?

I had been commissioned to make a project for Reading and had always cited *The Family* documentary as one of my early influences. Steven Bode from Film and Video had mentioned that Reading was where the family came from, so I thought it would be a great opportunity to make a project on this. Heather was approached and from the outset she was very interested in taking part. I had lots of different ideas initially – to film in Heather's house, or to make a straightforward documentary. I hadn't thought about doing a television interview until I realized that I wanted to include something about my own experience of the documentary and how it had affected me.

How much did you brief Heather on the interview?

I only had a very short meeting with Heather beforehand. At that stage I wasn't thinking of a television chat show style film, but felt it would be more of a straight interview. After researching Heather's television history I saw that she had been on *Wogan* several years after *The Family* had first been on television. It had been like a catch-up programme and I wanted to have a similar style of film – a friendly TV environment that echoed a living room, where you could ask questions that you would in a documentary, but in a more relaxing way, as if a friend was talking to you. Obviously Heather knew that we were going to be talking about *The Family* and her life now, and when we eventually told her that Trisha Goddard was going to be the interviewer she was very excited. Trisha's team put in a phone call to Heather to ask some questions but I was not privy to that. When I went over the structure of the questions with Trisha Goddard she said she would 'Trish-ify' them, adapting my questions to her style, which would be familiar to Heather, having being a viewer of her programmes.

When working with the public how do you feel about issues of authorship and ownership?

It's always something of a contentious issue when people talk about collaborations – 'collaborative element' is a more appropriate term. When you are the director and you are making a film you have to have an idea and a structure – that's your worry, your concern and your artistic vision. You start with the idea so you already have an image, although that tends to evolve over time. What changes the work is the unexpected nature of what

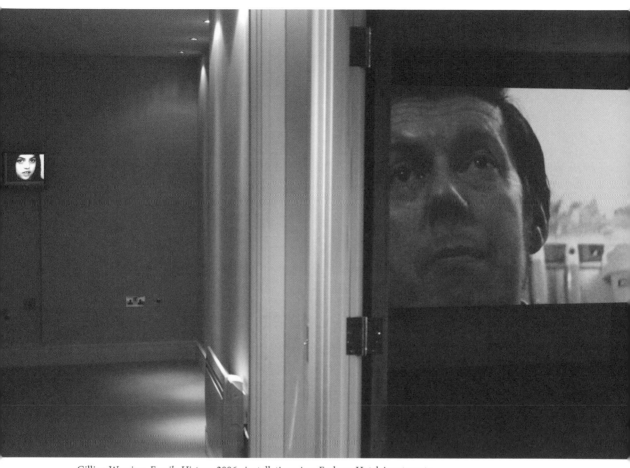

Gillian Wearing, *Family History*, 2006, installation view, Forbury Hotel Apartments.

people say or the choices they make within that structure. Depending on that structure, the collaborative nature may be small or large

How do you deal with issues around consent?
I always ask permission to film people. The only observational film without individual consent is *Broad Street* where I filmed clubbers in Birmingham from a distance. With *Drunk* where I worked with street drinkers several people questioned how I could get consent if the people were drunk, but I thought that was a bit patronising, as if the people had no ability to understand anything. I had gotten to know the drinkers over two years and had been with them both sober and drunk. What you got from these people was their complete honesty about their situation. They would constantly talk about what it was like to be drunk and to be part of a community of street drinkers. They all gave their consent both during and after the filming.

Why do you choose to work with the public in this way?
It's partly about giving people a platform to reveal things that otherwise no one would know existed. In the generation that I grew up in, only a minority of people's voices were ever heard on television, which was part of the revelation of the *The Family*, because they were working class. Also you can never second guess what people might say, or what their life might have been. The things that are uncovered when people are interviewed could never be scripted, which is part of the success of documentary and reality television and my interest

Gillian Wearing, *Family History*, 2006.

in it. Of course things can go horribly wrong but that mainly happens if the idea isn't good enough. It's about asking the right questions and having a structure that's interesting enough but at the same time isn't too narrow to kill any spontaneity.

The Participant's Experience

Heather Wilkins came to the public's attention aged fifteen, as the youngest daughter of *The Family*. Heather's behaviour only revealed the ups and downs of a typical teenager, but because this had not been shown in documentary format on television in this way before, the press reaction she and her family received was often negative. She was interviewed about her experiences as a major part of Gillian Wearing's film installation *Family History* (2006). Now with a family of her own, Heather runs a hairdressing salon outside Reading city centre.

Why did you decide to participate in *Family History*?
I was a bit taken aback initially because I'd had no involvement in art before, but after my first short chat with Gillian I felt that this could be something really good. I did some research into Gillian's art and thought that her way of working was really interesting and that this would be a project of substance. As a family we've lived in Reading nearly all of our lives so I felt that it would also be good to do something that was for the development of the town, as well as to have the opportunity to perhaps put some things straight about my feelings on the original documentary, for the benefit of my own family.

How was this experience different from other interviews you have done about *The Family*?
When I've been interviewed in the past by journalists, I tend to be asked factual questions about how the programme was made and not about how I felt. And if I was asked if there were certain aspects of the documentary that I didn't want to talk about, and I told them what they were, they would still ask the questions anyway. Working on this project I felt that my feelings and considerations were taken into account at all times. If people aren't considered in this way they may feel that their contribution wasn't that valued or was just plonked in. But I was kept informed about all aspects of the project and the interview and I felt that everyone, including Trisha, went out of their way to ensure that I was happy with what was happening.

Do you feel that *Family History* is in any way your project?
In a way I do because I felt so involved making it and still feel incredibly proud to be part of it. I had very positive feedback from my family too who felt that they had seen another side to me. I felt that I had been part of something that would make a difference, that was worthwhile and that would have a long-lasting impact. I'm sure that they would have made an equally interesting project with a different subject but this project wouldn't have happened without me and I still feel that taking part in it is one of the best things that I've done.

Chapter 14

An Audience with...

Adam Sutherland

This essay takes an entire programme of activity as its subject. Grizedale Arts in Cumbria has been committed to public art for over 30 years, but it is the approach they have taken since 1999 that is most relevant here. Adam Sutherland, the present Director of Grizedale Arts, believes that art has the capacity to influence social change and under his directorship the curated projects have become extended conversations between ideological positions within defined programme themes. Inspired by the aesthetics and interests of participants rather than the refined interests of the artist he discusses the way in which Grizedale Arts initially encouraged artists to express ideas drawn from the community in which they were placed and subsequently to foreground work where the participant not only created and directed the work, but ultimately became the work.

Since 2000 Grizedale Arts has been involving people in a broad range of the work made on the artist residency programme. This approach was seen as the most effective way to develop an audience in a remote location where the existing audience was principally interested in traditional formal art activity. The programme, acknowledging the particularity of the location, increasingly attempted to 'make itself useful' within a local community while retaining and developing a relationship with the contemporary art world centred in a few international urban locations. The arts organization and artists have had to exploit the benefits of working in this uniquely rural/urban, cosmopolitan/parochial conundrum. Attempting to generate benefit in both contexts, it offered the 'exotic' to both communities – the village halls and Women's Institute culture to the art audience and the complexity of contemporary cultural theory to a rural community.

For artists and the art world the benefits are clearly articulated in the increasing interest in folk art, the environment, nature-based imagery and small culture. This access to the rural resource is evident in the careers of many of the artists that have developed projects at Grizedale. The benefits to the local community are more difficult to identify as they are hard to measure and of a longer-term nature. Certainly there are many arts projects that have initiated ongoing activity, for example the Coniston Water Festival thrives, originally initiated by a Grizedale collective endeavour. The Grizedale programme has spawned a host of local arts activity, most of it missing the point and in many cases doing the very thing that the original programme was trying to challenge, i.e. the tourist economy.

Looking at the history of the Grizedale forest programme there is a clear distinction between the establishment of the public art programme, the process of placing work by

artists in the public, albeit rural, space and the engagement by artists with the communities that inhabit and use that space. The first period coincided with the establishment of public art as a genre and early work at Grizedale led the movement from the late 1970s. This programme largely failed to develop and was quickly eclipsed by the urban version. The Grizedale programme maintained its initial approach for over twenty years before a new (to Grizedale) emphasis was introduced in 1999.

The early period of the 'new approach' at Grizedale (1999–2003) by artists like Pope and Guthrie, Juneau Projects, Anna Best, Marcus Coates and Jordan Baseman engaged with people and communities, recording, documenting and presenting work for exhibition. In the case of Jordan Baseman this took the form of short films, generated through lengthy interviews with relatively randomly encountered people. Baseman set up camp on the periphery of the Lake District (and to some extent society) at lay-by food stops and the homemade Banger Racing track in Barrow. He then edited the footage to form coherent narratives and to present an analytical perspective on the participants and the culture they represent. The resultant films offer a brilliantly poignant portrait of contemporary Britain but a portrait of the individual that in some cases the participant was uncomfortable with and that in some instances alienated the exhibition audience. In the same way that nascent reality TV had begun to evolve, there was a way that these films could be seen as 'using' the participant.

In the case of Marcus Coates the work portrayed a fictional 'member of the public' – a character designed by Coates to illustrate his ideas about man's relationship to nature and existence. You cannot really describe this work as engaged but its subject was certainly the spectator – the audience. And this work marked a clear ambition in the programme to know more about the audience, finding the whys and wherefores of the audience/spectator to be the most interesting component in the broader context of the place – rather than the natural beauty that had previously been the inspiration to writers and artists from William Wordsworth to Kurt Schwitters.

As the Grizedale programme evolved the curatorial team (Adam Sutherland and Jenny Brownrigg) increasingly looked for artists who were foregrounding the participant and allowing them to create and direct – ultimately to be the work. The work of Nina Pope and Karen Guthrie exemplified this approach, establishing a framework and foregrounding participants' interests. Again the ambition of the artist and the ambition of the participant were different, but they acknowledged one another. The artists, exploring identity and drawing a cultural breadth and relevance to the 'material', acknowledged the wider creative impulse and placed that creativity alongside the lexicon of art, stating that this constitutes what we should think of as art. For the participants this was a means to an end and an end that they wanted to achieve, hence the committed involvement required for this kind of project to work. Alongside the successful participatory projects other types of public engagement

Left: Juneau Projects, *Like A Wayside Shrine* - Honesty stall for Toge Village, 2006.

continued the rather flat finger-pointing approach, the identification of interesting bits of culture, backwaters and eddies – the 'this is interesting and you should look at it' concept, which in reality is not very different to the 'look what I've done' tradition. Through the evolution of artists' projects, and the particular context of working in a rural and non-art setting, the Grizedale programme evolved further, bringing a committed body of artists to work on projects of public benefit, but benefit as likely to be identified by the participant as by the artist.

This approach was further evolved through a collaborative process between the organization and certain key artists involved and committed to the programme. Projects such as *Cumbriana Proof* and *Let's Get Married* took the emphasis away from 'art events' and integrated artists into 'real' events and activity with all the related risks and implications of impacting on people's actual lives rather than their use of leisure time. The role of the audience became increasingly important. As participators and leaders of the projects, they helped develop ambitions, strategic thinking and decision-making among the participants and consequently within the communities.

The most clear-cut example of this approach was *Seven Samurai* (2006), a project which resulted from an invitation to take part in the Echigo-Tsumari Triennale. Grizedale Arts asked the Triennale organizers to solicit an invitation from a community, or rather to find a community that needed help and could articulate that as a specific request. The community that came forward was a small agricultural village of 60 older people who identified the growing number of tourists visiting their village as a problem – a problem generated by the Triennale itself. The village wanted to find a way to enjoy a better relationship with these visitors, they wanted to know who they were and why they wanted to come to their village and they wanted to tell these visitors who they – the village – were and what their concerns were. The village was also convinced that the current generation was the last there would be and the village would vanish back into the land after their deaths.

Seven artists undertook as a group to address this request and lived and worked in the village for a month. The ambition was to find ways to help the villagers take control of their future and to make decisions about how they presented their village and the kind of relationship they wanted with visitors. The group evolved a series of engagements with the villagers, many of them portraits (in the broadest sense) of the individuals. Ben Sadler of Juneau Projects made an audio recording of many of the villagers singing or telling stories. This was presented as a CD and sold alongside other village produce and artist projects in an honesty stall sited at the main tourist viewpoint in the village. The CD gave visitors an insight into the village and the stall provided a simple point of access controlled by the village giving as much or as little information to passing visitors as they wished. The stall alone would not have had a great deal of impact but in conjunction with several other projects they aimed to transform aspects of the villagers' lives – for example one group set about rebranding the principal product of the village, rice. In conjunction with the villagers a design for packaging and an online shop were created to allow the rice to be sold direct to the public thereby vastly increasing the profit margins but perhaps more importantly giving

Toge village sing their village love song at the Ikebukuro International Arts Festival, 2006.

Marcus Coates, Answering the question of illegal bicycle parking for the Ikebukuro International Arts Festival, 2006.

a sense of pride in their product and a direct connection with the consumer and people outside the immediate community. The artists also organized for the village to take part with them in an arts festival in Tokyo; the programme aimed to promote the rice through a farmers' market style event and a series of art performances. The combined programme of projects had a considerable and lasting impact on the village. I think you could confidently say that it changed the village and the morale of the people. There was a sense that there were ways for the village to continue and that another generation might choose their way of life. With this and other programmes of work Grizedale sees the most important element of these projects as the legacy – what happens as a response to the programme. In most instances where this strategy has been tried (*Creative Egremont* 2006 and *Cumbriana Proof* 2005) the communities have taken on the ambition and intention of the programme and devised their own delivery, in most instances far removed from the artists' aesthetics and language but with elements that have the same intent – often alongside very contradictory motivations.

The components of these projects are still in many ways traditional artworks but as a composite body of material they become something else, a means to an end – art as a driver for social benefit. The legacy and longevity of the project belongs to the participant even in the instance of the artist being able to extract a saleable product from their work. At the end of the period of stay in the village there was a meeting between the director of the Triennale, the village leader and the Seven Samurai. The village leader told the Triennale that they did not want to take part in any future art projects where the artist made art to be appreciated or where the artist made them make work to be appreciated. They only wanted to work with artists where they were able to participate and direct the projects, projects that were of benefit to them and their community.

Chapter 15

Bata-ville: We Are Not Afraid of the Future

Nina Pope with contributions from Mike Ostler

It is not surprising to realize that Somewhere, the multidisciplinary company founded by artists Nina Pope and Karen Guthrie, has been an occasional contributor to the Grizedale Arts programme featured in the previous essay. Each of Somewhere's projects is built around a particular group of people. These collaborations may result in a film, a live webcam, a performance, a planted landscape, and they are valuable demonstrations of Somewhere's practice but they are just one element of the overall project, and in each case the artists' interest is in the process which unlocks many different experiences and engagements with audiences both inside and outside the work. The communities who contribute to their work can be defined geographically as in the case of the What Will the Harvest Be? *– a garden project in Newham, East London, or they may be identified by the work place, as in* Bata-ville: We Are Not Afraid of the Future *which is discussed here. The narrative does not derive from the artists, but is inspired by the working lives of the people in an East Tilbury shoe factory.*

Bata-ville *the film is a Somewhere project by Nina Pope and Karen Guthrie co-produced with Commissions East and Illumina Digital Ltd. It is a bittersweet record of a coach trip to the origins of the Bata shoe empire in Zlín in the Czech Republic. Against the backdrop of regeneration in their local communities, former employees of the now-closed UK shoe factories in East Tilbury (Essex) and Maryport (Cumbria) are led on a journey that begins as a free holiday but soon becomes an opportunity for a collective imagining of what entrepreneur Tomas Bata's maxim 'We are not afraid of the future' means for them in twenty-first century Britain. Inspired by the contrast between the idealism of Bata and the more recent industrial decline of East Tilbury and Maryport, host/directors Pope and Guthrie lead this unorthodox coach party on a journey through Bata's legacy.*

Bata-ville, "Bon voyage" party, 2004.

The following is based on a transcript of a presentation by Nina Pope (artist/director) and Mike Ostler (Bata-ville passenger) at the Searching for the Spectator symposium at University of Reading in September 2007.

NINA POPE

Rather than reading a paper I'm going to give you a bit of an introduction to the *Bata-ville* project and show some of the documentary feature film that was the final outcome. Then I will hand over to Mike Ostler who is one of the stars of the film or one of the '*Bata-ville* passengers', as they are otherwise known. I thought it would be interesting in the mix of presentations today to hear from someone who is actually part of one of the projects. To start with I am going to play a short extract from a conversation between Karen Guthrie and myself (the two directors of the film) – you can find the full clip on the project website: http://www.bata-ville.com/.

(Film clip:)

NINA POPE
...Bata-ville *is a sad film about optimism...*

KAREN GUTHRIE
...*it's a film about shoes...*

NINA POPE
…it's in some ways about Bata, a very strange company…

KAREN GUTHRIE
…it's film about old people…

NINA POPE
…on a bus trip….

KAREN GUTHRIE
…it's a film about four towns that nobody has heard of…

NINA POPE
…one is East Tilbury on the Thames estuary and the other…

KAREN GUTHRIE
… is Maryport in West Cumbria, which is the bit that no one has heard of…

NINA POPE
…and the town we travel to is called Zlín in Moravia in the Czech Republic…

KAREN GUTHRIE:
…via a place called Best, which is in the Netherlands, which is also a place which nobody has heard of!

KAREN GUTHRIE
It is essentially a road movie. We go somewhere and find out about people on the way there and when we get there we do some left-field sightseeing and discover something about those people's past histories. I suppose our roles are as the hosts of the passengers, in a way like travel agents, though as we get to Zlín our role changes a bit and we pursue everyone we meet with a series of questions which come from our interest in Bata and Thomas Bata's ideals. The question 'Are you afraid of the future?' – it's a really direct, gauche question that we raise. It comes up again and again in the film and comes from a Thomas Bata speech and the history of the company.

NINA POPE
Bata-ville *evolved out of an interest in East Tilbury. I was invited by Commissions East on behalf of Thurrock Council to make a work for East Tilbury. It had to be done very quickly and it had to make an impact in the town. There is lots of regeneration money being pumped into that area and I thought it would be funny to take people on a 'free holiday' which showed them something about the origins of where they lived. East Tilbury looks like a mini version of*

191

East Tilbury today – *Bata-ville: We are not afraid of the future*, production still.

Zlín – the original factory-town of the Bata empire – and we wanted to take people from East Tilbury off to this place, which was potentially a twin town for their newer version on the edge of the Thames. East Tilbury is a very surreal-looking place.

KAREN GUTHRIE
The factory in Maryport had a very different trajectory to East Tilbury. We found that though shreds of the building still remain, it had been shut since the mid-1980s. There were never any houses constructed for the workers so in terms of its impact on the town it was more about the sheer volume of employment.

NINA POPE
Making this project was a kind of experiment, as lots of our work is, in this case to see whether we could have an impact on arts and regeneration. We started from a very cynical viewpoint as to the value of art and regeneration projects and the way they usually occur. There is a lot of money pumped into placing objects that nobody really wants, or artists prophesising about an area that they don't really know anything about, and hopefully Bata-ville *is neither one of those things.*

(clip ends)

NINA POPE
So that is a short introduction to the three places in the film: East Tilbury, Maryport and Zlín. Now I'd like to say something by way of an introduction to the people in the project.

Archive image of Zlín.

We took 45 passengers on this trip and we made a documentary on the way. It's not really a film about Bata as such; it's more of a record of the journey made with this particular group of people. The group on the bus consisted of people from East Tilbury, people from Maryport and those affectionately known as 'the others' – who turned out to be a bizarre mix of writers, filmmakers and artists. Everyone had to fill in an application form to be considered and say something about what they would contribute to the journey; these 'contributions' could take any form and we'll see in a moment how this manifested itself during the trip.

During the week we followed the locations and activities we'd planned which involved visiting all the different places in Zlín relating to Thomas Bata – this in turn generated the script for the documentary. The journey finished with a party organized by all the passengers on the bus, which they put together to celebrate their visit to Zlín, and they invited all the people they'd met. So that is the 'structure' of how the film was made. The film was always an important part of the journey and we knew from the outset this would be the final way that the work was distributed. The decision to make a film for this context reflected our growing frustration with working on live or web-based projects, where we felt some disappointment with the way that the work engaged with the audience, not with the people who were directly participating in the projects and experiencing them, but with the partial way that an audience outside of the projects were able (or not) to experience them. So, we were frustrated with running large-scale projects, involving months and months of work, and in some cases only reaching a very small live audience on the day, outside of the direct participants. For example our project */broadcast/ (29 pilgrims 29 tales)* for Tate Modern happened to take place outside on a freakishly hot day, seriously reducing the audience for

Bata-ville – film still, visit to the Best Bata shoe factory.

a project which we had developed over several months working in close collaboration with the 29 'participants' who were at the centre of the work.

So with *Bata-ville* we were determined to document this journey and bring it to a wider audience – which we did by showing it worldwide in film festivals including the premiere at prestigious Edinburgh International Film Festival. Perhaps even more importantly for us, it's distributed (by Somewhere) on DVD, and sales continue at a steady pace which reflects a 'long tail' audience for the work, who are able to experience it very directly in their own homes. It is an interesting way to work which provides for us much more of a 'translation' of what happed during that week than a gallery exhibition may have done.

This is a short clip from the film, on our way to Zlin just after we have been to a Dutch factory – one of the last working Bata factories in Europe. For some it was quite an emotional experience as they saw machines doing the jobs they used to do by hand back in the United Kingdom…

(Film clip:)

ANNE OSTLE (PASSENGER)
Their factory where the shoes were made, when I got there, all they were doing were putting the soles on and I was very, very disappointed because I wanted to see the shoes we used to make – both me and Stella we used to sit and stitch at the binding machines, vamps, toecaps right down the whole shoe, but there (in the Best factory) there was nothing to see…

Archive film still.

STELLA MCCRACKEN (PASSENGER)
We all loved working at Bata and if it was re-opened now I would presume that nine out of ten would go back…

NINA POPE
Now I'd like to introduce Charlie Harsant who is going to show (on the overhead bus monitors) some of the films he made in East Tilbury for Bata back in the 60s…

CHARLIE HARSANT (PASSENGER)
…ladies and gentlemen my name is Charlie Harsant as you have just heard I was the advertising and display manager for Bata shoe company at East Tilbury and the first course that you got was how to serve the customer who was very important to Bata people. What you do when a customer comes into your store; you meet them at the door, you lead them to a chair, you take off both shoes and you put them behind the chair.

[at this point the audience see clips from Charlie's original film footage showing life in East Tilbury combined with shots of Bata shops and shoes from the period. We then see that the passengers are sitting sewing pieces of 'bunting' with different images on]

DUNCAN MCLAREN (PASSENGER)
I love the slogan on our bus, which says 'We are not afraid of the future', but I kind of am…So I wrote [on the bunting], well I sort of cheated. With a marker I've written 'We are shit scared of the future'.

'Egg dump' winner – *Bata-ville: We are not afraid of the future*, film still.

TONY MAAS (PASSENGER)
No I don't think I am ever scared of the future. It is something to be embraced.

DUNCAN MCLAREN (PASSENGER)
I've been asked to take part in some Scottish country dancing too. But I am afraid, I'm shit scared of Scottish dancing as well, but I will give it a go, because everyone is joining in so much, it would be really wrong not to join in…

(clip ends)

NINA POPE

That was just a little taste of what it was like to be on the Bata-ville bus. After Charlie's film Anne Ostle led us all in a bus-wide round of the little-known Cumbrian game of 'egg dumping' (for the uninitiated it's a bit like conkers but with boiled eggs!) but you'll have to watch the film to see that. I know people always use these slots to plug their projects, but I would really encourage anyone with an interest in the work to see the full film. A talk can really only serve as a partial introduction and this carries the same frustrations as I was mentioning earlier relating to the 'dilution' of projects as they reach a wider audience. Bata-ville was a complex, messy at times, moving and very significant project for us. It really challenged both the way we engage with our audience and the actual 'form' of our work. We're happy that the film reflects this complexity and that an audience can continue to engage with the project through this translation of the intense journey and relationships made during the project.

I am now going to hand over to Mike Ostler, one of the first people to sign up for the trip and certainly one who has since made the most of the opportunities started by the project.

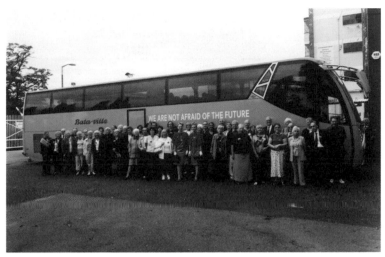

The passengers – *Bata-ville: We are not afraid of the future*, production still.

As a passenger and founding member of the Bata Resource and Reminiscence Centre[1] in East Tilbury he's very well positioned to talk about the legacy of the project more broadly, and to speak for people who were involved

MIKE OSTLER

Did you notice the cultural exchange on the bus between Maryport and Essex? That's before we even got to the Czech Republic? After retiring from 30 years in cinema and theatre management I got the chance, through *Bata-ville*, to actually appear in a film at the Edinburgh International Film Festival, so thank you Nina! We also had presentations at Tate Britain and the London Architectural Biennial and it even got me here today in Reading on my birthday. What more could I ask for? The raised profile has been very helpful to the Bata Reminiscence and Resource Centre. We have had many donations of artefacts or reminiscences that people have sent us on tape and others who have come in for us to record them. Attendances on the open days have doubled since the film was released. The Reminiscence and Resource Centre 'camps' in the corner of the East Tilbury library, we do not have much room, and have always wanted to expand and as we speak the builders are in there now revamping the whole of the place, so it will be a new reminiscence centre with a bit of library on the side! I do not believe we would have achieved this before the making of the film.

When in Prague we made further contact with Sonja Bata (Tom Bata junior's wife) and she has been running a charity foundation internationally. Since then Bata has withdrawn completely from the United Kingdom; East Tilbury has closed down and they have gone to Kuala Lumpur to make plastic shoes. We knew that was going to happen and that is why we

needed regeneration. Sonja came down to East Tilbury for a final visit and when she saw all we had in our centre she gave us stacks of stuff, including the executives ink well which they had in store. She has since gone back to Lucerne and the Bata head office is in Canada. She gave us £1,000 so that each year we could put a wreath on the memorial, but also to think of a future project. We used that £1,000 to make a bid to the East of England Development Agency and we actually got £110,000. We are getting real archive racking as a safe place to keep everything in. You are all welcome to the re-opening. Last year I hired one of my old theatres and we held a public film showing for over 100 people. We have had an increase in requests for more talks and displays in the community and much of this is down to the Bata-ville project, so if you ask me if these collaborations work my answer is 'yes, yes ,yes'.

Now we get onto the more controversial element of the day – 'Searching for the Spectator'… it should be 'searching for the participant'. The days of Angels of the North school-of-art are over. The days of sticking something in the ground and hoping the community will learn to love it is finished. We members of the public (and I am probably one of the only 'pure' members of the public here!), the paying public, we expect to be involved and not just given another statue. We don't want to be spectators, we don't want to be audience, we want to be participants. We no longer need to visit galleries for visual stimulation. It is all around us nowadays. Paint on gallery walls is for the stone-age. Modern-day galleries will end up being used incestuously – by artists visiting artists and no one else. When did you last have a taxi driver in any of the galleries that you run, or a car worker, or a newspaper columnist (unless he is there for a free sherry)? You have got to come out and live with the community.

Note

1. The Bata Reminiscence and Resource Centre is an archive and resource run by volunteers in East Tilbury to collect and exhibit a unique set of artefacts, memories and articles relating to Bata in both East Tilbury and worldwide. The steering group were key to the success of *Bata-ville* and the project legacy.

Chapter 16

Co-productive Exhibition-making

Paul O'Neill

Operating across the disciplines of academic research, exhibition curating and studio practice, Paul O'Neill is well placed to make the final contribution to this book. He proposes that a more open approach to gallery shows can deliver a less didactic experience for both the contributing artist and the spectator. An exhibition form, as a continuum which mutates over time, demonstrates the flexibility of the art object and its ability to counter traditional expectations of its function as it moves to new spaces where artists are invited to respond not only to the physical site, but to each other's work.

The group exhibition form as a continually evolving structure

Since the 1960s, the group exhibition has opened up a range of curatorial approaches to demystify the role of mediation and as such has also enabled divergent artistic practices to be exhibited together under a single rubric.[1] The term 'demystification' became a recurring trope within art and curatorial discourse for how the changing conditions of exhibition production were made manifest in the final exhibition-form. Curators, artists and critics were acknowledging the influential mediating component within an exhibition's formation, production and dissemination.[2] Demystification was a necessary process in revealing and evaluating the more hidden curatorial components of an exhibition, making evident that the actions of curators had an impact on which artworks were exhibited and how they were produced, mediated and distributed for the viewer.

The group exhibition has become the primary site for curatorial experimentation and, as such, represents a new discursive space around artistic practice. The following text describes how a cumulative and expanding exhibition-form can constitute an investigation into how the curatorial role is made manifest, through collaborative and collective exhibition-making structures applied through close involvement with artists during all stages of the exhibition production.

In order to focus on the spatial context of the exhibitions, any implementation of thematic displays of related works is resisted, whereby selected artworks would have been forced to collectively adhere to a single theme. The artists were not there to illustrate any overarching subject, nor were the works arranged so as to demonstrate a coherent intertextual relationship

Images on pages 204–207: Coalesce: Happenstance' and exhibition curated by Paul O'Neill.

between one another. Instead, the gallery is a setting for the staging of spatial relations between works, and between viewers, with curating put forward as the activity that structures such experiences for the viewer and for the work.

Coalesce: Three principle categories of organization

Coalesce is an evolving curatorial project established as a means of reflecting upon how the re-configuration of curatorial praxis in recent years can be made apparent within the final exhibition-form beyond the curatorial as master-planning scenario. Since 2003, it has marked a shift in my own curatorial practice towards a more collective curatorial methodology, achieved by working directly with artists on every aspect of the exhibitions' production. *Coalesce* is an accumulative exhibition that gathers its form across a series of distinct exhibition-moments. To date, the project has taken the form of five distinct exhibitions at London Print Studio Gallery, United Kingdom (2003); Galeria Palma XII, Villa Franca, Spain (2004); The Model and Niland Gallery, Sligo, Ireland (2005) and Redux, London, United Kingdom (2005).[3] *Coalesce: Happenstance* at SMART Project Space, (2009) was the final instalment in an evolutionary project.[4]

The project began with *Coalesce: Mingle Mangle* physically 'becoming' the gallery space, with each work accessing all of the available space and melting with other works. Jaime Gili, with his explosive silk-screens, covered part of the wall space, developing his research on repetition and the installation of painting. Intertwined with this Kathrin Böhm's work *millions and millions*, an ongoing project of printed posters, continued a strategy of penetration and mutation of the space. This ensemble of works, like an expanded, complex wallpaper, adapted and occupied the walls and ceiling of the gallery, while the work of Eduardo Padilha, in the shape of sleeping bags made with beautifully printed or embroidered fabrics found on discarded mattresses around London, was open for the viewers to sit, lie, relax and enjoy the created environment of the exhibition as a whole.

In each instalment, each exhibition-moment has taken the form of a mutating environment of overlapping artworks. Each new exhibition also gathers new artists and curators each time. Some invitees are called upon to activate the exhibition site by considering it as a possible pedagogical tool within an ongoing collaborative process. This also results in a staging of discursive events that respond critically to the concept, structure and form of the exhibition. The multiple outcomes of *Coalesce*, across locations and times, form part of a continuum, with the project being considered as an unending exhibition with artists being added for each new outing. Each time the title has been retained whereas a new subtitle is introduced in order to distinguish each outing from the other. For each exhibition, artists work collectively in a semi-autonomous way on an installation, with their work(s) literally merging into each other, resulting in an overall group exhibition-form rather than an accumulation of discernible, autonomous, individual artworks. The overall exhibition grows over time, at different speeds and with varying modes of display and foregrounds

mediating strategies by emphasizing exhibition design, structure and layout, all of which are intended to be as dominant as the individual works of art.

Throughout the series of exhibitions, there is an intentional balance inherent to each curatorial methodology articulated – through the exhibition form and the space of production for art made specifically for the exhibition – in which each participant within the exhibition becomes part of a dialogical structure, mediated from the outset by the curator. These series of exhibitions have no grand narrative, no single or unified way of reading the exhibition as a work, or of clearly separating out the curatorial and artistic work therein. In each project, artists responded to a curatorial proposition, strategy or imposed structure which resulted in artworks that would not have emerged without such orchestration. At the same time, each curatorial structure was responsive to each artist's practice, which always remained the starting point for the propositions.[5]

To focus on the spatial context of the exhibition-form, the gallery is a setting for the staging of spatial relations between works, and between viewers, with curating as the activity that structures such experiences for the viewer and for the work. *Coalesce* provides three potential planes of interaction, with the exhibition considered to be an organized built environment which:

1) surrounds the viewer who moves through it
2) the viewer interacts with only partly
3) contains the viewer in its space of display.

By applying Susan Stewart's understanding of landscape (and the gigantic) as a 'container' of objects and mobile viewing subjects[6] to our experience of the exhibition one can deduce a rejection of the notion of the autonomous objects of art as the primary medium through which the ritualized and ritualizing experience of art takes place. This perception is then replaced by a desire for an understanding of these rituals at the level of the space of exhibition(s), where 'our most fundamental relation to the gigantic is articulated in our relation to landscape, our immediate and lived relation to nature as it "surrounds" us' (ibid.). As a question of scale, landscape is that which encloses us visually and spatially, 'expressed most often through an abstract projection of the body' upon the world (ibid.). The metaphor of the exhibition-as-landscape also acknowledges the spatial world as a display space.

For Carol Duncan, the experience of the exhibition space is organized for the viewer through the 'arrangement of objects, its lighting and architectural details [that] provide both the stage set and the script' for gallery visitors to perform their experience of culture in a prescribed manner, with the exhibition site operating as the framework of this experience that has been passed down over time and understood by its users as a space of performed reception.[7] All exhibitions structure ritualized practices for audiences within 'those sites in which politically organised and socially institutionalised power most avidly seeks to realise its desire to appear as beautiful, natural, and legitimate.'[8] Such an ameliorated reception of art and objects of cultural value disguises the ideological forces behind such 'cultural

experience[s] that claims for its [exhibited] truths the status of objective knowledge'.[9] *Coalesce* considers in practice, how the ritual site of exhibition is structured for the viewer at each stage of the curator's involvement in the organization of an exhibition's contents, display and spatial arrangement.

Coalesce applies the metaphor of the exhibition as a landscape as a means of establishing a formal structuring device, responsive to three planes of interaction, available to the viewer. Structured around three spatial categories – the background, the middle-ground and the foreground – these terms of classification were used as three prescribed terms of reference for thinking about how exhibitions are constructed. These spatial co-ordinates are then utilized as organizational strategies through which the exhibition can consider the proximity of the viewer to each of the artworks as well as to the exhibition display, with respect to exhibition production as a form of co-authorship. Each artist or artwork is then selected to respond to one of the three organizational parameters.

1. The background is considered to be the architecture of the exhibition space, the primary layer of the exhibition under discussion. The white walls of each gallery are at least partly painted, covered or pasted over and converted from a blank space into a dominant aesthetic experience.
2. The middle-ground becomes an area with which audiences are intended to interact. It could be described as the manner in which the exhibition design and the layout of the

exhibition space is organized – prior to the placement of artists and their works – and the way in which such elements function within the overall organizational framework of a group exhibition. Display structures, gallery furniture, seating and overall exhibition design are considered prior to the exhibition installation, which the middle-ground utilizes as a means of conditioning and mobilising the exhibition viewer in prescribed ways.

3. The foreground represents a space of containment, in which the viewer is requested to take part in a subject-to-object relationship with those artefacts, images and works of art that could be categorized as autonomous objects for study in their own right. Such works arrive in their complete form and are left intact after the event of the exhibition. These works can not be adapted or changed by curatorial intervention, each of which require certain inherent conditions of display.

The three organizational categories described above are not only employed to facilitate the selection of works for each exhibition but also intermingle into the final exhibition form. The intention of *Coalesce* is to accommodate a cross-fertilization of different artistic and curatorial positions within a single unifying curatorial project over an extended period.

While all five exhibition-forms were responsive to the unique gallery contexts for which they were commissioned, there were intentional connections, structural attributes and curatorial overlaps between them. As important as it was to maintain a consistent curatorial

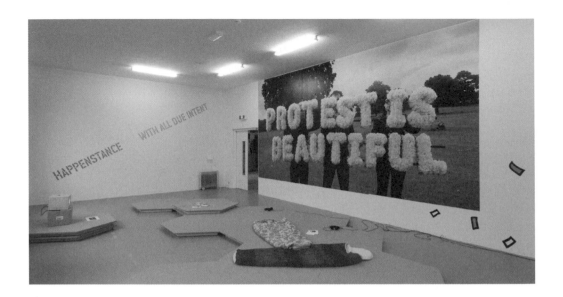

methodology across the five exhibition platforms, it was also crucial to extend the potentiality of this vocabulary while testing its limitations. Each of the five components of the exhibition project were used as a research tool in exploring the potential of the group exhibition as a space of collective co-production, in which curatorial and artistic work could operate in unison, with equal parts to play in the resulting exhibition. As research tools with practical outcomes, these projects were used to question the different ways in which the language of an exhibition is arrived at through a co-production process, working closely with artists within an open, yet predetermined, curatorial structure. Each exhibition attempted something unique, while adhering to an overarching curatorial framework set out beforehand. Each *Coalesce* can be read as a separate and discrete outcome, or as part

of a more cohesive investigation into the group exhibition as a space of experimentation that informs how exhibition-viewing is organized and structured.

The *foreground, middle-ground* and *background* are set out as three principal categories of organization for the viewer and for the works. The production of an exhibition is structured for the viewer around three separate, but interdependent, stages in which the group exhibition as a medium could be divided into three categories of organization regardless of what was contained therein. My intention was not to inaugurate or consolidate the curating of group exhibitions as a discipline; instead it was to define a curatorial strategy from the outset, across a period of time, as a means of demonstrating how such a methodology could be usefully applied to the production of group exhibitions. This strategy demonstrated how curating can bring about a certain order to the exhibition material through the configuration of the architectural setting, the exhibition design, form, style and artistic content. By focusing on an overarching organizational structure it was my intention to show how each individual curatorial statement, made manifest in these exhibitions, was the result of divergent, complex and dialectical relations between the curator and the artist as co-producers. By making these interrelations apparent from the outset, 'the difference between collaborative and authorial structures'[10] converge during a process of co-production, leading to the construction of co-operative and co-authored group exhibition-formations.

Notes

1. The thematic group exhibition emerged as a formative model for defining ways of engaging with such disparate interests as exoticism, feminism, identity, multiculturalism, otherness and queerness. As I argued in a previous paper, the ubiquity of the biennial model since the 1990s – and the consistency of such exhibitions in being centred on an overarching trans-cultural, cross-national and inclusive thematic structure – has helped to define the modes of art's engagement with a variety of socio-political and global cultural topics. Through their diversity of outcomes, group exhibitions have also offered an alternative to more traditional Western museum exhibition paradigms, such as the monographic or genre exhibition, or the permanent collection.

2. Much of the discussion around curators from the 1960s, such as Seth Siegelaub's curatorial projects, benefit from considerable hindsight for, even during the 1960s, the term 'curator' was never used by Siegelaub in relation to what he was doing at the time. It is only in the context of other people's subsequent texts about his practice of the 1960s and as part of curatorial debates in the 1980s and 1990s, that Siegelaub has been called a curator. In my interview with him, he stated: 'I probably wouldn't have used the word "curator" at the time, although I have recently done so in retrospect because there is a whole body of curatorial practice that has quantitatively evolved since then... While I can look back now and say that curating is probably what I was doing, it is not a term that I would have used when I was active for one simple reason: the dominant idea of the curator at the time was basically someone who worked for a museum. Since then, the definition of the term curator has changed. This is just another facet which reflects how the art world has changed since the 1960s/early 1970s; the art world has become much bigger, richer, more omnipresent; there are many more museums, galleries, artists, art bars, art schools, art lovers, etc. It is has also become more central and more attached to the dominant values of capitalist society...It is

clear that, in the last 30 years or so, art has become a more acceptable profession, even a type of business, a more acceptable thing to do, both as a practitioner, as well as an art collector. One can think of becoming an artist as a possible "career choice" now, which just didn't exist back then. One just didn't have this opportunity. The question of the curator, in this context, is also related to another modern phenomenon today: the need for freelance curatorial energy to invigorate museums that no longer have this kind of energy' (Seth Siegelaub, interview with the author). For a comprehensive examination of Siegelaub's practice between 1965 and 1972, see Alberro, A. *Conceptual Art and the Politics of Publicity* (Cambridge, MA: MIT Press, 2003).

3. Documentation from all four manifestations to date are viewable on the website www.coalescent. org.uk which shows documentation of each exhibition and represents the development of the project since 2003.

4. The final exhibition at SMART involved the following artists:

Dave Beech and Mark Hutchinson, David Blandy, Het Blauwe Huis with M2M radio, Kathrin Böhm, Nina Canell, Oriana Fox, Freee, General Idea, Jaime Gili, Clare Goodwin, Lothar Götz, Tod Hanson, Toby Huddlestone, Tellervo Kalleinen and Oliver Kochta-Kalleinen, Cyril Lepetit, Ronan McCrea, Jonathan Mosley and Sophie Warren with Can Altay, Jem Noble, Isabel Nolan, Harold Offeh, Mark Orange, Eduardo Padilha, Garrett Phelan, Sarah Pierce, Manuel Saiz, Savage, temporarycontemporary, Richard Venlet, Robin Watkins, Lawrence Weiner, Matt White, Mick Wilson. *Coalesce* film programme involved: Ursula Biemann and Angela Sanders, Jakup Ferri, Esra Ersen, Adla Isanovic, Helmut and Johanna Kandl, Tadej Pogacar and the P.A.R.A.S.I.T.E Museum of Contemporary Art, Marko Raat selected by B + B. Special opening event: musical performance by Irish music research group TradFutures@W2.0, organized by Mick Wilson. TradFutures@W2.0 consist of Nollaig Ó Fiongháile, Brian Ó hUiginn, Patrick Daly and Bill Wright.

5. See O'Neill, P. interviewed by Fletcher, A., 'Introduction', in ed., P. O'Neill, *Curating Subjects* (Amsterdam and London: De Appel and Open Editions, 2007), p. 18.

6. Stewart, S., 'The Gigantic', in *On Longing: Narratives of the Miniature, the Gigantic, the Souvenir, the Collection* (Durham and London: Duke University Press, 1993), p. 71.

7. Duncan, C., *Civilising Rituals: Inside Public Art Museums* (London and New York: Routledge, 1995), pp. 12–13.

8. Duncan, Carol. *Civilising Rituals*, p. 6.

9. Duncan, Carol. *Civilising Rituals*, p. 8.

10. In his keynote address for the Banff 2000 International Curatorial Summit at the Banff Centre, 24 August, 2000, Bruce Ferguson highlighted three recurring issues in contemporary curating, the third of which was 'the difference between collaborative and authorial structures'. See Townsend, M., 'The Troubles with Curating', in ed., M. Townsend, *Beyond the Box: Diverging Curatorial Practices* (Banff: Banff Centre Press, 2003), p. xv.

Contributors' Biographies

Dave Beech

Dave Beech is an artist in the collective Freee. He teaches at Chelsea College of Art and writes regularly for Art Monthly. Recent exhibitions include *spin[freee]oza* at SMART project space, Amsterdam, *Nought to Sixty* at ICA, London, *We Collaborate Better Than You*, at the Good Children Gallery, New Orleans and V22 PRESENTS *The Sculpture Show*, London. He is the author of *Beauty* (MIT/Whitechapel, 2009) and co-author of *The Philistine Controversy*. (Verso, 2002).

Will Bradley

Will Bradley is a critic and curator currently based in Oslo. He has contributed to many art journals including *Frieze*, *Afterall*, *Metropolis M*, *Untitled* and *Bidoun*. He co-founded the Modern Institute in Glasgow in 1998 and his recent projects include the book *Art and Social Change* (Tate Publications, 2007) and the exhibitions *Forms of Resistance* (Van Abbemuseum, Eindhoven, 2007) and *Radical Software II* (Den Frie, Copenhagen, 2008).

David Briers

David Briers has contributed to over 30 national and international arts periodicals, and has written more than 60 essays for exhibition catalogues, and professional guides for visual artists. He has also worked as a public art consultant and arts lottery assessor, and was full-time exhibitions organizer at Chapter Arts Centre in Cardiff (1976–1984) and the Ferens Art Gallery, Hull (1991–1994). His specialist fields of interest include the histories of hybrid practices such as mail art, Fluxus, artists' books, visual and sound poetry, live art and sound art. In 2002 he curated the exhibition *Groove*, a historical and contemporary survey of visual artists working with gramophone records, from Marcel Duchamp to Philip Jeck (the exhibition was reviewed by both *Art Monthly* and *Record Collector*). He is currently undertaking a research project into the history of British experimental and live art during the 1960s and 1970s.

Jonathan Lahey Dronsfield

Jonathan Lahey Dronsfield is Reader in Theory and Philosophy of Art, University of Reading, and sits on the Forum for European Philosophy at the London School of

Economics. He has published extensively in the area of contemporary continental philosophy and art.

Harrell Fletcher

Harrell Fletcher has worked collaboratively and individually on a variety of socially engaged, interdisciplinary projects for over a decade. His work has been shown at SF MoMA, the de Young Museum, the Berkeley Art Museum and Yerba Buena Center for the Arts in the San Francisco Bay Area, the Drawing Center, Socrates Sculpture Park, the Sculpture Centre, the Wrong Gallery and Smackmellon in NYC, DiverseWorks and Aurora Picture show in Houston, TX, PICA in Portland, OR, CoCA and the Seattle Art Museum in Seattle, WA, Signal in Malmo, Sweden, Domain de Kerguehennec in France and the Royal College of Art in London. Fletcher exhibits in San Francisco and Los Angeles with Jack Hanley Gallery, in NYC with Christine Burgin Gallery, in London with Laura Bartlett Gallery and Paris with Gallery In Situ. He was a participant in the 2004 Whitney Biennial. In 2002 Fletcher started *Learning to Love You More*, an ongoing participatory website with Miranda July. A book version of the project was published by Prestel in 2007. In 2005 he was the recipient of the Alpert Award in Visual Arts. His travelling exhibition *The American War* originated in 2005 at ArtPace in San Antonio, TX, and travelled in 2006 to Solvent Space in Richmond, VA, White Columns in NYC, the Center for Advanced Visual Studies MIT in Boston, MA and PICA in Portland, OR. Fletcher is a Professor of Art at Portland State University in Portland, Oregon.

Vincent Honoré

Vincent Honoré is an independent curator. In 2008, he was appointed Artistic Director and Head of Collection of the David Roberts Art Foundation. Prior to taking up his role with the Foundation, he was a curator at Tate Modern where he worked on exhibitions such as *Mohamed Camara, Jeff Wall, Catherine Sullivan, Pierre Huyghe, Carsten Höller, Learn to Read* and *Louise Bourgeois*. He was also formerly a curator and editor at Palais de Tokyo in Paris and has been commissioned as a guest curator on a range of projects including *Past Forward* at 176, the Zabludowicz Collection and *From a Distance* at Wallspace Gallery, New York.

Sophie Hope

Sophie Hope's work inspects the uncertain relationships between art and society. This involves establishing how to declare her politics through her practice; rethinking what it means to be paid to be critical and devising tactics to challenge notions of authorship. Since co-founding the curatorial partnership B+B in 2000, Sophie has gone on to pursue her independent practice, with recent projects taking place in a Dutch new town, south London housing estate and Austrian cultural embassy. Sophie also writes, teaches and facilitates workshops, dealing with issues of public art, the politics of socially engaged art and curating as critical practice. See www.welcomebb.org.uk.

Juneau Projects

Juneau Projects were formed in 2001 as a collaborative practice by Ben Sadler and Philip Duckworth. Their work engages with people and folk histories, bringing together live work and installation in new interactive combinations. In early performance works they used mobile phones, wood chippers, microphones and CD walkmans, often destroying them to make unexpected sounds. In their gallery shows their work has developed to encompass video, installation, sculpture and painting, featuring an array of natural imagery such as animals, birds and landscapes, which seek to express how they think we feel about nature in the twenty-first century.

Their collaborative projects have included *Stag becomes Eagle*, a large-scale commission for the RSPB, which brought together local young people in Purfleet, Essex. They met on a nearby bird reserve to record an album of music inspired by their lives and local surroundings. An event where the participants performed their songs was held on the reserve in the summer of 2005. One of the most recent participatory projects was Juneau Projects' exhibition *The Principalities*, 2008, at Stanley Picker Gallery, Kingston. They turned the gallery into an open performance space with an evolving programme of events by the University's students and staff. The exhibition marked the culmination of Juneau Projects' fellowship at Stanley Picker Gallery. They have a longstanding relationship with Grizedale Arts leading to projects in the United Kingdom, United States and Japan. They were included in the British Art Show 6 and have had solo exhibitions at the Showroom, fa projects, Ikon Gallery and Tate Britain. See www.juneaurecords.co.uk. Juneau Projects are represented by fa projects, www.faprojects.com.

London Fieldworks

London Fieldworks was co-founded by artists Bruce Gilchrist and Jo Joelson in 2000 to produce hybrid artworks at the art, science and technology intersection. Their practice moves between landscape, an East London studio and the gallery, and includes elements of installation and video filmmaking. Imaginatively sited projects typically engage with technology and the methods of science within a wider cultural context to explore the notion of ecology as a complex interworking of social, natural and technological worlds. Recent projects have created speculative works of fiction out of a mix of ecological, scientific and pop cultural narratives. *Spacebaby: Guinea Pigs Don't Dream* (commissioned by Arts Catalyst for Space Soon, London, 2006) and *Hibernator: Prince of the Petrified Forest* (commissioned by Beaconsfield, London, 2007) are part of a trilogy of works exploring themes of suspended animation, technology, fantasy and death. The third project in the trilogy, *Super Kingdom* (commissioned by Stour Valley Arts, 2008) explores the enfolding of human and animal habitat in an architectural intervention in the ancient forest of King's Wood in Kent. Despot's palaces, the assisted migration of animals and the strategy of re-wilding inspire *Super Kingdom*. London Fieldworks were recipients of a British Association for the Advancement of Science and Royal Society Millennium Fellowship (2000); Arts Council England International Fellowship (2002); Special Mention from the 10th Edition

of International Art and Artificial Life prize VIDA (2007); British Council, Arts Council England Artist Links Brazil (2009). See www.londonfieldworks.com.

Graeme Miller

Graeme Miller's work often deals with the idea of place – looking at how mental landscapes respond to actual space and how these inner and outer geographies meet or contradict. Starting with *The Sound Observatory* (Birmingham, 1992) and most recently *Bassline* (London, 2009; Vienna, 2004) – public spaces that deal with their own location and interact with it. *Listening Ground, Lost Acres* (Artangel/Salisbury Festival, 2004) and *Linked* (an ongoing installation along the edges of the M11 motorway in East London) place radio transmitters in the landscape. Much of Miller's work uses elements of sound as a medium to explore narrative and engage with the idea composition – not just as an artist who works as a composer of things which may include music, but as an artist interested in our co-composition of reality. Recent video works have been composed from found locations – *Lonesome Way* a C&W song written from found details in an eponymous street in south London and *Crepuscular Manoeuvres*, a duet synchronized live to pulsing pharmacy signs in Paris. His ongoing work, *Beheld*, is an installation of images of the sky taken a sites where migrant stowaways have fallen from the undercarriages aircraft – projected with sound into glass. See www.artsadmin.co.uk.

Paul O'Neill

Dr Paul O'Neill is a curator, artist and writer, based in London and Bristol. He is currently Great Western Research Alliance Research Fellow in Commissioning Contemporary Art with Situations at the University of the West of England, Bristol, where he is leading *Locating the Producers* – a three-year international research project that investigates curatorial methodologies and the commissioning of contemporary art through internationally focused public events. In 2008, he was awarded his PhD from Middlesex University. From 2001–2003 he was curator at London Print Studio Gallery, and from 1997–2006 he established and co-directed *MultiplesX*, an organization that commissions and supports exhibitions of artists' editions. He has curated or co-curated over 50 exhibitions including: *Coalesce*: *happenstance*, SMART Project Space, Amsterdam, (2009); *Tape Runs Out*, Text and Work Gallery, Bournemouth (2007); *Making Do*, The Lab, Dublin (2007); *Our Day Will Come*, Zoo Art Fair, London (2006); *General Idea: Selected Retrospective*, Project, Dublin (2006). As an artist, he has exhibited widely including: Zaçheta Gallery of Contemporary Art, Warsaw; the Irish Museum of Modern Art, Dublin and many others. He has lectured on curatorial training programmes at Goldsmiths College London; de Appel, Amsterdam and the Whitney ISP, New York. His writing has been published in many books, catalogues, journals and magazines including *Art Monthly*, *Space & Culture*, *Everything*, *Contemporary*, the *Internationaler* and *CIRCA*. He is the commissioning editor of the anthology *Curating Subjects* (de Appel and Open Editions, 2007) and with Mick Wilson, a second volume in 2009 focusing on curating and the educational turn. See www.situations.org.uk.

Sally O'Reilly

Sally O'Reilly is a writer, contributing regularly to many art publications, including *Art Monthly*, *Frieze*, *Art Review*, *Spike* and *Time Out*, and has written essays on emerging and established artists (for international organizations such as Tate Modern, London, Mori Art Museum, Tokyo, Gemeentemuseum, The Hague and BALTIC, Gateshead). She is a Dean of Brown Mountain College of the Performing Arts, an itinerant platform for the production of performative events and was co-editor of the thematic, interdisciplinary broadsheet *Implicasphere* (2003–2008). She was also co-producer of the performance programme for Whitstable Biennale 2006 and curator of Beacon Art Project 2007. See www.implicasphere.org.uk and www.brownmountain.org.uk.

Nina Pope

Nina Pope (b. 1968) and Karen Guthrie (b. 1970) live and work in London and the Lake District (UK) respectively. After studying together at Edinburgh College of Art they completed MAs in London and began their collaborative and solo careers in 1995. They launched their creative organization Somewhere in 2001, and have led diverse projects with an emphasis on new audiences and innovative technology.

In 2003 they began work on Bata-ville which a year later took them on a journey to Zlin in the Czech Republic with a coach full of former UK Bata employees, and two years later resulted in their first feature film *Bata-ville: We Are Not Afraid of the Future*. The film has been shown internationally including the premiere at the prestigious Edinburgh International Film Festival. In 2007 they released their second documentary feature *Living with the Tudors*. They are currently working on a public garden project in east London called *What Will the Harvest Be*? and developing a new film looking at the world of cat breeding and feline genetics.

Marisa C. Sánchez

Marisa C. Sánchez is the Assistant Curator of Modern and Contemporary Art at the Seattle Art Museum. Sánchez joined SAM's curatorial staff in late April 2007. From February 2003, Marisa was curatorial assistant in the photography department at the Museum of Fine Arts, Houston (MFAH). In this position she curated *Two Women Look West* and *The Target Collection of American Photography: A Century in Pictures*.

Since arriving at the Seattle Art Museum, Sánchez has been involved in a number of curatorial projects, including *Weavings*, an ambitious photographic installation by Corin Hewitt on view at the museum 4 April–18 October 2009. For a recent artist book, designed and published by J&L Books, Sánchez wrote *An Evolution of Experience*, an essay on Hewitt's work. She also contributed an essay, *More Than an Object*, highlighting post-war sculptures within the permanent collection, in celebration of the 75th anniversary of the Seattle Art Museum. A native of New Jersey, Marisa holds a Masters in art history, theory and criticism from the School of the Art Institute of Chicago.

Helen Sumpter

Helen Sumpter is a London-based art writer and commentator, specializing in contemporary visual art. She studied art and writing and publishing at Middlesex University and has fourteen years experience writing interviews, features and reviews for publications that include *Time Out*, *Art Review*, *The V&A Magazine*, *i-D*, *The Times*, *Art & Music*, the *Big Issue*, the *Observer Magazine*, *Artworld* and the *Evening Standard*. She has also broadcast on BBC Radio and produced audio interviews for Audio Arts and BBC Online.

Adam Sutherland

Adam Sutherland has been Director of Grizedale Arts since 2000. He initially established a practice as an artist with work centred on an interest in people and their interaction with, and forming of, culture. After formal art school training in the early 1980s he established a community art programme working on public art and product-orientated output with mental health, schools and community centres in North London. The project evolved into what was increasingly termed socially engaged practice drawing from the aesthetics and interests of participants rather than the refined interests of the artist. In 2000 he became director/curator of Grizedale Arts extending his interest in using artists to express ideas drawn from the community practice – incorporating artists' perspectives alongside a wider range of activity. The curated projects became extended conversations between ideological positions within defined programme themes. The results generally appear as big messy events, often confusing to the audience and to the participant as well. Although Grizedale is centred in the Lake District the organization has recently undertaken projects in New York, Japan and China. The current programme has seen the development of a farm and design collection focused around the small rural community of Coniston. In general Adam believes that art should perform a useful function with a direct benefit to society. See www.grizedale.org.

Jeni Walwin

Jeni Walwin is an independent curator, writer and public art consultant. Since 2001 she has been Project Director of the public art programme, *Artists in the City* – working with a local authority, private developers and architects to create opportunities for artists to make new work for a variety of city centre contexts. For several years she has been the lead curator for the Contemporary Art Society's annual selling show, *ARTfutures*. She continues to work in a freelance capacity for the Society and is currently the Curatorial Advisor to Pictet Asset Management where she is helping to develop a collection of contemporary work. With the artist Henry Krokatsis, she devised and selected *You'll Never Know: Drawing and Random Interference*, a national touring exhibition for the Hayward Gallery. She has written extensively on live art and performance. *Low Tide,* her writings on artists' collaborations, was published by Black Dog. For Rivers Oram she co-edited the book *A Split Second of Paradise* – a collection of essays on live art, installation and performance. As well as essays for catalogues and books, she has contributed articles to *Blueprint, Art Monthly, a-n knowledge bank* and *Art Review*. She is a member of the Advisory Board of the Drawing Room, on the selection panel for the 2009 Edinburgh Art Festival and is a trustee of the performance theatre company Crying Out Loud. See www.artistsinthecity.org.uk.

Index

Credits

All images courtesy of the artist/artists unless otherwise indicated.

p. 16 Freee, *Protest is Beautiful*, photograph, poster, 2007.

p. 19 Harrell Fletcher and Jon Rubin, *Garage Sale*, Gallery HERE, Oakland, CA, 1993. Photo: Harrell Fletcher.

p. 27 Adam Dant, *Operation Owl Club*, 2004. Commissioned by Artists in the City to highlight 'Reading Explorer' the new sign system for the centre of Reading.

p. 39 An installation image of Robert Morris's 1971 exhibition *Bodyspacemotionthings*. Copyright Tate, London 2009.

p. 40 public works, *Granville Cube*, South Kilburn, London, UK, Nov 2005 – ongoing. Copyright public works.

p. 40 public works, *Granville Cube – Launch of the Friends of the Cube Group*, April 2008. Copyright public works.

p. 40 public works, *Granville Cube Swap Shop*, Feb 2006. Copyright public works.

p. 48 Chris Evans, *Three Sculptures for Marseille* (Detail: The Stranger), 1998.

p. 52 Chris Evans, *Cop Talk*, event part of Hey Hey Glossolalia, New York, 2008.

p. 52 Chris Evans, *Cop Talk*, event part of Hey Hey Glossolalia, New York, 2008.

p. 61 Adam Dant, *Operation Owl Club*, 2004. Commissioned by Artists in the City to highlight 'Reading Explorer' the new sign system for the centre of Reading.

p. 63 Adam Dant, *Operation Owl Club*, 2004. Commissioned by Artists in the City to highlight 'Reading Explorer' the new sign system for the centre of Reading.

p. 65 Adam Dant, *Operation Owl Club*, 2004. Commissioned by Artists in the City to highlight 'Reading Explorer' the new sign system for the centre of Reading.

p. 70 Sophie Hope, *Art is Useless*, staged protest outside Het Reservaat, 2007. Image by Sophie Hope.

p. 70 Sophie Hope, *Dead in Leidsche Rijn*, 2007. Image by Barry Sykes.

p. 70 *Critical Friends*, front cover of magazine, 2008.

p. 75 Sophie Hope, *Het Reservaat*, exiting the time-tunnel into the museum, 2007. Image by Jeroen Wandermaker.

p. 75 Sophie Hope, *Het Reservaat*, the most famous rock band of 2007, Eitherway, 2007. Image by Jeroen Wandermaker.

p. 80 Harrell Fletcher and Jon Rubin, *Garage Sale*, Gallery HERE, Oakland, CA, 1993. Photo: Harrell Fletcher.

p. 85 Harrell Fletcher, *Corentine's Turtle*, Domaine De Kerguehennec, Brittany, France, 2006. Photo: Harrell Fletcher.

p. 87 Harrell Fletcher and Jon Rubin, *Garage Sale*, Gallery HERE, Oakland, CA, 1993. Photo: Harrell Fletcher.

p. 94 *Scratch Orchestra Cottage*, Alexandra Palace, London, August 1971. Left to right: Michael Chant, Bob Cobbing, Cornelius Cardew.

p. 99 Mauricio Kagel's, *Eine Brise* ('*A Breeze*'), 1996, performed at 'East Festival' 2009. LONDON, ENGLAND – MARCH 05: Cyclists perform a 90 second symphony using bicycle bells on March 5, 2009 in London, England. The piece composed by Maurizio Kagel launches the start of the 'East Festival' 2009 which features hundreds of events over six days across the East End of London. (Photo by Dan Kitwood/Getty Images).

p.101 Janet Cardiff, *The Forty Part Motet*, 2001. Top image photo: Markus Tretter. Bottom image photo: Hugo Gledinnin, both images Courtesy of the artist and Luhring Augustine, New York.

pp. 108–115 Juneau Projects, 'Stag Becomes Eagle', Aveley Marshes, Purfleet, Essex, 2005, commissioned by RSPB and Commissions East, images courtesy of the artists and fa projects.

p. 120 Melanie Pappenheim, *Primrose Dispatch*, performance, 2006. Courtesy of The Reading Post.

p. 123 Melanie Pappenheim, *Primrose Dispatch*, performance, 2006. Courtesy of The Reading Post

pp. 130–135 Thomas Hirschhorn, *Anschool*, 2005 at Bonnefantenmuseum, Maastricht. Photos: Jonathan Lahey Dronsfield.

pp. 138–143 Graeme Miller, Waveform images – screenshots of speech from *LINKED*, 2003.

p. 149 London Fieldworks, *Polaria Fieldwork*, 2001. Photo: Anthony Oliver.

p. 149 London Fieldworks, *Polaria Installation Interface*, 2002. Photo: Stephen Morgan.

p. 151 Cllr. Olwyn Macdonald JP signing the Little Earth twinning agreement, 2004. Photo: Alex Gillespie.

p. 152 London Fieldworks, *Polaria Installation*, 2002. Photo: Gideon Cleary.

p. 153 London Fieldworks, Little Earth Production Still, Ben Nevis, 2004. Photo: Alex Gillespie

p. 154 London Fieldworks, Fixed 42m UHF parabolic antenna Eiscat Svalbard Radar, Frontiers, 8. 2004. Photo: London Fieldworks.

p. 154 London Fieldworks, *Little Earth Installation*, Wapping Hydraulic Power Station, London, 2005. Photo: London Fieldworks.

pp. 164–165 Nina Beier, *All Together Now*, Event, 2008. Commissioned by CollectingLiveArt and Zoo Art Fair, Photo: Bobby Whittaker.

p. 170 Gillian Wearing, *Family History*, 2006, installation view, Forbury Hotel Apartments. Commissioned by Film and Video Umbrella and Artists in the City in association with Ikon Gallery.

p. 173 Gillian Wearing, *Family History*, 2006, installation view, Forbury Hotel Apartments. Commissioned by Film and Video Umbrella and Artists in the City in association with Ikon Gallery.

p. 174 Gillian Wearing, *Family History*, 2006. Commissioned by Film and Video Umbrella and Artists in the City in association with Ikon Gallery.

p. 180 Juneau Projects, *Like A Wayside Shrine* – Honesty stall for Toge Village, 2006. For Seven Samurai, a Grizedale Arts project.

p. 183 Toge village sing their village love song at the Ikebukuro International Arts Festival, 2006. For Seven Samurai, a Grizedale Arts project.

p. 184 Marcus Coates, Answering the question of illegal bicycle parking for the Ikebukuro International Arts Festival, 2006. For Seven Samurai, a Grizedale Arts Project.